70s Style & Design

Thames & Hudson

70s Style & Design

Dominic Lutyens & Kirsty Hislop

with 430 illustrations, 339 in colour

Half-title Wallpaper in Wilde Carnation by Osborne & Little, the design and textile company set up by Peter Osborne and Antony Little in 1968. *Frontispiece* New Wave collides with hard-gloss disco in this 1978 creation by cutting-edge label, Swanky Modes.

First published in the United Kingdom in 2009 by Thames & Hudson Ltd, 181A High Holborn, London WC1V 7QX

thamesandhudson.com

Copyright © 2009 Dominic Lutyens and Kirsty Hislop

All Rights Reserved. No part of this publication may be reproduced or transmitted in any form or by any means, electronic or mechanical, including photocopy, recording or any other information storage and retrieval system, without prior permission in writing from the publisher.

British Library Cataloguing-in-Publication Data
A catalogue record for this book is available from the British Library

ISBN 978-0-500-51483-2

Printed and bound in China by Imago

INTRODUCTION	6
FROM POP TO POSTMODERNISM	14
BELLE EPOQUE	68
SUPERNATURE	112
AVANT GARDE	164
RESOURCES	220

The 1970s have long been maligned as 'the decade that taste forgot', but over the past twenty years or so 70s style has evolved from being a mere retro fad to a perennial inspiration for fashion, interiors, design and music. And perhaps its influence is finally being recognized: in 2009, the BBC's *Style on Trial* – a television programme that set out to find the most stylish decade, from the 1940s to the 1990s – awarded the honour to the 70s, applauding among other things the decade's androgyny and, perhaps the word that best defines the period aesthetically, its diversity.

Indeed, the style of the 1970s benefited from an explosion of new visual languages. This was precipitated in part by a backlash against the lean, clean functionality of Modernism, which was first set in motion by the fun-loving pop movement of the 1960s. In the 70s, this really came on stream, banishing traditional notions of 'good' taste in favour of pluralism, playfulness and originality. In architecture and design, conventional forms were challenged, decoration made a comeback, and historicism was embraced – the latter endorsed particularly by the Postmodernist movement. In fashion, eclecticism and individuality ruled, there was no 'right' look, and the wearer set the trends. 'Today's fashion is an opportunity for self-expression, fulfilment, of little head trips,' as American countercultural magazine *Rags* pointed out in 1970. 'A chance to break tradition and stereotype.'

BOYS LIKE FLOWERS, TOO

This rejection of convention was afforded by new social freedoms. The affluence of the post-war boom had impacted on both the US and Britain by the late 1960s, and this – along with a raft of social reforms, from the legalization of homosexuality to the liberalization of divorce – put the post-war baby boomers, the movers and shakers of the day, in the privileged position of being able to question the values, mores and tastes of their parents' generation and do their own thing.

As the 70s opened, traditional institutions such as the family unit were under attack from the growing gay and women's liberation movements. The UK's Gay Liberation Front was formed in 1970, and its 1971 manifesto outlined 'a far-sighted, radical agenda for a non-violent revolution in cultural values and attitudes', as activist Peter Tatchell recalls, 'questioning marriage, the nuclear family, monogamy, sexism and patriarchy. Making common cause with the women's, black and workers' movements, gay liberationists never sought equality within the status quo. We wanted fundamental social change.'

POPPING UP ALL OVER THE PLACE Italian architect and designer Gaetano Pesce's Up series of furniture *(opposite)*, designed in 1969, ticks virtually every box on artist Richard Hamilton's defining checklist of popular culture: 'popular, transient, expendable, low-cost, mass-produced, young, witty, sexy, gimmicky, glamorous, big business'. As well as challenging traditional ideas about form – the Lady armchair came complete with a pair of big, bouncy 'breasts' – Pesce was particularly innovative when it came to materials and techniques, making the most of the fast-evolving technology available to him. Made from flexible polyurethane foam with a jersey covering, the furniture was vacuum-packed flat for ease and economy of transportation. Once released from their heat-sealed plastic envelopes, the chairs bounced 'up' into shape as their polyurethane cells filled with air.

Meanwhile, the demands of the Women's Liberation Workshop included equal opportunities in both education and the workplace. By 1975 feminist campaigning had helped bring the Sex Discrimination and Equal Pay Acts into force. Similar goals were achieved in the US, along with the legalization of abortion in 1973. Lesbians – who sometimes allied themselves with radical feminists, calling on them to get rid of men 'from your beds and your heads' – also made themselves heard. The Labour MP Maureen Colquhoun was openly gay, and American writer Rita Mae Brown's 1973 novel, *Rubyfruit Jungle*, had an explicitly lesbian theme.

Change was afoot within the conventional family structure, too. Writing in the *Sunday Times* in 1977, journalist Rick Sanders noted that he and his wife, who shared the responsibilities of bringing up their baby daughter equally, hadn't 'found that parental excellence has a great deal to do with sex', nor did he find co-parenting 'emasculating'. By the late 1970s, even Ladybird Books were combating sexism with new, right-on language: 'Jane says, Girls like flowers. Peter says, And boys like flowers.' This social shake-up also gave rise to what Tom Wolfe dubbed 'the great Divorce Epidemic', and certainly the higher incidence of promiscuity, adultery and single-parent households suggested that the sexual revolution of the 1960s was simply a beginner's course for Wolfe's 'Sexed-up, Doped-up, Hedonistic Heaven of the Boom-Boom '70s'. As the decade progressed, this social diversity further encouraged the pursuit of individuality and self-expression.

DESPERATELY SEEKING SPIRITUALITY

The tastes and desires of the ordinary man had been the original inspiration for the pop movement and its rebellion against the coldly rationalist, one-style-for-all credo of Modernism. By the 1970s, the importance of the individual and his or her emotional needs was a major theme in architecture and design. Norma Skurka, in her cult book *Underground Interiors* of 1972, noted that the Bauhaus 'failed to recognize that…man is an emotional animal, drawn as much to beauty as he is to lack of logic. He needs his whimsies, his fantasies. But all of this good-natured nonsense was ruled out by the intellectualism of the Bauhaus follower.'

The idea of endowing architecture and design with more human qualities was explored in the narrative, humorous, inclusive aspects of pop and Postmodernism, as well as in the rustic, hand-hewn aesthetic that derived from America's

spirituality-seeking hippie movement, although these styles were poles apart visually. The hippies, appalled at their country's involvement in the Vietnam War, rejected the American Dream that had played muse to the pop movement, denouncing it as plastic and soulless. Their 're-humanization' involved embracing nature and the communality of rural life as an antidote to the alienating experience of modern city living. The hippies also drew inspiration from the simple, slow-paced past and from cultures untainted by the relentless pursuit of technological progress, which offered an alternative to Western ideals of beauty and gave rise to so-called 'ethnic' styles in fashion and interiors. A greater awareness of the rest of the world was disseminated by the rise of the electronic media, as well as by forays around the globe in search of enlightenment. Eastern mysticism, along with mind-expanding drugs, allowed for a more in-depth exploration of one's inner space.

The dawning preoccupation with the self dovetailed with the rise of the human potential movement, which, drawing from the field of humanistic psychology of the 1950s, encouraged self-acceptance and personal growth. Central to the movement was the 'growth centre', the most famous being the Esalen Institute in Big Sur, California, conceived in 1962 as a place where psychotherapy met Eastern religious practices and creative arts workshops. By the 1970s, Esalen had inspired scores of imitators in the US, and the search for the self – via psychotherapy, encounter groups and meditation, to name a few – had pervaded the mainstream, inspiring Tom Wolfe to dub the 1970s the 'Me Decade'.

BLUEPRINTS FOR SURVIVAL

The widespread awakening of the individual's creativity also chimed with a huge crafts renaissance, which was as popular in the suburbs as it was in the art schools. 'The dream of the preponderance of students in the 70s was to set up a craft workshop,' wrote historian Fiona MacCarthy, noting a shift away from 'the design-orientated ideals of the 50s, when students' main aim was to…work in industry'.

And, since they were made by hand using natural materials, crafts also appeased growing concerns about pollution and the depletion of the Earth's resources due to an over-reliance on technology and mass-production. In America, a grass-roots environmental movement had been bubbling up since 1962, when Rachel Carson's bestseller *Silent Spring* blew the whistle on the threat of pesticides. Student activists were doing their bit, too. The anti-war 'teach-ins' of the late 1960s provided US senator Gaylord Nelson with the idea for Earth Day, the first

TECHNICAL ECSTASY With its magazine-lined walls and trolley stacked with audio-visual essentials, Archigram exponent Peter Cook's house, circa 1970, hints at the radical architecture collective's passion for media and technology *(opposite)*. In true pop spirit, the London-based group questioned the limitations of Modernism in a fast-moving, mass-produced world. In artist Linder's untitled photomontage from 1977 *(below)*, depicting a mod-con-obsessed couple with nothing to say to each other, technological imagery conveys alienation; there are televisions where their emotions should be housed, and even the most intimate contact is administered via the remote control. Linder's collages (including a famous example that appeared on the sleeve of the Buzzcocks' single, 'Orgasm Addict') also delighted in subverting the sexual stereotypes depicted in the media. 'I wanted to look in the mirror of my times and find myself reflected there,' she says. 'I never did, but I found photographs of women in magazines that seemed like strange mutant sisters.'

INTRODUCTION
9

FASHION INSURRECTION Brazilian model Rio sports a pair of must-have Emmanuelle Khanh shades *(above)*. Young French prêt-à-porter stars, including Khanh, Popy Moreni, Elisabeth de Senneville and Agnès B, gleefully colluded in the assault on Paris's stuffy haute-couture tradition that exploded in the 1970s. Brits were first introduced to funky French labels in the early 1970s by London boutiques Joseph, Escalade and Browns and, from mid-decade, by Bombacha, Elle and Les Deux Zèbres. A new generation of Japanese designers, notably Issey Miyake, who created this tattoo-print dress in 1970 *(opposite)*, were part of this revolution. Their avant-garde reworking of classic oriental clothing was at the sharp end of a huge Chinoiserie/Japonaiserie craze, which also included a mania for martial arts and cooking with woks.

of which, in 1970, flagged up the consequences of consumer wastefulness, along with oil spills, the dangers of nuclear power and the population explosion. Shortly afterwards the Environmental Protection Agency was established. In 1972, the UN held a major conference on the environment in Stockholm and the Massachusetts Institute of Technology produced *The Limits to Growth*, a report warning that an infinite increase of material consumption in a finite world was an impossibility. The sentiment was echoed in 'Blueprint for Survival', a special issue of Britain's *Ecologist* magazine, also in 1972, which inspired the formation of the Ecology (now Green) Party.

It was the 1973 oil embargo, however, imposed by the OPEC countries in the wake of the Arab-Israeli War that provided the real wake-up call to the profligate West. The ensuing fuel shortages and price hikes led to a global recession, but the upside, from an ecological perspective, was that for the first time since the Second World War the West had to admit that it could no longer rely on an unlimited supply of low-cost energy to feed its rampant consumerism. And although technology continued to fascinate – the decade witnessed the world's first test-tube baby and the rise and rise of the microchip, while the exploration of space continued in earnest – alternative technologies and energy sources were investigated as governments were forced to take action. By 1977, the blue jeans-wearing, environmentally responsible US president Jimmy Carter had taken measures to help Americans with the cost of installing solar hardware in their homes, and in 1979 he practised what he preached by equipping the White House with a solar water-heating system.

WASTE NOT, WANT NOT
The crisis also inspired a wave of experimentation with eco-friendly architecture. 'Because people were frightened that oil prices would continue to rise, they were looking for other ways in which to do just about everything,' says American designer Michael Jantzen, who designed and built a number of passive-solar houses during the decade. Jantzen's projects also challenged conventional ideas about how buildings should look, an inclination shared by everyone from hippie self-builders to radical designers and Postmodernist architects. Jantzen, who trained as an artist rather than an architect, attributes this approach to the 'free-thinking' movement of the 1960s and 70s and its do-it-yourself, anything-goes philosophy, which gave many the 'fuel to experiment without the constraints of conventional thought'.

But Jantzen's work was functional, too, and the aesthetic of his designs evolved from the ways in which they had to work. His innovative reutilization of industrial materials for domestic purposes (like prefabricated silo domes as roofs) was an early example of what would later become known as High-Tech. Fittingly, the movement, which saluted the integrity, economy and style of what architect Emilio Ambasz called 'noble pieces of anonymous design', gained ground after 1973, when people had to learn to live with less and the environmental crisis could no longer be ignored. This new climate also gave greater credence to thinkers like Victor Papanek, whose *Design for the Real World* (1971) blamed the crisis on designers who wasted resources and fed materialism by making unnecessary items, such as a computer for practising golf swings in the bathroom.

The decade has become synonymous with technology-crazy gimmicks like these, but it was also the period when design was called upon to do more than just look good and work well. Design, according to Papanek, had to be 'ecologically responsible and socially responsive', a credo that more and more designers were adhering to by the mid-1970s. Aesthetics had been 'deposed by social responsibility', noted Misha Black, professor of industrial design at London's Royal College of Art from 1959 to 1975, who also observed that his students tended to choose projects that would 'serve world needs…rather than encourage the proliferation of consumer products'. In 1976, the RCA held a Design for Need symposium to raise greater awareness of how design could be more socially beneficial.

PLUNDERING THE PAST

The new austerity that hit the West mid-decade also impacted on fashion. The thrifty High-Tech look in interiors was complemented by the craze for inexpensive utility clothing, and 1975 – the 'year of inflation' in the UK, with prices rising at an annual rate of more than 26 per cent – was distinctly khaki-coloured; ironic considering that this was also the year that the Vietnam War ended. According to Lloyd Johnson, owner of neo-Mod mecca Johnson's Modern Outfitters, in the King's Road, the recession also 'inspired people to buy old stock from warehouses, which encouraged the trends for retro looks'.

Undoubtedly, the pillaging and pastiching of past styles was a key 70s trend. Many observe this as a nostalgic, perhaps escapist hankering for better, less economically and environmentally troubled times (like Laura Ashley's modern-day milkmaids, following the hippies back to nature). Others might argue that this revivalism – which had kicked off much earlier in the decade, most notably with Barbara Hulanicki's Biba, and which continued with the collaging of almost every youth subculture since the war (a trend epitomized by punk) – was just another strand of Postmodernism's playful pick 'n' mixing from the past.

Perhaps more than anything, however, the increasingly broad assortment of looks that coexisted in the 1970s can be linked with the growing autonomy of the individual and the move away from mere fashion to a preoccupation with personal style. 'It was an age, sartorially speaking, to do with pure style, with doing yourself up to your own…satisfaction,' observed Angela Carter, writing in the *Sunday Times* in 1978. 'This could only have happened…when certain rules and conventions of appearance…are relaxed.' The influence of feminism, she noted, was partly responsible for this sea change: 'The trousered female office worker is the single most significant sign of visible change in the status of women. More women are wearing the trousers now and nobody is noticing any more.'

THE NEW NARCISSISM

Times got even harder by the second half of the 1970s. In addition to continuing industrial unrest, the UK suffered soaring unemployment levels and, as the value of sterling plummeted, was granted the largest loan ever issued by the International Monetary Fund, offset against huge public spending cuts. The world at large braced itself for another recession following a second oil shortage, this time sparked by the Iranian revolution in 1979. All the same, many were reluctant to relinquish the luxury of self-contemplation.

As Tom Wolfe observed in 1979, it was in this decade that people 'moved from the plateau of the merely materialistic to a truly aristocratic luxury: the habit of putting oneself on stage, analyzing one's conduct, one's relationships, one's hang-ups... the way noblemen did it during the age of chivalry'.

When it came to putting oneself on stage, nobody did it better than David Bowie and his numerous ultra-theatrical personae. 'What he did to teenage style in the 70s was introduce the idea of conscious stylization – Oneself as a Work of Art... to a wider audience than ever before,' wrote cultural commentator Peter York, identifying the decade's image-fixated youth, who drew from a far bigger repertoire of looks than their predecessors. Whereas old-school dandies – like the Teddy Boys and Mods – had been equally obsessed with appearance, their 70s counterparts had more eclectic dress codes, due to an increasingly nuanced knowledge of style, which led to expressions of individuality in ever more sophisticated and self-conscious ways. Fanning the trend was a fascination with artifice and reinvention exemplified by Bowie, his hero Andy Warhol, and art rockers Roxy Music.

Britain's art schools played their part, too, and the roots of this more conceptual, individualistic approach owed much to the introduction in 1961 of the Diploma in Art and Design. Its liberal entrance criteria, which valued talent as much as formal qualifications, led to a far higher intake of students in the 1960s and 70s. It was equally open-minded in its attitude to art and design education, promoting an experimental approach by introducing a fine-art element to vocational courses such as fashion and graphics, all of which fostered creativity and self-expression. Its other legacy was a more multidisciplinary outlook, enjoyed, for example, by postgraduates at the RCA, who moved freely between previously segregated departments. One former student, interior designer Ben Kelly, recalls 'taking advantage of the fantastic blend of fashion, painting, sculpture, all under one roof'.

STYLE OVER SUBSTANCE
The self-conscious stylization that York observed became ever-more democratized thanks to the do-it-yourself approach of punk and its more accessible successor New Wave, which spawned a plethora of subcultures, from neo-Mods to New Romantics. The growing interest in outward appearances contrasted with the hippie preoccupation with inner space, although it was no less self-indulgent. 'We were interested in how things looked, much more so than the 60s generation,' says designer Peter Saville. 'We can even call the 70s an era of exceedingly superficial values and very proto-80s. In the 1960s, people looked for like minds and issues were on the agenda, but in the 70s there was a desire to distinguish oneself.'

Others, like sociologist and media theorist Dick Hebdige, noted that the lure of style and glamour set in train by David Bowie and Roxy Music had signalled a growing depoliticization. 'Not only was Bowie...uninterested in contemporary political and social issues,' he wrote, 'his entire aesthetic was predicated upon a deliberate avoidance of the "real" world.'

Some believed that this complacency sprang from disillusionment with – or simply fatigue caused by – the lost political battles of the 1960s. 'People realized that pop culture's potential to change things – Woodstock, Bob Dylan – hadn't brought Vietnam to an end,' says Saville. 'This bred an intellectual, aesthetic, detached sensibility in pop.' But despite this detachment, Hebdige pointed out that Bowie also opened up 'questions of sexual identity, which had previously been repressed'. In this respect, his influence was progressive.

HAVEN'T GOT IT? DON'T FLAUNT IT

Indeed, compared with the right-wing elitism of the 1980s, what Saville describes was arguably harmless – simply a case of wanting to stand out sartorially from the crowd, as the preening New Romantics did. And politics weren't cast aside entirely among the young and hip. In 1976, when the Commission for Racial Equality was established in the UK, the National Front was gaining ground. Bowie's comment that he believed 'strongly in fascism' partly inspired the formation of Rock Against Racism. By raising anti-racist awareness through music, the movement helped to discredit the National Front and to politicize a generation.

According to members of the decade's arty circles, the 70s were markedly less materialistic, careerist or acquisitive than the overtly aspirational 1980s. Times may have been hard, but rents in London, Paris and New York were relatively low, allowing creative types to flourish and live for the moment. The presence of so many artists and designers created a hotbed of 'originality', remembers fashion designer Antony Price: 'People won't take risks now.'

'Business wasn't a priority,' adds designer Mattia Bonetti, who hung out with Paris's cutting-edge creatives. 'Rents were cheap, there was more access to social security. Time was more elastic, nights were longer. There was less shopping, no designer labels, at least not like now. Our only goal was to be subversive, to behave provocatively.' Today's celebrity culture didn't exist and would have been disdained at a time when, as hairdresser Ricci Burns observes, 'talent was what counted'. Photographer Dennis Morris notes that this also applied in the music world: 'Anger is what fired bands in the 70s; playing in a band wasn't a career move. People had to demonstrate passion and talent.'

CREATIVITY CO-OPTED

But it would be simplistic to suggest that the 70s were immune to the cynical machinations of the marketing men, who were quick to co-opt countercultural trends. 'Hedonism wasn't

STYLE ODDITIES David Bowie as Ziggy Stardust in 1973 *(opposite)*, in an outfit by cutting-edge Japanese designer Kansai Yamamoto. Bowie's nonchalant adoption of androgynous looks challenged gender-stereotyping on a mass scale, however subliminally. An equally influential icon was Jordan, who worked at Sex *(above, right)*, the London boutique which, with its confrontational façade and geographical remoteness at the extremity of the King's Road, filtered out all but the most hardcore punks.

vigorously opposed by the Establishment, they helped to engineer it,' remembers Peter York. 'They could see it was the key to greater consumption.' In 1979, he commented on the 'drive to sell to minorities', noting that 'blacks get…discofunk, Blaxploitation movies; women get Virginia Slims, the female-orientated cigarettes, the Women's Bank of New York [and] gays get amyl nitrate and the Village People.'

The hippie/human potential movements likewise inspired such New Age faddery as pyramid power and biorhythms. Even the inward-looking 'cult of me' shifted towards superficiality in the late 1970s, giving rise to the narcissistic cult of the body with its attendant jogging and health-food crazes, as magnificently satirized by Cyra McFadden in her 1977 novel, *The Serial: A Year in the Life of Marin County*.

THE 70S REAPPRAISED

Despite the striking variety of the decade, four overarching themes stand out, and form the four chapters of this book: the pop movement, the retro revivals epitomized by Biba, the back-to-nature phenomenon, and its polar opposite, the artifice-adoring avant-garde scene. Rather than treading the well-worn path of platforms and polyester flares, we were instead drawn to the rise of Postmodernism, the eco and High-Tech tends in architecture, minimalism and the New Romantics, as well as to such perennially fascinating episodes in 70s history as Biba and punk. The more we delved, the more we discovered the enormous creativity and diversity of this previously poorly documented era.

FROM POP TO POSTMODERNISM

In 1970, London's *Evening Standard* reported the opening of a new shop in Kensington Church Street, the like of which had never been seen before, even amid the city's trendy boutique scene. Once inside this rainbow-hued pleasure-dome, decked out in Tom Wesselmann shades in a hybrid of 'pop, Art Deco and Italianate', customers were greeted by a giant Statue of Liberty sculpture on their way to the clothes, which hung from a wire coathanger of Claes Oldenburg proportions. Here, to a roaring rock 'n' roll soundtrack provided by several vintage jukeboxes, hip young things could pore over a kitsch pick 'n' mix of British pop culture, 1950s Americana and 30s Deco: Minnie the Minx T-shirts, bomber jackets emblazoned with rockets, blue suede 'brothel creepers' and billowing Oxford bags.

This was the wonderful, anything-goes world of Mr Freedom, the embodiment of pop style in the early 1970s. After the shop closed in 1972, its satin and flash, pop motifs and platform shoes would continue to influence glam rock and high-street fashion. Crucially, Mr Freedom's taste-challenging pluralism also represented a new spirit that would define fashion and design throughout the decade.

Of course, an iconic pop style had emerged during the 1960s, when designers such as Mary Quant and the youthquakers put Swinging London on the map. But while Quant's thoroughly modern mini-dresses looked forward to a brave new Britain, Mr Freedom harked back to the pop movement's roots in post-war America.

THE AMERICAN DREAM MACHINE
Pivotal to the evolution of pop as a style and an attitude was the post-war boom in the West, which kicked off in the US. By the 1950s, the convergence of technological progress, increased production and greater affluence had created a consumerist society that opened up a debate about the language of art and design. Modernism, the functional machine aesthetic of the pre-war era, had gained a lot of ground, but to some its tenets of purism, permanence and universality – summed up by the term 'International Style' – seemed out of touch in a fast-moving world that offered an increasing variety of choices. More appropriate to the minds of artists and thinkers such as London's Independent Group was the rich iconography of 1950s American popular culture. And whereas Modernism sought to impose standardized design on the masses, making no allowance for the individual's needs or aspirations, popular design embodied the consumer-boomers' personal enthusiasms: diversity, decoration, expendability and technological glitz, as exemplified by the colour-saturated imagery of the supermarket, billboard advertising, comic strips and the chrome-and-fins Cadillac. This vernacular was famously celebrated in Richard Hamilton's *Just What Is It That Makes Today's Homes So Different, So Appealing?* of 1956, which presented the obsessions and must-haves of the day as a collage of magazine cuttings. 'We assumed an anthropological definition of culture,' observed art critic and fellow IG member Lawrence Alloway, 'in which all types of human activity were the object of aesthetic judgement and attention.'

FREEDOM OF EXPRESSION Pierre Paulin's Tongue chair *(right)*, designed in 1967, echoed the trippy colours and amorphous shapes synonymous with light shows, while its floor-level, body-contouring curves pointed to pop furniture's move away from uptight Modernism towards designs that were marked by informality and sensory appeal. Paulin believed that furniture should be friendly, fun and colourful, as well as functional. The same could be said for the ultra-pop designs of London boutique Mr Freedom, whose good taste-challenging ensembles embodied the expressive mix-and-mismatch approach to fashion that was emerging in the early 1970s *(opposite)*. Mr Freedom also produced Claes Oldenburg-inspired pop furniture in the shape of liquorice allsorts, giant false teeth and jigsaw shapes, designed by Jon Wealleans – shown here at home in London, circa 1970 *(below)*.

LESS IS A BORE

By the 1960s, as the boom hit the rest of the West, the lexicon of the consumerist society was fuelling the imagination of pop artists on both sides of the Atlantic, and the boundaries between high and low culture became blurred. Just as Pop Art looked to mass production for inspiration, design began to follow its inclusive, playful example, with fun furniture in the shape of teddy bears and baseball gloves that were a nod to Claes Oldenburg's soft sculptures of hamburgers and popsicles.

At the same time, new, expressive forms began to emerge that challenged Modernism's rationalist ideas about shapes, colours and materials. Function was no longer the only aim, as sensory appeal also became a consideration. Along with Pop Art, the psychedelic experience of the 1960s must have had a hand in the soft-edged, colour-drenched furniture of designers like Pierre Paulin, Verner Panton and Gaetano Pesce, and developments such as injection-moulding of plastics and the advent of polyurethane foam made for greater experimentation.

This elaborate new language also defied Modernism's abstract aesthetic with forms that were loaded with symbolic meaning. Italian architect and designer Ettore Sottsass fused pop accents with inspirations from such sensorially and spiritually led cultures as India, recognizing early on that it was 'important to realize that whatever we do or design has iconographic references, it comes from somewhere; any form is always metaphorical, never totally metaphysical.'

In addition, International Style rationalism was attacked for being too simplistic a response to the demands of the turbulent

FLASH STANCE *Nova* showcases the Mr Freedom look in 1970 *(left and below)*; unsurprisingly, the shop was a favourite with glam rock stars from Roxy Music to Marc Bolan. A more tasteful take on pop style was promoted by Habitat, but Terence Conran's empire was no less eclectic and inclusive, as its catalogue so perfectly conveyed *(opposite, top right)*. Habitat was the first retailer to showcase its wares within inspirational room sets. In a catalogue from 1972, the modern, must-have Campus range rubbed shoulders with an antique grandfather clock, an oil painting and Provençal-style dried flowers *(opposite, top left)*. The controversial picture of the couple in bed from the 1973 catalogue *(opposite, bottom)* was part of what former Habitat manager Geoff Marshall describes as 'an evangelical crusade to convert people to the design philosophy that things should look good and work well, and be anti-discriminatory in a social sense'.

late 20th century. 'Less is a bore' was American architect Robert Venturi's riposte to Mies van der Rohe's dictum 'less is more' in his 1966 book *Complexity and Contradiction in Architecture*, which called for an 'architecture based on the richness and ambiguity of modern experience'. Modernism's detachment from the latter was increasingly blamed for the ills of contemporary urban renewal; the soulless, socially disastrous concrete blocks 'in which Le Corbusier's ideas… found terrifying vulgarization'.

MULTICOLOURED POP SHOP

As the 1970s dawned, pop had done much to damage Modernism's one-style-suits-all credo, as evidenced by the emergence of shops like Mr Freedom, which also represented pop's shift away from the Mary Quant look of the 1960s. 'Prior to Mr Freedom, I'd done Union Jack T-shirts, Perspex visors, that mod/space-agey look,' remembers the shop's designer, Pamla Motown. 'Mr Freedom wasn't like Carnaby Street, our fantasy was of 50s America, which the hippies hated.'

Indeed, while disillusioned young people stateside were dropping out of the American dream in the wake of the Vietnam War, trendy Londoners couldn't get enough of it, or at least its imagery. The entire Mr Freedom team – from proprietor Tommy Roberts to furniture designer Jon Wealleans – cited influences from Pop Art to Disneyland to Captain Marvel. Ironically, the shop's name and aesthetic were partly inspired by William Klein's anti-American film *Mr Freedom* of 1969, but the word 'freedom' also perfectly defined the loosened-up new spirit of fashion and design.

Pop's promotion of individual expression, experimentation and taste-challenging was quickly assimilated into mainstream fashion. In 1971, as a Mr Freedom-inspired uniform appeared on the high street, even *Vogue* asked if bad taste was a bad thing. The following year, magazine-of-the-moment *Nova* likewise coaxed readers to 'let your bad taste out for an airing'. Mary Quant had pioneered the concept of mix-and-match separates back in the 1960s, but now it was all about clashing colours, textures and cultures.

The fashion world was wise to move with the times, as people were becoming more resistant to hard-and-fast dictates about what to wear, dressing instead to please themselves. *Vogue* stepped into the fray and claimed 'there are no rules in the fashion game now. You're playing it and you make up the game as you go.'

GETTING THE HABITAT HABIT

This relaxed mood influenced interiors, too, which generally became less formal and more individual. In the UK this was epitomized by Terence Conran's Habitat chain, which had been on a crusade since the mid-1960s to banish stuffy three-piece suites and fussy fixtures from British homes, wooing pop's first wave of forward-looking baby boomers with the more laid-back look of open-plan rooms, stripped floors, whitewashed walls and flashes of vibrant colour. This pared-down brand of pop certainly nodded to Modernism, and, like the Bauhaus, Conran wanted to democratize good design, which led to accusations that he was similarly prescribing good taste to the masses. He was indeed selling a lifestyle, but what made Habitat so relevant in the 1970s, when the brand boomed and transformed mainstream interiors, was its pluralism and inclusivity.

'The eclectic style was very much what I wanted,' says Conran, and crucial to promoting such eclecticism was the Habitat catalogue, which spread the gospel nationwide and became a home-decorating bible. Whereas Habitat's revolutionary shopping experience offered everything from rainbow-hued plastic furniture to rustic kitchenalia, the catalogue added to the diversity, throwing in non-Habitat vintage pieces and flea-market finds. 'We were trying to say, if you've inherited stuff, don't throw it away,' notes the catalogue's creative director and stylist Stafford Cliff, 'but keep it and mix it with modern things. Terence wanted people to mix things at home and not have a total Habitat look. It was a more individualistic age and people were thinking for themselves. We encouraged them to do their own thing. There were Michael English posters on the walls.

'I was mixing Persian carpets with OMK Design high-tech style. I'd put in a dartboard – I was trying to give the catalogue life. A dartboard takes you to a place that has nothing to do with orange furniture.'

And it wasn't just Habitat's aesthetic that was inclusive. 'We wanted the people shopping at Habitat to be a real cross-section,' says Conran, and appropriately the catalogues featured people of all ages and races. In the early 1970s attitudes were changing, thanks to the socioeconomic shake-up of the 1960s, but by mainstream standards Habitat were sticking their necks out. A photo of a mixed-race couple in bed in the 1973 catalogue provoked letters of complaint, but Habitat were unrepentant, and from 1976 complaints were forwarded to the Commission for Racial Equality. 'We were on a mission against conservatism,' explains former manager Geoff Marshall.

LEARNING FROM LAS VEGAS

By the mid-1970s, the peppy pop style that had ruled mainstream interiors was on its way out. The fuel shortages resulting from the 1973 oil embargo had hammered home what the ecology lobby had been saying for years about the world's finite resources. This heightened environmental awareness, together with the deepening global recession, triggered a trend for all things rustic and retrospective, typified by the Victoriana craze. As the recession began to bite, consumers sought refuge in a rose-tinted past.

But pop's anti-rationalist sensibility continued to influence architecture and design, and the Modernist backlash gained ground. Architectural theorist Charles Jencks declared that modern architecture had died in 1972, with the demolition of the Pruitt-Igoe housing scheme in St Louis, Missouri, an iconic example of Modernism's utopian vision gone bad. 'The remains should have a preservation order slapped on them,' Jencks later wrote, 'so that we keep a live memory of this failure in planning and architecture.'

Architect Robert Venturi had already warned against 'separating architecture from the experience of life and the needs of society', suggesting that it is 'from the everyday landscape, vulgar and disdained, that we can draw the complex and contradictory order that is valid and vital for our architecture as an urbanistic whole'. In his 1972 book *Learning From Las Vegas*, co-written with Denise Scott Brown and Steven Izenour, Venturi further explored this theme, finding inspiration in the 'forgotten symbolism of architectural form', of which Las Vegas offered abundant examples.

Style as a symbolic language came into its own in the 1970s. In 1977, Jencks codified the rise of the narrative building in *The Language of Post-Modern Architecture*, defining what he dubbed the 'Post-Modern building' as 'one which speaks

Modernism's flat-topped boxes, architect Philip Johnson crowned the AT&T building in New York with a classical pediment *(opposite, right)*. 'Form was very important to Johnson,' says Alan Ritchie. 'For him, function never took precedence over form.' Italian architect and designer Ettore Sottsass pushed ideas about form even further, as demonstrated in this 1977 painting entitled *If I Were Very, Very Rich I Would Confront Myself With My Complexes (opposite, left)*. Meanwhile, Sottsass's Studio Alchimia cohort Alessandro Mendini embraced decoration, a visual language long suppressed by Modernism's lean, clean aesthetic, with his Proust armchair of 1979 *(right)*.

on at least two levels at once: to other architects…and to the public at large, or the local inhabitants, who care about other issues concerned with comfort, traditional building and a way of life. Thus Post-Modern architecture looks hybrid.' Unlike Modernism, which stripped away everything that had gone before it, Postmodernism was refreshingly inclusive, marrying the old and the new, the highbrow and the lowbrow. It welcomed ornamentation, acknowledged context, and cracked visual jokes.

It was clear that Postmodernism had arrived when, in 1978, exalted American architect Philip Johnson – the man who had introduced the International Style to the US back in 1932 with an exhibition at the Museum of Modern Art – proposed crowning the New York headquarters of American Telephone & Telegraph with a Chippendale top. Not that Johnson affiliated himself with the new movement: despite his love of Mies van der Rohe, he had been dabbling with historicist elements (a cornerstone of Postmodernism) since the 1950s. By the mid-1970s, like many, Johnson had grown bored with how formulaic Modernism had become. 'He asked how many more flat-topped boxes can we keep creating?' recalls Alan Ritchie, principal at Philip Johnson/Alan Ritchie Architects, who oversaw the AT&T project. The sentiment was shared by the company's chairman. 'People were looking for something fresh at the time,' adds Ritchie. 'When we interviewed the chairman, he said he was tired of seeing flat-topped buildings from the plane as he came in to land in New York.' So taking his cue from the impact of such landmarks as the Chrysler building, Johnson proposed the striking broken pediment that put Postmodernism on the map.

CLASHING SYMBOLS

The Modernist backlash also inspired the Italian design collective Studio Alchimia, which was founded by Alessandro and Adriana Guerriero in 1976 and rounded up radical design luminaries including Ettore Sottsass, Alessandro Mendini, Andrea Branzi and Michele De Lucchi. Like Venturi, Studio Alchimia's proponents rejected rationalism in favour of alternative design languages, which in their case ranged from redesigning existing pieces using decoration to radical rethinks about form, all served up in exhilarating candy colours.

'The Bauhaus was rational, Alchimia was very romantic,' says Mendini, who also edited the influential magazines *Modo* and *Casabella*, and was a spokesperson for the group. 'We were against the Bauhaus.' To prove the point, Studio Alchimia issued a couple of collections ironically entitled Bau.Haus,

blondie

denis
contact in red square
kung fu girls

ARTY TARTY Fiorucci's brazen brand of pop was mirrored in New Wave, punk's more accessible successor, and the look was no better flaunted than by the sassy chanteuses of the day, including Blondie's Debbie Harry, a mussed-up Marilyn who in 1978 poured herself into a leopard-print dress for the cover of the band's first UK hit, 'Denis'.

the first of which, in 1979, included Mendini's Proust armchair, a baroque affair rendered all the more decorative via the pointillist brushstrokes stippling its surface, a playful allusion to Marcel Proust's ties with Impressionism. Believing that it was no longer possible to come up with anything new form-wise ('design is redesign'), Mendini subverted a series of classic chairs and generic pieces of furniture, drawing on sources from Kandinsky to kitsch. As well as giving old styles new meanings, this visual narrative imbued functional forms with 'soul', allowing Mendini to make a connection with 'the lives of the people' who bought his designs.

Like Mendini, Sottsass was led by sensory perceptions, but unlike his colleague he wanted to push the possibilities of form as far as he could. His furniture designs for Alchimia were as unprecedented as the giant laminated 'superboxes' he designed in the mid-1960s, his need 'to refound and discuss the issues of current taste' blasting away prevailing ideas about shape, size, volume, proportion, materials, context and colour. More ambitious still, Sottsass wanted to release this exuberant visual idiom into the mainstream design arena, which meant parting from the small-scale, atelier-based Studio Alchimia to form the Memphis Group in 1980. The latter prompted a media storm and its output, although controversial at first, infected all areas of design throughout the 1980s, proving, as the group's spokesperson Barbara Radice observed, that 'the radical years... had affected public taste more deeply than it seemed'.

FIORUCCI: THE 20TH CENTURY IN ONE PLACE

Indeed, times and tastes were changing, a fact illustrated by the international influence of Italian fashion label Fiorucci, whose more-is-more collaging of cultural references led its biographer Eve Babitz to describe it as 'the whole 20th century in one place'. The brainchild of pop pioneer Elio Fiorucci, who imported 'the spirit of Carnaby Street' to Milan for his first store in 1967, Fiorucci took Mr Freedom's pop-culture pastiche to dizzying new heights, combining 40s glamour, 50s kitsch and 60s youthquake with keenly sourced inspirations from around the ever-shrinking globe. 'We visited the whole world, choosing antique, modern, ethnic,' says Elio Fiorucci. 'There were no limits. Maybe this was the secret of Fiorucci's success.'

Like their sometime collaborators Studio Alchimia, Fiorucci also had fun playing with form and reinventing existing designs,

PLANET FIORUCCI Inspired by Mr Freedom, Fiorucci's look cribbed from the same lexicon – the 1950s American dream, sci-fi, comic books, kitsch – and similarly celebrated the young and the fun. But what distinguished the Italian label from its predecessor was its sexiness *(right)*. Fiorucci's fascination with retro Americana has long been shared by Japanese youth cults, so it is fitting that the label is now owned by Japanese clothing company Edwin International, who started out by importing second-hand blue jeans from the US in the late 1940s. The 50s sci-fi element tapped into a particular zeitgeist that peaked in the late 1970s and is perfectly evoked by Kenny Scharf's *Self-Portrait with Cadillac* of 1979 *(below, right)*. The artist's first solo exhibition was held at Fiorucci's New York store that same year.

making, as Babitz wrote, 'ballet-dancer tutus out of stiff plastic [and] briefcases out of aluminium toolboxes', and all manner of items in unexpected materials and contexts. 'I came from a revolutionary culture, in which everything was called into question,' Fiorucci explains. 'Why couldn't a jute sack used for onions also be a bag? Why couldn't polythene be used for sandals? Why couldn't the American hydraulics bag, carpenter's belt and work shoes be appropriated as fashion objects, just like jeans had been?'

Fiorucci's knowingly flashy, trashy aesthetic was in synch with the same late-70s swerve in taste that spawned the arty, ironic New Wave style, which filtered down from music into fashion and design. As well as sharing a penchant for man-made materials in shrill fluoros and animal prints, Fiorucci and New Wave both helped popularize a sexier, more body-conscious silhouette, which dovetailed nicely with the end-of-decade disco craze. Fiorucci's New York store became a home from home for the Studio 54 crowd, which no doubt prompted Sister Sledge to namecheck the brand, along with Halston and Gucci, in their 1979 hit, 'He's the Greatest Dancer'. The two Italian labels had little else in common, however. 'Gucci is a no-freedom concept,' Elio Fiorucci pointed out in 1980, making the distinction between Fiorucci and high fashion. 'By 1990 there will be no class distinctions in terms of dress or fashion. People will just wear what they want.' And, thanks largely to the inspiration of people like him, he was right.

POP-A-PORTER

Mr Freedom was pivotal in putting pop on the style map in the early 1970s, and its playful grab bag of Pop Art, 1950s Americana, Art Deco and comic strips whet fashion's new appetite for fun. The boutique's novelty factor, combined with a celebrity following – from Mick Jagger to Paloma Picasso, who bought a T-shirt for her father there – prompted plenty of press, and its influence was wide-ranging. As well as inspiring designers from Yves Saint Laurent to Elio Fiorucci, Mr Freedom even managed to sell pop Americana back to the Americans.

CARTOON CAPERS In 1972, designers Pamla Motown and Jim O'Connor *(above)* left Mr Freedom to set up on their own, working for such labels as Marshall Lester's Scott Lester line, for which they created these rock 'n' roll sweaters (available at the Peter Robinson department store in Oxford Circus from £3 a pop). As early as 1970, Mr Freedom was wowing the US fashion scene, as evidenced in this illustration by Albert Elia for San Francisco's street style magazine, *Rags (opposite)*. American pop artist Tom Wesselmann, and in particular his *Great American Nude* series, was a big influence on the Mr Freedom team, from the flesh pinks favoured by the shop's interior designer and furniture maker Jon Wealleans, to this letterhead by graphic designer du jour George Hardie *(left)*. 'The 70s were all about pastiche,' says Hardie.

FROM POP TO POSTMODERNISM

ABRACADABRA This exuberant fantasy footwear was conjured up by shoemaker Thea Cadabra, who spent the late 1970s subconsciously imbibing the 'eclectic cultural soup' of the decade. 'Self-expression and creating one's own style became an all-consuming passion,' she says. 'People were seriously busy having fun. There were no rules, just tremendous creative freedom.'

POP-A-PORTER

NOVA
3/6

MAY 1970

THE DARING DUDS OF MAY

Are middle-class women mean?

Farewell (and good riddance) to the big-time surgeon

FROM POP TO POSTMODERNISM

POP-A-PORTER

DARING DUDS *Nova* flags up the Mr Freedom phenomenon in May 1970 *(opposite)*, while Keith Wainwright, of trendy hairdressers Smile, sports a baseball-inspired jumper by the label's designer, Jim O'Connor *(bottom, right)*. As the decade progressed, pluralism and playfulness became more widespread in fashion, in keeping with the anti-Modernist sentiments that were creeping into architecture and design. In this 1971 *Nova* story *(right)*, fashion editor Caroline Baker sends a model through the air in satin hotpants, fake-fur bolero and rainbow socks. Unlikely pairings also inform this 1973 photograph from *19 (below)*, shot in London's Brixton market, a place that offered kitsch pickings for the magazine's fashion editors Norma Moriceau and Jo Dingemans. The leopard-print jacket, Wild Thing T-shirt and satin pedal pushers are all by Wonder Workshop, the label of 50s enthusiasts John Dove and Molly White, who designed for everyone from Mr Freedom to hip King's Road shop Paradise Garage during the early 1970s.

FROM POP TO POSTMODERNISM

FROM POP TO POSTMODERNISM

POW! POP ART AND PLASTICS

Pop Art was also big in interiors by the early 1970s, although it tended to be enjoyed by those who could afford real Roy Lichtensteins (like the clients of leading interior designers David Hicks and John Stefanidis). The pop spirit, however, entered many a home thanks to Terence Conran's influential Habitat chain, which popularized informal, modular furniture and sassy plastics in vibrant colours, the latter thriving before the 1973 oil crisis.

ANYONE FOR SAUCE? At home with pop artist Allen Jones in the early 1970s, featuring his Table, Chair and Hat Stand sculptures of 1969 *(opposite)*. Their reclining female forms went on to inspire the furniture in the Korova Milk Bar scene of the 1971 film, *A Clockwork Orange*. A waitress at Mr Freedom's basement eatery, Mr Feed'em *(left)*; the interior was designed by Jon Wealleans, who started working for the shop in 1969 after a stint in the US, where he became fascinated with American diners and Disneyland. As well as a curvy, chrome-covered bar and reliefs of giant hamburgers oozing ketchup on the walls, the restaurant featured napkins adorned with Mae West as the Statue of Liberty and cakes in the shape of blue jeans. Wealleans was a big fan of Ettore Sottsass, who had become similarly enraptured by pop Americana when he worked in the US during the 1950s, the legacy of which is reflected in this neon Ultrafragola mirror of 1970 *(above)*.

FROM POP TO POSTMODERNISM

POW! POP ART AND PLASTICS

POP TILL YOU DROP Fittingly, this design for Biba's food hall by Steven Thomas (of Whitmore-Thomas, the team that transformed an old Art Deco department store into Big Biba) brings Pop Art to the supermarket, the original inspiration for artists such as Andy Warhol, who is namechecked in this fun reference to his *Campbell's Soup* series *(below)*. Other pop flourishes in Big Biba included the cartoon-like toadstool seating in the children's department *(opposite, top right)*. Comics (and the comic-strip style of Roy Lichtenstein) were a huge influence, according to George Hardie, who designed this menu card for Mr Feed'em *(left)*. From high-end interiors by John Stefanidis *(opposite, top left)* to more humble homes, plastic furniture and accessories conveyed the pop vibe. Kartell, who produced the Componibili cupboard by Anna Castelli Ferrieri *(opposite, bottom right)*, was one of the biggest manufacturers, selling the work of Italian designers like Castelli Ferrieri and Joe Colombo through shops such as Habitat.

POW! POP ART AND PLASTICS

POPADELICA

The psychedelic experience of the 1960s had a big influence on early pop style, from its rounded, expressive forms to its kaleidoscope of colours. By the 1970s the psychedelic movement had fizzled out, and many of the poster artists who were synonymous with it, including Michael English and Nigel Waymouth of Hapsash and the Coloured Coat, had moved on to other things. But its sinewy lines and trippy hues, informed by the pop-meets-psychedelic styles of Milton Glaser, Heinz Edelmann, Peter Max and Alan Aldridge, lingered on in everything from food packaging to children's television programmes. 'There was an explosion of this style after *Yellow Submarine*,' says Hilary Hayton, creator of the BBC cartoon *Crystal Tipps and Alistair*, 'which came into its own with the rise of colour TV.'

KALEIDOSCOPE HIGHS *Crystal Tipps and Alistair* take a trip in 1972 *(top)*; the programme's creator Hilary Hayton was a fan of Milton Glaser, whose 1967 portrait of Bob Dylan *(above)* provided popadelic inspiration to many. The psychedelic style of Alan Aldridge informs this 1973 advertisement for Winsor & Newton *(right)*, and Aldridge himself produced this 1971 poster for the hugely successful restaurant, The Great American Disaster, opened by Peter (Hard Rock Café) Morton in 1969 *(opposite)*. The poster's anti-American sentiment may have chimed with the times, but Britain still couldn't get enough of US-style hamburgers. Morton's idea inspired a host of imitators, and by 1976 McDonald's had launched its assault on the British palate.

FROM POP TO POSTMODERNISM

DO YOUR OWN THING

'The 1970s were the beginning of the DIY boom in the UK,' says Terence Conran, who made a significant contribution to the trend himself with the well-designed, affordable flat-pack furniture available at his Habitat stores. 'People liked flat-pack because as they assembled it they felt involved in making the furniture themselves.' Indeed, the desire to do it yourself was perfectly in synch with the pop movement's principles of self-expression and individuality, which also inspired the customizing craze that tore through homes during the 1970s. How better to convey one's creativity than by letting rip with a paintbrush and covering walls and furniture with murals, supergraphics and stencils in an explosion of colours?

FROM POP TO POSTMODERNISM

PAINT JUST TOOK A TRIP

COATS OF MANY COLOURS This 1972 advertisement for Bright and Bold paints *(above)* channels both psychedelia and the supergraphics inspired by artists like Frank Stella. The influence of Stella is also evident on the walls and ceiling of this dining room, decorated by New York artist Bill Topley in the early 1970s *(opposite, top)*. Rainbow stripes made a splash throughout the decade, and postcards of artist Patrick Hughes's 1979 screenprint *Rainbow's End* sold by the million *(opposite, left)*. Flat-pack furniture pioneer Habitat's Prima range came complete with paints and stencils to help customers get creative *(opposite, bottom right)*. The DIY bug also extended to Claes Oldenburg-inspired pop furniture. Designer Keith Gibbons created this pencil sofa in 1975 *(opposite, centre)*, but the following year anyone could have a go with the help of the 1976 book *Furniture in 24 Hours* by Spiros Zakas and his students at the Parsons School of Design in New York.

POP GOES SURREALISM

Surrealism was reappraised in the late 1960s, its rejection of rationalism, celebration of sex and flouting of good taste holding particular appeal for the psychedelic and pop movements. 'We believed and adopted anything that contradicted the rational world,' noted artist Michael English in his 1979 book, *3D Eye*. By the 1970s, a surreo-pop hybrid was informing everything from fashion to furniture, and myriad record covers referenced everyone from René Magritte to Max Ernst. Surrealism also fed the trompe-l'oeil trend that dovetailed with the mania for DIY, bringing us walls and windows transformed with trick-of-the-eye rustic scenes and Manhattan skylines, along with T-shirts that masqueraded as tuxes and aprons that aped women's torsos.

BELLE DE NUIT Thea Cadabra's Maid shoe *(opposite)* was created to complete a 1920s French maid's outfit that the designer – a big fan of *The Rocky Horror Picture Show* – wore to a themed party. The leg-shaped heels were made by jeweler James Rooke. Also taking inspiration from Surrealism, John Dove and Molly White's T-shirt *(below, left)* featured the torso of model Pat Booth, photographed by James Wedge, and was sold in Wedge and Booth's London boutique, Countdown. Designed back in 1969, it kicked off the trend for trompe-l'oeil T-shirts and was relaunched in 1977 when, fittingly, it collided with punk. Indeed, Dove and White were in the vanguard of the post-punk T-shirt graphics revolution, having created designs that fused elements of Pop Art, Dada, Surrealism and rock 'n' roll much earlier in the decade. The cover of Germaine Greer's feminist bestseller *The Female Eunuch*, published in 1970, featured a surreo-pop illustration by *Nova* magazine favourite, John Holmes *(below)*.

POP GOES SURREALISM

FROM POP TO POSTMODERNISM

42

POP GOES SURREALISM

REALM OF THE SENSES The twin muses of Pop Art and Surrealism, drawing from Tom Wesselmann to Man Ray, made lips a favourite motif in the 1970s. Here, designer Óscar Tusquets and Salvador Dalí, shown at the artist's home in Cadaques, Spain, stand behind Tusquets's Saliva sofa, designed for his company Bd Barcelona Design in 1972 and inspired by Dalí's 1936 painting of Mae West *(above)*. French sculptor Claude Lalanne was a fan of both artistic movements; her *Pomme-Bouche* of 1975 *(opposite, bottom)* alludes to a painting by Magritte and echoes her earlier choker designs for Yves Saint Laurent. Sex and Surrealism go hand in hand in James Rooke's Hammock necklace of 1979, made from gold, diamonds and ivory recycled from an old umbrella handle *(opposite, top)*. 'I wanted to achieve the sensual effect of the weight of the woman's body as held by the taut fabric of the hammock,' he says.

FROM POP TO POSTMODERNISM

POP GOES SURREALISM

the modern historical consciousness

the camera

the walter benjamin

the contradiction

MAGRITTE DREAMS Together with Dalí, René Magritte was a major muse in the 1970s, and his new currency was acknowledged with a retrospective at London's Marlborough Fine Arts Gallery in 1973. British conceptual artists Art & Language's *The Key of Dreams (above)*, from 1978, pastiches Magritte's paintings of the same name from the 1930s. Even the humble apron received the trompe-l'oeil treatment, as demonstrated by this saucy, super-pop design by Dodo Designs *(right)*.

POP GOES SURREALISM

SURREAL THINGS Magritte's smooth brushstrokes and unexpected juxtapositions are conjured up in this 1978 make-up campaign for Christian Dior by *visagiste* and photographer, Serge Lutens *(above)*. Leading graphic-design studio Hipgnosis were often associated with Magritte, and their artwork for Pink Floyd's 1975 album *Wish You Were Here* similarly fuses the ordinary with the extraordinary *(above, right)*. *Nova* magazine was a big promoter of pop Surrealism, commissioning such illustrators as Mike McInnerney and John Holmes, and referencing the cabbage-head sculptures of Claude Lalanne for this January 1975 cover *(right)*.

NOVA
JANUARY 1975 30p

'The time has come,' the housewives said,
'To talk of many things:
Of pay- and hours- and nursery schools-
Of cabbages- and
AND ABOUT TIME TOO!'

FROM POP TO POSTMODERNISM
45

GET YOUR KIT ON

Sportswear was synonymous with the pop style of the 1970s. Mr Freedom harnessed its potential early on, and this increasingly informal decade's adoption of utility wear as day wear assured the trend's popularity until the end of the 70s, when it collided with disco and the keep-fit fad. 'Sports clothes are built for speed, endurance, power and winning,' said Caterine Milinaire and Carol Troy, the duo behind alternative fashion bible *Cheap Chic*. 'And who can't use a little injection of that in everyday life?'

GO-FASTER STRIPES In keeping with the Olympics theme of 1972, *Nova* magazine's Caroline Baker puts a team of models through their paces in a mix of real sports kit (Umbro, Lonsdale) and designer takes on the trend (Biba, Mary Quant and Pamla Jim).

FROM POP TO POSTMODERNISM

PRET-A-SPORTY The free and easy spirit of sportswear was perfectly embodied in Oliviero Toscani's shoots for French *Elle*. Here, Chantal Thomass's rugby shirt-inspired dresses are captured with typical joie de vivre in 1976 *(right)*. A model at Kansai Yamamoto's 1979 show strikes an aerobics-meets-martial-arts pose *(below)*. This was also the year that the king of the laid-back unisex look, Daniel Hechter, sent strapping, suntanned boys and girls down the catwalk in his reworkings of functional classics *(below, right)*.

GET YOUR KIT ON

IN GEAR *Nova* magazine was promoting the sporty look as early as 1971 *(below)*, and it was still sought after by 1978, when it was adopted by such disco divas as France's Sheila and B. Devotion *(left)*. Meanwhile in 1976, *L'Uomo Vogue* declared the baseball shirt a winner *(opposite, top)*, and Italian *Vogue* showcased the pop-à-sporty designs of Jean-Charles de Castelbajac *(opposite, bottom)*.

GET YOUR KIT ON

GET OFF YOUR BIKE AND DO WHAT YOU LIKE

by Caroline Baker/Photographs by Harri Peccinotti

And that's exactly what you'll be doing when it comes to sweaters; doing what you like. Remember, of course, the way to do it is in layers. Two or three sweaters at a time, you choose the way to layer — the colours and the combinations. As a guide to beginners, start off with something long sleeved that comes down to your waist, or even your hips, and pile on top of it short or no-sleeved sweaters, finishing barely under the bust. If you don't want to bother about doing your own thing knitwise, manufacturers have done it for you. In the shops now, as well as all the gorgeous sweaters on their own, are little ready-mixed-and-matched sets, sometimes they have their own shorts and, more rarely, their own socks. Altogether a gay, colourful, layered look making us all look a tiny bit rounder this winter, but keeping us a whole lot warmer.
Multi-striped wool shorts at The Hollywood Clothes Shop, £3.15. Stockists on page 89

FROM POP TO POSTMODERNISM

GET YOUR KIT ON

POP GOES POSH One of the biggest trends of the late 1970s, see-through plastic was fashioned into jumpsuits, jackets, jewelry, jelly sandals and, of course, visors. The star of this 1978 shot *(below)*, however, is the ivory and gold necklace set with diamonds, designed by Steven Behrens and chosen for the De Beers Diamond Collection of 1979, which signalled that pop could now be posh. The laid-back sporty vibe was also picked up by high-end French label Georges Rech for its 1979 ad campaign *(right)*, which channels both the disco and keep-fit trends and anticipates the 1980s.

COMPLEXITY AND ECLECTICISM

The search for new visual languages was a defining theme of architecture and design in the 1970s. Elements long banished by the Modernist movement, such as ornamentation, symbolism and historical context, were considered more relevant to human needs than the spare, standardized International Style, which, out of touch and administered by inept bureaucrats, was also blamed for the ills of urban planning. The backlash against the latter yielded building and designs that pushed the boundaries of form, celebrated colour and decoration, and was often marked by an eclectic free spirit.

FROM POP TO POSTMODERNISM

WHO NEEDS VANDALISM? The Indeterminate Façade showroom *(opposite)*, built in Houston, Texas in 1974, was one of a series of buildings by James Wines's partnership Sculpture in the Environment (SITE) for the Best Products Company. SITE used the project to explore architecture as art, and here a Modernist box is treated as a found object upon which to project a narrative that challenges conventional ideas about form and the role of buildings in the environment. The Trubek-Wislocki houses on Nantucket Island *(below)*, designed by Venturi, Scott Brown and Associates and completed in 1971, are a nod to the island's fishermen's cottages. Local context is also key to Charles Moore's Piazza d'Italia in New Orleans *(bottom)*, which, with its playful take on classical architecture and references to the Trevi Fountain and Hadrian's Villa, was created with the city's Italian community in mind.

FROM POP TO POSTMODERNISM

COMPLEXITY AND ECLECTICISM

FORM FOLLOWS FUNKY The Los Angeles home of artists Mick Haggerty and Ros Cross, seen here in 1978 *(opposite)*, eschewed convention in favour of eclecticism. Decorating the walls with paint patches rather than harmonious colour schemes, the couple also chose furniture that challenged 'what was acceptable as a chair or a table'. As early as 1970, Japanese designer Shiro Kuramata had been experimenting with furniture in irregular forms, the name he gave to this chest of drawers *(left)*. Later in the decade, Italian design collective Studio Alchimia pushed form even further, as seen in Alessandro Mendini's Modulando cabinet *(above)* and Michele De Lucchi's Sinvola lamp *(top)*, both from 1979.

FROM POP TO POSTMODERNISM

COMPLEXITY AND ECLECTICISM

FROM POP TO POSTMODERNISM
56

COMPLEXITY AND ECLECTICISM

COVER STORY In 1978, Andrea Branzi and Alessandro Mendini explored how the language of decoration could change the meaning of architecture through their Giulianova project *(opposite, top left)*, while Mendini embellished Marcel Breuer's strict leather-and-chrome armchair in a reaction against the banality of mass-produced design *(opposite, top right)*. The following year, Michele De Lucchi used candy colours and playful shapes to bring a human element to household appliances *(right)*, and Ettore Sottsass's drawing for a bookshelf *(below, right)* anticipated his later designs for the Memphis design group. Fellow Italian Gaetano Pesce also experimented with form and decoration in his Sit Down armchair of 1975 *(opposite, bottom)*. Meanwhile in America, Venturi Scott Brown's Eclectic House Project of 1977 imagined a series of minimal, standardized houses that benefited from the addition of flamboyant façades *(below)*.

FROM POP TO POSTMODERNISM

FROM NEON TO XENON

By the late 1970s, the Fiorucci phenomenon and the emergence of New Wave were adding a brash sexiness to pop's pick 'n' mix attitude to fashion. Elio Fiorucci had long been flouting his native country's conservatism with bare-breasted models and see-through plastic jeans, while New Wave was informed by punk's trash aesthetic and the neo-fetish wear of its grande dame, Vivienne Westwood. Whereas the early pop look had been predominantly childish and cartoon-like, all flappy flares and chunky shoes, its successor was brazenly body-con, favouring spray-on ciré and spike heels. These influences danced alongside disco, which in turn cross-pollinated with a sci-fi heroine look. The latter, in true pop style, owed more to the comic-book glitz of Flash Gordon than the pared-down modernism of Courrèges.

DAY-GLO A GO-GO Artist Susanna Heron's Perspex Multiples of 1976 *(below)*, designed to be worn on the arm and sold at London shops Detail and Mrs Howie, pre-empted the trend for all things fluorescent that coincided with the rise of New Wave. The same year, Mr Freedom designers John Dove and Molly White opened Kitcch 22 in London's Woodstock Street. Described as a 'bizarre and garish establishment with a vast following of day-glo juvenile barbarians', the shop caused much consternation in neighbouring Bond Street. Standing outside in 1977, shop assistant Wendy works the New Wave look in a Jan Horrox sweater, Terry de Havilland boots and jeans from Dove and White's Modzart label *(opposite, below left)*. Fellow Mr Freedom designers Pamla and Jim, who decamped to Los Angeles and opened their shop Poseur in 1978 *(opposite, top left)*, also embraced the pop/punk hybrid. By the end of the decade, the look was available everywhere *(opposite, right)*.

sunglasses - Howie, 138 Long Acre, £5.95

Ciré arrow top £12.95 with skirt - mini - £14.95 - Hot, Kensington Church Street

mini dress £27 - Hot, Kensington

'Zebra' belt £2.50 - Liberated Lady, Kings Road
Suede stiletto shoes £16.50 - as above
Strap sandals £10 - as above

FROM POP TO POSTMODERNISM

FROM NEON TO XENON

HIGH FIDELITY

the B-52's

ART ON HER SLEEVE Textile designer Val Furphy, seen here in a 1979 sketch in by her friend, the illustrator Chloë Cheese *(opposite)*, created fabrics for everyone from Strawberry Studio to Yves Saint Laurent and Karl Lagerfeld. But like many creatives of the time, Furphy was more influenced by art than fashion, citing Kandinsky as a muse – an influence clearly seen in the dress she is wearing in Cheese's drawing. The dress was fashioned from one of her own 1976 fabric designs *(background)*, which was also used by designers Peach and Cockle for their summer '77 collection, sold at the cool Covent Garden boutique, Howie. When she wasn't wearing her own creations, Furphy mixed designer labels with vintage finds from London's Brick Lane, Portobello Road and Kensington markets. Fifties and 60s retro was synonymous with New Wave style, and the latter was no better exemplified than by American band the B-52's, shown here on the cover of their eponymous 1979 album *(above)*.

FROM POP TO POSTMODERNISM

FROM NEON TO XENON

LOST IN SPANDEX Fiorucci's dancing dollies embody the New Wave/disco look of the late 1970s *(opposite, top)*. Fiorucci was also sold at Peter Golding's King's Road boutique Ace *(opposite, below)*, itself synonymous with disco finery, including stretch jeans *(top, right)*, satin trousers and T-shirts dusted with diamanté. Customers included Studio 54 stalwart Bianca Jagger and saucepot dance troupe, Hot Gossip. Sexy spray-on style was also the stock-in-trade of London designers Swanky Modes, who began experimenting with Lycra in 1976 when the fabric was still only used for swimwear. Their first collection in 1978 *(right)* was 'perfect to dance in and show off a great body', and beloved of Grace Jones and Cherry Vanilla. But thrifty London girls headed to the Dance Centre *(above)* for all their essential disco kit: footless tights, headbands, leotards and legwarmers, the last worn most fetchingly at legendary New York discothèque, Xenon *(top, left)*.

FROM POP TO POSTMODERNISM

FIORUCCI

FROM NEON TO XENON

INVASION OF THE BODY CINCHERS
The body-conscious silhouette was taken to new extremes in the late 1970s by French designers Claude Montana *(opposite, left)* and Thierry Mugler *(right)*, their exaggeration of the female form and penchant for metallics evoking comic-book sci-fi heroines. This super-camp notion of strong women had been explored earlier in the decade by British designer Antony Price, and the 1979 advert for his shop Plaza continued the theme *(opposite, right)*. Space cadets could accessorize with aluminium bracelets and hairpins by Stephen Rothholz *(background)*, while Terry de Havilland provided the Zebedee shoe *(above)*, and Thea Cadabra's Lunar Loper *(top)* came complete with flashing lights.

FROM POP TO POSTMODERNISM

FROM NEON TO XENON

FROM POP TO POSTMODERNISM

JAGGED EDGY

BOUNCING IDEAS The diversity promoted by pop, along with the return of decoration, saw designers seek inspiration from a wider range of sources. 'The moment Pop Art arrived,' remembers George Hardie, who designed this molecular pattern for the inner sleeve of Wings' 1975 *Venus and Mars* album *(above)*, 'you looked at all the things that were around you.' Comics were another big influence, hence the straight edges and black outlines that crept into graphic design, as illustrated by Barney Bubbles's 1978 sleeve for Ian Dury's 'Hit Me With Your Rhythm Stick' *(above right)*.

The collaging of influences that informed New Wave fashion was paralleled in graphic design, which, thanks to the anything-goes approach to visual languages afforded by the retreat of Modernism, enjoyed a renaissance in the second half of the 1970s. 'Artists were suddenly free to plunder and reprocess about sixty years of design history,' explains designer Mick Haggerty. West Coast artist April Greiman echoes the sentiment, noting that designers 'were encouraged to explore, break rules, try many variations, and use type as if it had a voice of its own, not just as a subservient media'. This new freedom was given an extra boost by the post-punk shake-up in music and the rise of independent record labels, which encouraged experimentation.

FROM POP TO POSTMODERNISM

NEW ANGLES 'I was always crazy for anything visual that sneaked up on you and poked you in the eyes,' says Haggerty, who, along with George Hardie and Barney Bubbles, pre-empted the pluralism of the New Wave graphics revolution. *Stereo*, an illustration from 1975 *(left)*, zings with shrill pastels influenced by the colours of Los Angeles, a palette that similarly excited April Greiman, who designed this 1979 cover for CalArts' *View* magazine *(top, left)*. Her use of dynamic diagonals is mirrored in Malcolm Garrett's cover for the Buzzcocks' *A Different Kind of Tension* of the same year *(top)*, which references Russian Constructivism of the 1920s and 30s. The lyrical expressionism of another Russian influence, Wassily Kandinsky, is recalled in Bubbles's design for The Damned's 1979 album cover, *Music for Pleasure (above)*.

FROM POP TO POSTMODERNISM

BELLE EPOQUE

In April 1970, Barbara Hulanicki, the founder of Biba, threw a 1930s-themed tea dance to launch the brand's cosmetics line at her recently opened boutique on London's Kensington High Street. A key mover and (cocktail) shaker of the decade's nascent Art Deco revival, she had been thrilled to discover that the store featured original Deco pillars, complete with Egyptian motifs. For the launch, she dived wholeheartedly into a full-blown 1930s fantasy, decking out the interior with hundreds of cream ostrich feathers. A three-piece orchestra, consisting of a man in 'gigolo regalia', hair slicked back, and two women in white satin dresses, serenaded journalists as they nibbled cucumber sandwiches. A cake shaped like Mae West with chocolate lips was the swanky event's sumptuous centrepiece.

Biba co-founders Barbara Hulanicki and husband Stephen Fitz-Simon, with their son Witold in 1972 *(left)*. The Art Deco-meets-pop shopfront of cult King's Road boutique Granny Takes a Trip, as featured in *Nova* in 1967 *(opposite, top)*, pictured Jean Harlow's face, painted by Nigel Waymouth and Michael Mayhew. Osbert Lancaster's drawing *Nouveau Pop* shows a hippie bedsit decorated with an on-trend Mucha poster and Tiffany lamp *(opposite, centre)*. Milton Glaser flirted with Edwardiana and Deco as early as 1959, when he designed this cover for *Esquire* magazine *(below)*, and continued the trend with his 1968 typeface, Baby Teeth *(opposite, bottom)*. 'These are the earliest images I produced in response to the Beggarstaff Brothers and Félix Vallotton,' he says. 'I think they are among the earliest signs of an Art Nouveau revival in the graphic arts community.'

FROM BEARDSLEY TO BIBATASTE

The Biba shindig was but one example of a huge revival in the 1970s of the Art Deco era of the 1920s and 30s, a vogue that also encompassed the earlier, ultra-glam Art Nouveau and Belle Epoque periods, Victoriana, and, to a lesser degree, the 1940s. The escalation of a phenomenon that had originated in the 60s, the trend pervaded interiors, fashion, graphics, cinema, television and pop music. This was partly a logical progression of the way the 1950s had revisited the Edwardian era, a brief period of peace and affluence in Europe following the death of Queen Victoria in 1901 and predating the outbreak of World War I in 1914. Illustrations from the late 1950s, notably those by American graphic designer Milton Glaser, often pictured Edwardian gentlefolk, while Cecil Beaton's costumes for the 1964 film *My Fair Lady* were a panegyric to turn-of-the-century high fashion.

The Deco revival's foundations were laid by the earliest of these retro crazes, Art Nouveau, whose influence lingered well into the 1970s because its style was in tune with changing mores. It was commonly conflated with Art Deco because of their shared attributes: opulence, exoticism, decadence. Two seminal influences on the revival were a couple of exhibitions at the Victoria & Albert Museum: on Alphonse Mucha in 1963 and Aubrey Beardsley in 1966, both of which resonated hugely with a young, post-war generation.

'Beardsley had a big influence on London's creative crowd,' recalls Michael Rainey, who owned the hip King's Road boutique, Hung on You. 'London in the late 1950s had been very grey, filled with bombed-out sites. It was a very stiff, authoritarian climate. You were constantly told: "Take your elbows off the table. Don't listen to that disgusting American music." We were coming out of a dark cloud of hypocrisy and moralizing. Beardsley's languid, relaxed drawings chimed with our desire for a more laid-back society.'

Granny Takes a Trip boutique by Nigel Waymouth and Michael Mayhew. Hung On You boutique by Michael English. Warning. By the time this issue is on sale the appearance of these things may well have changed to yet another new design. See page 137 for addresses of shops, details of painters, paints used and prices. By Molly Parkin: photographs Peccinotti.

In a similar spirit, the baroque psychedelia of the poster art of the 60s counterculture fed off the extravagantly convoluted arabesques of Art Nouveau, as did the logos of Barbara Hulanicki's earlier boutiques. Created in black and gold, these gloried in fin-de-siècle excess, and so bucked the 60s obsession with futuristic silver. 'The decadent sinuosities of Mucha and Beardsley were as captivating as in the 1890s,' wrote Bevis Hillier, author of the influential *Art Deco of the 1920s and 30s*, 'and Beardsley in particular…appealed to the Permissive Society. It is difficult today to recall how shocking were the phallic drawings of the *Lysistrata* series by Beardsley, first reissued in a portfolio on sale among the clothes at [the King's Road boutique] Granny Takes a Trip.'

By the late 1960s, there was growing, if gradual, evidence of a Deco revival: in 1966, the Musée des Arts Décoratifs in Paris mounted an exhibition whose subtitle – Les Arts Déco – gave the style its modern name, while in 1967 French *Elle* devoted twenty-five pages to the same movement. That year, the Beatles' album, *Sgt Pepper's Lonely Hearts Club Band*, on whose cover the Fab Four, in pop-Victorian militaria, consorted with old-Hollywood titans – from Marlene Dietrich to Marlon Brando – was another manifestation of the trend. But there was a salient difference here: the album cover's imagery equated the revival not just with European Art Nouveau or 1920s and 30s decadence (as had hitherto been the case), but with American, and specifically Hollywood, glamour. Its global success hugely popularized and cemented the nostalgia boom. Co-created by pop artist Peter Blake, in fluoro pastels eminiscent of Warhol screenprints, the album cover highlighted the fact that the revival was partly a scion of the pop movement.

BELLE EPOQUE

The trend was also boosted by the phenomenal success of the stylish 1967 movie, *Bonnie and Clyde*, whose tale of rebellion, despite its questionable morality, appealed greatly to an increasingly anti-authoritarian younger generation.

Thanks largely to Hulanicki, by the early 1970s Art Deco prevailed over Art Nouveau, making Deco retro more quintessentially of the time. Its apogée was 'Big Biba', the nickname for Hulanicki's even larger emporium, which opened in 1973. Occupying the painstakingly refurbished, splendiferously Deco Derry & Toms department store on Kensington High Street, its Hollywood-on-acid interiors proffered fashion, food and homeware – an entire lifestyle and sensibility that cultural commentator Peter York dubbed 'Bibataste'. Such was Biba's success that it diffused the Deco craze worldwide: from 1971, its cosmetics – in challenging, silent movie-type hues like black and prune – were sold in Italy, France, Japan and the US, while a Biba concession opened in the New York store Bergdorf Goodman that same year.

A further sign that the revival was on the ascendant came, also in 1971, when preservation orders were placed on several previously overlooked London Underground stations and department stores from the Deco era. Stateside, the Miami Design Preservation League campaigned for the renovation

PAST PERFECT The sharp, tailored look of *Bonnie and Clyde* helped blow away the cobwebs of amorphous hippie fashions *(opposite, top left)*. 'The late 60s looked bedraggled, with dirty Afghan coats,' remembers Peter Saville, 'and suddenly there was Beatty in a double-breasted suit and Dunaway in a pencil skirt. I saw the film three times.' The career of artist and designer Erté, seen here in his Paris home in 1972 *(opposite, right)*, was relaunched in 1967 by London art dealer, Eric Estorick. Erté's extravagantly camp theatre costume illustrations – which were widely available as prints and cards – hugely influenced graphics in the 1970s. The London living room, circa 1971, of Deco-lovers Janet and Tim Street-Porter featured a Deco three-piece suite covered in dusty pink velvet from Biba *(right)*, while Paris-based milliner Jean-Charles Brosseau boosted the craze with his cloche hats, sold at Parisian department store, Au Printemps *(opposite, bottom)*.

of long-neglected Deco buildings along Miami's South Beach. Meanwhile, it was becoming fashionable to collect objects from the period. Journalist Janet Street-Porter in London, Andy Warhol and Barbra Streisand in the US and Karl Lagerfeld and Yves Saint Laurent in Paris were all Deco-holics.

In the UK, Deco-mania, as with Beardsley's comeback, offered pure escapism from the puritanism and privation of the 1950s. 'I wanted to claw back my parents' golden age when sweets weren't rationed,' remembers Hillier. 'When I was very young [in the 50s], the chocolate-vending machines in the Underground stations didn't have chocolate bars. The Deco revival represented bubbles, fizz, frivolity.'

It's not far-fetched to suggest that Deco retro's crystalline, streamlined, hard-edged aesthetic not only helped to oust Art Nouveau-influenced psychedelia, but also paved the way for the sharper, more angular, decidedly post-psychedelic style of many a 70s trend – including utility clothing from the 1930s and World War II uniforms, punk and New Wave fashion and graphics, and minimalism. London's Deco-influenced Mr Freedom boutique was a 'favourite haunt' of punk pioneers Vivienne Westwood and Malcolm McLaren before they opened their first shop, Let It Rock. That said, colour-wise the 70s take on Deco wasn't impervious to psychedelic influences: it was often lairy compared with its 1920s forebear, filtered as it was through pop's technicolour prism.

NOSTALGIA AIN'T WHAT IT USED TO BE
A defining characteristic of all this Biba-fuelled nostalgia – or 'retro', a word first coined, appropriately, in the 1970s – was that it wasn't purist but pluralist. Many of its fans were too young to have witnessed these eras, and so interpreted them in whichever way they fancied, usually viewing them through rose-tinted lorgnettes and blithely glossing over such crises as the 1926 General Strike and the Great Depression. In the UK, the recession in the early part of the decade, particularly in the wake of the 1973 oil crisis, intensified the craze because people were seeking escapism and – in a neatly circular repetition of history – turning to the same panacea their parents had latched onto during the Depression: Hollywood glamour. One rare concession to realism was an exhibition devoted to London in the 1930s, held at the Museum of London in 1973, which showcased both maplewood cocktail cabinets and photographs of Oswald Mosley's fascist marches.

From the start, this phenomenon was politically ambivalent: on one hand, its obsession with 1930s high society was potentially reactionary and class-obsessed; on the other, it was progressive because its undeniably camp qualities helped erode rigid sexual stereotypes. But overall, 70s homages to the 1920s and 30s – decades that were portrayed as racier, more louche than they originally were – were more liberal than literal, infused as they were with the increasingly permissive, let-it-all-hang-out hippie spirit of the age. Hair was worn leonine, shaggy, Afro-influenced, rather than neatly gamine, and Biba's muses were licentious vamps like Pola Negri and Theda Bara, not ingenues à la Mary Pickford.

Surprisingly, Hulanicki claims today that Big Biba faithfully reproduced 30s style, insisting that 'it was filled with genuine Deco furniture.' She also disagrees that it was hippie-influenced.

Yet her emporium – which promiscuously sampled elements of Art Nouveau, Art Deco, Hollywood's golden era, 50s kitsch and 60s Pop Art – had a 'casbah' department which, in a nod to hippie chic, stocked Egyptian henna.

'As a purist Art Deco historian, I was disturbed by Biba,' remembers Hillier. 'Its designers…had left most of the Deco structure intact, but everything else was a camped-up pastiche of Art Nouveau and Deco. Yet I was also delighted. It was kitsch, clever.' Hillier relished its rampant eclecticism in an article for the *Sunday Times* in 1973: 'There is a skinny black skyscraper in the style of [Charles] Rennie Mackintosh to contain slimming foods like Limmits, next to it a chubby, ballooning showcase in Gaudí style for fattening farinaceous foods. A giant soup-can, labelled "Warhol's Condensed Soup", contains what you'd expect…'.

THE VINTAGE CRAZE

Despite Biba's popularity, to begin with the Deco revival was relatively underground, espoused mainly by a young, hip, arty minority. 'When we started buying Deco stuff, most people in their thirties and older thought it was granny-ish,' says Michael Costiff, who, with his wife Gerlinde, ran the café in Antiquarius, an indoor market on the King's Road that touted Art Nouveau and Deco clothes and furniture. 'All they wanted was G-Plan three-piece suites.'

One reason for the retro fad's appeal, then, was economic: Deco furniture and 30s threads were cheap. Yet, paradoxically, this brand-new vintage craze (although the glamorous-sounding word 'vintage' wasn't used then) was also a symptom of greater affluence. In the past, only the poor had bought what the rich considered moth-eaten, rank-smelling second-hand clothes. Now, indifferent to such prejudice, the relatively well-off young – notably the model Twiggy, an ardent Biba fan whose all-time idol was Greta Garbo — coveted clothes they knew no one else would be seen wearing, which made perfect sense in the increasingly individualistic 70s, summed up by Tom Wolfe as the 'Me Decade'.

'Older people who'd worked themselves to death scouring, cooking, cleaning wanted wipe-clean Fablon, non-stick Teflon,' says Costiff. 'We'd take our own sheets when we stayed at my parents because they had drip-dry nylon ones which we hated.' In the early 1970s, vintage clothing shops mushroomed in London, Paris, San Francisco and New York. In London, *the* mecca for ragtime-era glad rags was Portobello Road market,

graphic that features on the cover of the catalogue for an exhibition on Art Deco that he curated at the Minneapolis Institute of Arts, also in 1971. Another author, Martin Battersby, likewise fuelled the craze with his books *The Decorative Twenties* (1969) and *The Decorative Thirties* (1971). Twiggy in *The Boy Friend*, a movie that helped spawn many a retro mini-craze, including tap-dancing, 20s golfing looks, and Pierrot-inspired fashion.

although they were also sold at such shops as the retro-loving Granny Takes a Trip and Nostalgia. Another boutique, The Last Picture Frock, was owned by Shirley Russell, wife of Ken Russell, whose effervescent cinematic celebration of Busby Berkeley, *The Boy Friend* (1971), heralded a plethora of movies that rhapsodized about the Jazz Age.

A young Parisian beau monde scoured the city's flea markets at Clignancourt and Montreuil for retro togs. The craze proved particularly intoxicating in Paris – not surprisingly, given that it was one of Art Deco's birthplaces – although perhaps for more complex reasons. An enthusiasm for its rich Deco heritage sprang from a curious blend of patriotic insularity, political engagement and apolitical escapism. 'There was a big anti-American sentiment because of the Vietnam War,' recalls Philippe Morillon, an illustrator, photographer and flea-market junkie at the time. 'This made us love the old, pre-war France. And many of us were tired of the intense political activism of the 1960s, particularly May 1968. We were living in a world of glamour, but a fantasy version of the 30s. We were smoking joints, some of us were openly gay.'

In San Francisco, the mainly gay, LSD-taking, hippie theatrical troupe the Cockettes loved cross-dressing in 1930s thrift-store frocks and, presaging glam rock, caking their faces in glitter – confirmation that the nascent vintage craze often had strong underground roots. A 1971 article in *Rolling Stone* cited a local paper which had described the group as 'an acid flashback to 30s glamour'. The writer agreed, but commented that the Cockettes' shows were 'overtly homosexual, which Busby Berkeley musicals weren't'.

HOLLYWOOD FLASHBACK
In London, a subculture of old-Hollywood cinephiles gathered to ogle musicals starring Fred Astaire and Ginger Rogers at the Mayfair Rooms, Piccadilly, while the National Film Theatre

held late-night screenings of 1930s fare. 'One was watching those films for the first time then,' recalls artist Duggie Fields. 'We hadn't seen them before as they weren't shown on TV. There weren't books about recent history like there are now, so these films educated us about the recent past. Television in the 1970s gradually showed more 30s movies, and this fanned the Deco revival.' Seventies Hollywood, too, soon became besotted with Jazz Age pizzazz, thereby giving it huge exposure. And its movies didn't always gloss over uncomfortable truths: *Cabaret* (1972) addressed the rise of fascism; *The Great Gatsby* (1974) painted the era as doom-laden and brittle; and *Paper Moon* (1973) was set in the Great Depression.

On the literary front, Stella Margetson's 1974 bestseller *The Long Party* scrutinized 20s and 30s high life, while 1976 alone saw the publication of biographies on Noël Coward, Marlene Dietrich, Rudolph Valentino and Sergei Diaghilev. To a younger generation exploring the still largely uncharted territory of sexual ambiguity, including gay liberationists, drag queens, pop stars – Rod Stewart or Elton John, say – and eccentrics and extroverts everywhere, the razzmatazz of old Hollywood was liberating. Adopting its flamboyant style gave them an outlet for their outré personalities.

An offshoot of this liberation was the allure of pre-war Berlin's decadent, sexually deviant café society, epitomized by *Cabaret*. In fact, the words 'divine decadence' were *the* 70s epithet for Jazz Age retro. Perhaps Weimar Republic Berlin and the interwar years captured the public's imagination because their hedonism, cut short by the Depression, paralleled the way the permissive 1970s were bedevilled by economic troubles.

Black pop acts had an empowering frame of reference in the Harlem Renaissance of the 1920s and 30s, a period of cultural confidence for New York's black community. Its style influenced the swaggering, superfly look of 70s blaxploitation movies and the ritzy, neo-Deco togs beloved of the disco fraternity. Seventies feminists, too, may have seen the era as progressive, given that its emancipated flappers and Bloomsbury-style bluestockings had won the right to vote like men in 1928.

Since the trend encouraged people to adopt different personae, it perhaps appealed in an age of greater social mobility. When East End photographer Justin de Villeneuve, Twiggy's boyfriend and manager at the time, affected an aristo-chic pseudonym and Gatsby-esque, double-breasted suits by maverick Savile Row tailor Tommy Nutter, these props camouflaged his class and allowed him to hobnob seamlessly with the upper-middle classes. Such role play was intended to be tongue-in-cheek, however, not snobbish.

MORE REACTIONARY THAN REVOLUTIONARY?

By the time Big Biba closed its doors in 1975, Bibataste had reached saturation point and become clichéd. No matter how incongruous they looked, cod-Deco fonts had become *the* default typeface of the decade, adopted by everyone and everything from discos to dry-cleaners. But Biba had its detractors, too. As early as 1971, the radically left-wing Angry Brigade attacked the consumerism and, as they saw it,

SIMPLY SPIFFING! Stella Margetson's best-seller, *The Long Party (opposite, left)*. Art Nouveau and Deco aficionado Rod Stewart looks raffish on the back cover of his 1976 album, *A Night on the Town (opposite, right)*. An earlier album, *Every Picture Tells a Story* (1971), bore a Deco sunburst pattern, while his two homes brimmed with Tiffany-style lamps, cane peacock chairs, Mucha posters and Victorian taxidermy. *Upstairs, Downstairs (left)*, which aired from 1971 to 1975, opened the floodgates to countless period dramas set in the Victorian era and the early decades of the 20th century: *The Pallisers*, *Lillie* (about Lillie Langtry), *Edward and Mrs Simpson*, *Lord Peter Wimsey*, *All Creatures Great and Small*... Films of the 1970s followed the trend; among the string of movies that looked back to the period were *Cabaret*, starring Liza Minnelli and Joel Gray *(below)*, *Death in Venice*, *The Day of the Locust*, *The Hindenburg* (a 30s-retro take on the disaster movie), *Chinatown*, *Bugsy Malone*, *The Sting* and *Julia*.

retrograde retrospection of Biba by planting a bomb inside the store. 'All the sales girls...are made to dress the same and have the same make-up, representing the 1940s,' their communiqué stated. 'In fashion as in everything else, capitalism can only go backwards – they've nowhere to go – they're dead.'

In 1976, the film critic Alexander Walker noted in *Vogue*: 'It is well known that you can go once too often to the well for inspiration, but Hollywood is going to the grave. This isn't nostalgia, it's necrophilia.' A new biography of Unity Mitford – a salutary reminder of Mosley's fascists – came as another dampener. But the biggest blow to the fashion was dealt by punk, which, inspired by 1950s American rock 'n' roll, British working-class subcultures and 50s kitsch, reviled the elegance – or perceived piss-elegance – of 30s aristo-chic. Others began to regard the fixation with the class system – typified by the globally popular television drama *Upstairs, Downstairs* – as reactionary.

By the late 1970s, this view seemed to be borne out by a shift in the cultural climate, which Peter York dubbed 'reactionary chic'. With the right-wing politics of Ronald Reagan and Margaret Thatcher poised to dominate the US and UK, this revivalism was about to yield the sentimental heritage cinema of Merchant Ivory, television programmes like *Brideshead Revisited*, and Sloaney Lady Di-inspired fashion such as neo-Edwardian pie-crust collars and pearls. Writing about this syndrome in his book *Modern Times*, published in 1984, York scoffed: 'The lurid Gainsborough video of a posh English past that built up in things like *Brideshead* (Waugh's love affair with aristos, the hangdog hopeless devotion the upper-middle classes felt for grandees) or *Chariots of Fire* (filmed like a Hovis commercial, Euston Road admen go taffeta) suited the time perfectly, the *Easy Rider* and *Alice's Restaurant* of our day.'

And so the once-egalitarian yearning for the glamour and fun of the Jazz Age hardened into a display of self-aggrandizing materialism and an assertion of class values. The spangles and sequins of Biba – in whose window seats everyone had once been free to loll – had lost their subversive sparkle.

DIVINELY DECADENT DECOR

In the US, Britain and France, homes everywhere emulated Big Biba's unabashed opulence. Living rooms, bedrooms and bathrooms in particular masqueraded as Belle Epoque bordellos or Deco dressing rooms. Demand for Mucha and Beardsley posters from Athena (a company aptly named after the Greek goddess oft-sculpted by Art Nouveau artists) skyrocketed. Rooms aping *What the Butler Saw*-style parlours groaned with Tiffany lamps, mirrors bearing Edwardian adverts, and peacock chairs redolent of the soft-porn *Emmanuelle* flicks. Deco-fabulous flourishes included mirrors decorated with 1920s *Vogue* covers, chryselephantine statuettes, smoked glass coffee tables, and velour three-piece suites with zig-zags in Deco shades like cocoa and café au lait – a throwback to old-fashioned sepia photographs.

LA VIE EN REPOSE Illustrator Malcolm Bird created many an illustration for Big Biba; the silk fringed lampshades, ostrich feathers, wallpaper and leopard-print curtains in this 1974 advertisement *(opposite)* all came from Biba's home department. Hulanicki's own living room in London's Holland Park *(right)* was aglitter with amber frosted glass lamps, candles in smoky, Gitanes-packet blue, and peach-coloured mirrored tables. Antony Little, who created Biba's gold-and-black logo in 1966 and was chief designer of wallpaper and fabric company Osborne & Little, with his wife Jenny at their London home, circa 1970 *(below)*. Its style was a paean to fin-de-siècle exotica with its peacock feathers, 'Greco-Roman-inspired' floor cushions, and Little's own drawings in the style of Beardsley – a major influence on his colourful and 'anti-Modernist' designs, which borrowed from Aztec and Native American motifs. Stencilled Chinoiserie walls created by artist/designer Lyn Le Grice for Anouska Hempel's London hotel, Blakes, in 1978 *(bottom, right)*.

DIVINELY DECADENT DECOR

BELLE EPOQUE

OCEAN-LINER LIVING Janet and Tim Street-Porter's kitchen, designed by top 70s architect Max Clendinning, featured a ceiling light which had once graced London's partially Deco Strand Palace Hotel, before it was modernized in the late 1960s *(opposite, top left)*. They also owned a sycamore dining table from the period and a collection of Clarice Cliff and Susie Cooper teapots. Fashion designer Thea Porter's London pad *(opposite, top right)*, photographed by Oberto Gili for *Underground Interiors*, was a Deco-fest of mirrors, lilies, silver-and-gold wallpaper and black-suede banquettes. Rupert Williamson's Deco-influenced LWS chair *(opposite, bottom right)*, designed in 1977 and soon after bought by the V&A. That year, Williamson was commissioned to make similar dining furniture in 'an ocean liner style' for a Clendinning-designed home, whose owner had original Deco pieces by Jacques-Emile Ruhlmann. Seventies nightclub queen Régine's eponymous London boîte *(opposite, bottom left)*, which opened in 1978 in Biba's old roof garden. Lyn Le Grice adorned it with stencils of cranes, flappers and top-hatted tycoons. Photographed in 1979, contemporary art curator Henry Geldzahler's New York apartment boasted a Deco sofa and Lucite table *(above)*.

BELLE EPOQUE

DECO IN EXCELSIS Big Biba's fifth-floor, 10,000-square-foot Rainbow Room, with its 500-seat restaurant and stage, was the store's pièce-de-résistance. Its parties were legendary, particularly its closing-down knees-up in 1975. 'People dined on lobster and champagne and the guests were shoved into the lifts completely rat-arsed at 10am in the morning,' recalls fashion designer Antony Price. 'It was the best party ever.'

DIVINELY DECADENT DECOR

FROM BAUHAUS TO OUR HOUSE David Hockney's Notting Hill flat, seen here in the early 1970s *(below)*, shows that some collectors looked beyond Art Deco to its Bauhaus or early Modernist roots. In true eclectic 70s style, Marcel Breuer's B33 chair from 1927 and a chair designed by Charles Rennie Mackintosh were mixed with artist Mo McDermott's pop cut-out trees. A 'Modernism-inspired' shelving unit shaped like Gerrit Rietveld's 1924 Schröder House, made by furniture designer Keith Gibbons in 1974 *(opposite, top left)*. Zanzibar, the ultra-hip cocktail bar in newly fashionable Covent Garden, London, designed in 1976 by architect Julyan Wickham, who remembers being influenced by a book on the streamlined bars of the 1930s *(opposite, top right)*. Noted *Vogue* that same year: 'Zanzibar has everything Raymond Chandler would invent for a Puerto Vallarta cruise.' Susan Collier, who with her sister Sarah Campbell formed one of the decade's most influential textile design teams, produced this Bauhaus fabric *(opposite, centre)* as an homage to a 1926 tapestry by the Bauhaus's weaving director, Gunta Stölzl, seen by the sisters at a major retrospective on the design school in the late 1960s. It was created as a furnishing fabric for Liberty, where Collier was employed as a consultant, in 1972. A 1977 bumper sticker in support of the Miami Design Preservation League, which had been founded the previous year *(opposite, bottom)*.

BELLE EPOQUE

BELLE EPOQUE
85

BELLE EPOQUE

FOXY FLAPPERS AND DAPPER DUDES

Like Barbara Hulanicki before them, in the early 1970s established designers, a new generation of pret-a-porter stars and the general public were gaga about the 20s, 30s and 40s. First came a fleeting trend for a tarty 40s starlet look, followed, in a backlash against the 60s' coltish dollybird image, by a taste for a more soigné 30s demeanour – from crêpe-de-chine tea dresses to Deauville-chic matelot get-ups, all accessorized with neo-Deco jewelry and platforms or wedges. A popular alternative to these traditionally feminine styles, which surely appealed in an increasingly feminist climate, was the more androgynous, sportif look epitomized by Oxford bags, golfing gear and Amy Johnson-inspired jumpsuits. Men weren't left out: 70s blades impersonated French Riviera gigolos, suave lounge lizards, 30s mafiosi and 40s sleuths.

BRIGHT YOUNG THINGS Cartier diamond barrettes grip gamine hair, photographed by Joe Gaffney for French *Vogue* in 1978 *(opposite)*. A *19* fashion story, featuring model-of-the-moment Mouche, shot in Big Biba *(left)*. Although often resembling evening wear, Biba's clothes were also worn during the day. Hulanicki aside, another fashion designer, Wendy Dagworthy, made Lurex, satin and brocade jackets for London shop Che Guevara as daywear in the early 1970s. A big fan of Art Deco, Dagworthy picked out collars on her crêpe-de-chine clothes with fan pleating and embroidery. Vampish Theda Bara-esque make-up created by Serge Lutens in 1973 for Christian Dior *(above)*.

FOXY FLAPPERS AND DAPPER DUDES

WISTFUL THINKING Molly Parkin, then the fashion editor for the *Sunday Times*, in a hat by David Shilling and surrounded by her early 70s Biba wardrobe, a gift from her bosom pal, Barbara Hulanicki *(right)*. Model and actress Ingrid Boulting in a cosmetics poster for Big Biba, shot by its house photographer, Sarah Moon *(below, right)*. Moon's grainy, impressionistic aesthetic was synonymous with the store's nostalgic style. Twenties Marcel waves were revisited early in the decade by hairdresser Ricci Burns *(bottom)*, whose clients included Parkin, Boulting, the Jaggers and Rudolf Nureyev. 'This haircut was modelled after a Cecil Beaton portrait of Nancy Cunard,' Burns recalls. An early example of flapper fashion styled by Parkin in 1967 for *Nova (below)*, where she was 'one of the first fashion editors to feature antique clothing and jewelry'.

LOOK BACK IN LANGUOR An admirer of turn-of-the-century caricaturists Max Beerbohm and Phil May, cartoonist Haro Hodson created this drawing of a flapper for stationery company, Gallery Five, in the 1970s *(opposite, left)*. A 'Beardsley-inspired' fashion sketch by French designer Adeline André *(opposite, top right)*; another illustration by British textile designer Celia Birtwell *(opposite, bottom right)*, both circa 1970. Birtwell's fabrics were inspired by Deco illustrator Georges Lepape and Léon Bakst, costume designer for the Ballets Russes, and fashioned into tea dresses by her husband and close collaborator, Ossie Clark. Clark's own clothes, with their satin, lace and 30s-style prints, were described as 'nostalgic film fashions' by the *Sunday Times* in 1970.

BELLE EPOQUE

FOXY FLAPPERS AND DAPPER DUDES

BELLE EPOQUE
89

FOXY FLAPPERS AND DAPPER DUDES

POP GOES DECO The Deco revival was partly an offshoot of the pop movement, as this *19* fashion story, featuring clothes mainly from Biba and shot in Mexico by John Bishop, shows *(below and opposite)*. Pearls in sugared-almond shades, halter-neck tops, skullcaps and bubble-curl bobs nod to the 1920s and 30s, while the sequins, satin, Lurex and pearlized platforms scream glam rock. The fashions of the early 1970s assimilated the influences of those decades so efficiently that most people were oblivious to the fact that platform shoes (designed by Salvatore Ferragamo in 1938 for Judy Garland), high-waisted flares, flyaway lapels, plucked eyebrows, tennis visors and kipper ties with Windsor knots had originated then. A 1975 clutch bag from groovy Barcelona boutique, Blanco *(right)*, designed to accessorize an all-denim outfit in a year when top-to-toe denim was de rigueur. In true pop-meets-Deco style, the denim was appliquéd with Deco ziggurats and a faux-Bakelite clasp.

BELLE EPOQUE

FOXY FLAPPERS AND DAPPER DUDES

ANYONE FOR TWENTIES? A 1972 fashion shoot from *19* magazine *(above)*, with tennis-playing flappers styled by fashion editor, Jo Dingemans (herself pictured blowing the whistle by the net). The story included clothes designed by Ian Batten for trendy fashion label Stirling Cooper and by Betty Jackson for Alfred Radley's label Quorum, sold at the eponymous London boutique. Manolo Blahník, who loved the 1920s and 30s (he went to one of the fashionable drag balls at London's Porchester Hall as Nancy Cunard), at his London shop, Zapata, in 1974 *(opposite, top left)*. His first shoes, for men, were vibrant versions of the correspondent shoes he had seen in old movies. Designer and fashion retailer Lloyd Johnson's 1971 Sea Cruise jacket, with its neo-Deco print by Sue Saunders *(opposite, top right)*, which was sold at the designer's Kensington Market shop. 'A big influence was *The Great Gatsby*,' says Johnson. 'We did four-piece suits – jacket, trousers, waistcoat and matching cap like the one Robert Redford wore – worn with two-tone platforms. There was a big trend for pastel-coloured gabardine suits. Ian Batten did men's-style suits for women – very Marlene Dietrich – for Stirling Cooper.' A page from Big Biba's newsletter advertises its menswear department *(opposite, bottom right)*, while an ad for Plum *(opposite, bottom left)* features its upscale line of shoes, sold at the Natural Shoe Store in the late 1970s. The shop also carried shoes by Charles Jourdan, Walkers, and Italian designer Ottorino Bossi.

BELLE EPOQUE

BELLE EPOQUE
93

FOXY FLAPPERS AND DAPPER DUDES

JOLLY GOOD SPORT The 1920s-inspired motoring-and-golfing look, as seen in *Nova* in 1972 *(opposite, top right)*, was a tomboyish alternative to dressing up to the nines, while Kenzo's autumn/winter 1977 collection paid tribute to a more refined image of the decade *(opposite, top left)*. Fair Isle knits and baker-boy caps – less formal than Gatsby-esque pastel suits – were popular with men. This Fair Isle tank top *(opposite, bottom right)*, designed by Patricia Roberts in 1976, appeared in one of her knitting pattern books, which were sold in newsagents throughout the UK. Rebelling against the acrylic knitwear of the 1960s and inspired by pre-war knitting patterns, Roberts brought back hand-knitting in the 1970s, creating 1920s-style sweaters for new London shop, Joseph. Fair Isles were donned by male stars of *The Boy Friend* and *Cabaret*, along with Michael Crawford in television's *Some Mothers Do 'Ave 'Em*. Gilbert O'Sullivan's 1970 album *Nothing Rhymed* *(below)* – could his salt-of-the-earth, Northern lad image have inspired Ridley Scott's 1973 Hovis ad?

BELLE EPOQUE

than youth
y 'cos today

Nothing Rhymed

Side One
Intro:-
1. January Git
2. Bye-Bye
3. Permissive Twit
4. Matrimony
5. Independent Air
6. Nothing Rhymed

Side Two
1. Too Much Attention
2. Susan Van Heusan
3. If I Don't Get You (Back Again)
4. Thunder And Lightning
5. Houdini Said
6. Doing The Best I Can
7. Outro.

℗ 1971, M.A.M. Records Limited, London

Sausage, Egg and Chips
Supplied by: Gordon Jones

BELLE EPOQUE
95

BELLE EPOQUE

BABY TEETH AND ALL THAT JAZZ

Pastiche Deco typefaces – a direct descendant of Milton Glaser's neo-Deco font, Baby Teeth – and Jazz Age imagery were used time and again in ad campaigns, illustrations, and packaging for just about anything. Chunky, mainly sans-serif fonts were ubiquitous in graphics for restaurant menus, record sleeves, magazine headlines, company logos, posters and shopfronts. The aesthetic had become stale by the late 1970s, yet it steadfastly refused to go away. Even ultra-hip nightclub Studio 54 (which opened in 1977) had a Deco-a-gogo logo.

RETRO LOGOS The poster for the Minneapolis Institute of Arts' Deco exhibition, curated by Bevis Hillier in 1971 *(opposite, top left)*, was created by design group Bentley/Farrell/Burnett, who also designed Penguin's Deco-tastic covers for the publisher's Evelyn Waugh novels. An enamel plaque of a classic Victorian advert produced by the massively popular company, Dodo Designs *(opposite, top right)*. Set up by Robin Farrow and Paula McGibbon, Dodo also made enamel tins, trays and tea towels emblazoned with Edwardian and Deco motifs. The menu for London restaurant Nikita's was designed by Antony Little, of design company Osborne & Little *(opposite, bottom right)*. Big Biba's newsletter announcing its grand opening in September 1973 – and featuring its staff striking hammed-up poses *(opposite, bottom left)*. A poster for the star-studded 1978 film *Death on the Nile (left)* recalls the 20s and 30s' obsession with Egyptiana, encouraged by the discovery of Tutankhamen's tomb in 1922. Perhaps the Deco revival made the blockbuster exhibition on the same pharaoh at the British Museum in 1972 all the more of a hit.

BELLE EPOQUE
98

REPACKAGING THE PAST A packet of josticks pays homage to Alphonse Mucha and highlights the affinity between 70s hippiedom and fin-de-siècle decadence *(opposite, left)*. Also referencing the revivalist trend were advertisements for Guerlain *(opposite, top centre)* and textile company Dormeuil *(opposite, bottom right)*, the latter melding the influence of Erté and the style of Dietrich. A Penguin edition of *The Great Gatsby*, with a still from the movie starring Robert Redford and Mia Farrow on its cover *(opposite, top right)*. The cover of Belle Epoque's 1978 album, *Ramalama (right)*, with its decorative typeface featuring flappers' heads. The all-female, Paris-based disco trio were best-known for their hit single, 'Black is Black'. A 1977 illustration by Hélène Majera for the Dutch magazine *Nieuwe Revue (below)* fused, from left to right, the 1950s (Elvis), the 70s (a rangy rock dude), the 30s (Marlene Dietrich), and the 40s (a Vargas girl).

BELLE EPOQUE

20TH-CENTURY DRESSING-UP BOX

Afashionados caught the bug for second-hand clothing and flocked to new thrift stores (and existing flea markets) in Europe and the US. The craze received an official stamp of approval in 1971, when Sotheby's in London held an auction of costumes worn by such silver-screen legends as Bette Davis and Ginger Rogers. In a decade when there was both greater consumer choice and the freedom for self-expression, the vogue for wearing something unique was part bid for individuality, part anti-capitalist rebellion against a fashion industry bent on dictating trends. Vintage threads appealed, too, because they predated the post-war era's mass-produced synthetic fibres and were often of better quality – yet cheap with it.

BELLE EPOQUE

BOHEMIAN RHAPSODY Tom Osher, who owned Osher's, a second-hand clothing shop in San Francisco, and his vintage-clad friends *(opposite, top left)*. The Cockettes were regular customers. Other well-known US thrift-stores were Aardvark's Odd Ark in Los Angeles and Cherchez and Jezebel in New York. Anna Piaggi – swathed in what looks like a Paul Poiret coat – with her friend Vernon Lambert, a chief pioneer of London's vintage craze *(opposite, right)*. He and Adrian Emmerton had a stall in the indoor Chelsea Antiques Market where they sold designs by Elsa Schiaparelli and Madeleine Vionnet, beaded Charleston dresses, and sailors' bell-bottoms from the 1930s, which, according to Nigel Waymouth of Granny Takes a Trip, prompted the fashion for flares. Another key London vintage boutique was the Purple Shop at Antiquarius. Freddie Mercury, seen here in 1974 *(right)*, sold second-hand clothes in Kensington Market before hitting the big time with Queen. A business card for vintage shop, Tatters *(below)*. Manolo Blahník in a stall at Chelsea Antiques Market in 1972 *(opposite, bottom left)*.

BELLE EPOQUE

20TH-CENTURY DRESSING-UP BOX

EXCLUSIVE DAY AND EVENING COSTUMES, KNITWEAR AND SEPARATES FOR THE DISCERNING LADY OR GENTLEMAN

THE UNIVERSAL WITNESS LTD.

WHOLESALE-RETAIL CLOTHIERS.
167 FULHAM ROAD
LONDON S.W.3 6QR
TELEPHONE 01-589 7873-39

"the last word in comfort, quality and style."

VINTAGE YEARS Maureen Bampton in her vintage clothing and furniture shop Déjà Vu in Liverpool *(opposite)*, which opened in 1973 in 'alternative market' Aunt Twackie's Bazaar on Mathew Street before moving to Hardman Street in 1975. 'I sold Clarice Cliff ceramics, Deco dining suites and beaded dresses, which I wore myself even to go to Tesco's,' she says. Vintage threads were also available from fashion and interior designer Paul Reeves's shop, Universal Witness *(above)*, whose customers included Talitha Getty and Jimmy Page of Led Zeppelin. 'The stock was a mishmash of old and new stuff,' remembers Reeves, 'original Shirley Temple fan club and Beatles badges, 30s-style knits, and new clothes by Wendy Dagworthy and Margaret Howell.' Art Deco and Art Nouveau brooches by Butler & Wilson *(right and top)*, which started out as an antique jewelry stand at Antiquarius, founded by Nicky Butler and Simon Wilson, in 1970. Fans included fashion editors Caroline Baker of *Nova* and Grace Coddington of *Vogue*.

BELLE EPOQUE
103

BELLE EPOQUE

THAT'S ENTERTAINMENT!

Key to the revival was an adoration of classic Hollywood flicks, screened for the first time in decades in cult cinemas in London, Paris and San Francisco. Cinema-goers in 1974 could gorge on an orgy of footage from eighty-nine MGM movies in the film *That's Entertainment!* By embracing Hollywood's ultra-camp showmanship, extroverts, cross-dressers, glam rock acts and black pop and disco groups that recalled the glory days of the Harlem Renaissance could express their flamboyant, sometimes sexually ambiguous personalities with abandon. To their delight, some of their idols were still appearing on screen or stage: Mae West in *Myra Breckinridge* (1970), tap-dancing legend Ruby Keeler in the 1971 Broadway revival of *No, No, Nanette* (a hugely successful production supervised by Busby Berkeley), and Marlene Dietrich, co-starring with David Bowie, in *Just a Gigolo* (1979).

SHOWBIZ SHOW-OFFS Never mind Bobby Farrell's anachronistic asymmetric Afro, disco troupers Boney M succumbed to Deco-fever big time *(opposite, top)*. In the early 1970s, disco queen of undetermined gender Amanda Lear found inspiration by attending late-night screenings of old Hollywood movies at London's National Film Theatre. Lear posed like Marlene Dietrich in *The Blue Angel* on the back cover of her 1978 album *Sweet Revenge* *(above)*, and delivered its lushly nostalgic song 'Hollywood Flashback' in a gravelly, Dietrich-esque drawl. America's Pointer Sisters lived and breathed retro chic, donning 30s and 40s thrift-store threads to perform their repertoire of be-bop, scat and jazz songs *(opposite, bottom)*. They also performed at Biba's Rainbow Room, and starred in the 1976 blaxploitation movie, *Car Wash*. Diana Ross as Billie Holiday in *Lady Sings the Blues*, the 1972 biopic of the Harlem Renaissance star *(left)*.

BELLE EPOQUE

THAT'S ENTERTAINMENT!

GLITTER BUGS America's Charles Pierce *(above)* performed impressions of old Hollywood legends – he was best known for impersonating Bette Davis. Cabaret, including drag revues, enjoyed a major revival, particularly in Paris. The cult theatre company La Grande Eugène mixed homages to Josephine Baker with satirical attacks on such current phenomena as Black Power, Jesus freaks and the Art Deco cult. Pianoforte drag entertainers Hinge & Bracket, who formed the duo in 1974 and were hugely popular on mainstream television *(opposite, top left)*. Marc Bolan, who sported glam-meets-Deco feather boas and women's 20s-style tap shoes from London shop Anello & Davide *(opposite, top right)*. Brandishing a cigarette holder, Dave Hill of glam rock band Slade underlines the influence of 1920s camp on glam rock's attitude *(opposite, bottom right)*. Peter Mintun, piano player for the Cockettes' shows, with Cockette John Rothermel, who wears a vintage flapper dress *(opposite, bottom left)*. Mintun lived in a San Francisco commune which strictly re-created a 1920s lifestyle.

BELLE EPOQUE

THAT'S ENTERTAINMENT!

An Evening with Hinge and Bracket

BELLE EPOQUE

JAZZ BABIES

Many a star had a crush on the Jazz Age. Elton John hobnobbed with Mae West and Groucho Marx; Ken Russell, director of *The Boy Friend*, drove a 1930s Rolls-Royce; and Russell's wife Shirley, who sourced the film's 1920s clothes, later opened a vintage clothing shop in London called The Last Picture Frock. To prepare for her role in the movie, Twiggy bobbed her hair and 'watched every 20s and 30s film ever made'. Woody Allen loved Gershwin, while the denouement of his movie *Play It Again, Sam* (1972) parodied the ending of *Casablanca*. Other Jazz Age buffs included Liza Minnelli, singer Noosha Fox and Peter Bogdanovich, director of such time-travelling movies as *Paper Moon* and *At Long Last Love*, both of which were set in the 1930s, and *Nickelodeon*, loosely based on the career of film impresario Cecil B. De Mille.

NOOSHA BOBBED HER HAIR Designer Thea Porter, seen here in 1973 *(above)*, married hippie-chic gypsy dresses with 1930s retro, including Gloria Swanson-style turbans. Dancer Lindsay Kemp, with his plucked eyebrows and ostrich feather fans, also oozed 30s glamour *(right)*, as did Elton John *(top, right)*, and Twiggy and her boyfriend/manager, Justin de Villeneuve, who wore Mafia don-style suits from Savile Row tailor, Tommy Nutter *(centre, right)*. Tim Hauser of Manhattan Transfer *(above, right)* remembers that they were 'into Big Band music and groups from that era who sang four-part harmony'. Singer Noosha Fox, who had a UK hit with her song 'S-s-s-single Bed' in 1976, said that stumbling across a wardrobe filled with flapper dresses sparked her idea to dress in 1920s boho attire *(opposite)*.

BELLE EPOQUE

BELLE EPOQUE
110

SEND IN THE CLOWNS

Art Deco's infatuation with the commedia dell'arte was reprised in the 1970s with a mini-trend for clowns, mime, and that lachrymose melancholic, Pierrot. Mime's foremost guru was Lindsay Kemp, a former pupil of Marcel Marceau (who uttered the only audible line – 'Non!' – in Mel Brooks's 1976 film, *Silent Movie*) and later the teacher of both Kate Bush and David Bowie (in whose Ziggy Stardust concerts mime would play an integral part). Ruffled, clown-inspired clothes, doleful Pierrot dolls and Leichner's deathly white theatrical make-up were a brief fad. In 1970, Federico Fellini released his television film *The Clowns*, based on his childhood memories of circuses, and three years later Leo Sayer performed his UK hit 'The Show Must Go On' while dressed as a cringe-makingly mimsy Pierrot.

ENFANTS DU PARODY Leo Sayer performing 'The Show Must Go On' *(opposite, left)*. A Pierrot brooch by Lea Stein *(top)*, who also created brooches shaped like flappers' heads. Lindsay Kemp *(above)* spearheaded the Pierrot revival with his 1968 show, *Pierrot in Turquoise*. Twiggy and David Bowie, catatonic on the cover of his 1973 album *Pin Ups*, photographed by Justin de Villeneuve *(left)*. Artist squatters outside their home in Islington, London *(opposite, right)*. Their harlequins-in-leotards look was a popular uniform among many of the decade's countless street performers. San Francisco, too, had its own 'sad-faced clowns' – Raggedy Robin and Raggedy Jane – hippies disguised as jesters or Pierrots who performed at boutique openings and underground movies. Meanwhile, the Cockettes adored the movie *Les Enfants du Paradis* and its Pierrot character, Baptiste.

BELLE EPOQUE

SUPERNATURE

On 22 April 1970, twenty million Americans took to the streets in celebration of the first national Earth Day, raising awareness about pollution, pesticides, urban sprawl, the dangers of nuclear power and the population explosion. The event marked the dawning of a new era of ecological enlightenment and appreciation of the natural environment that would help to define the rest of the decade. Saving the planet was just one aspect of the huge back-to-nature trend of the 1970s, which gave equal importance to the wellbeing of humankind and found inspiration in the wisdom of the past. Like the pop movement, it was born of the post-war boom in the West. But rather than celebrating the consumerist culture that the boom created, the newly ecologically aware saw mass-production and the worship of technology as the root of the world's problems.

BACK TO EARTH An Earth Day activist on the streets of Manhattan in 1970 *(left)*. Drop City in Colorado *(opposite, top left)* was one of the first-ever communes, an alternative lifestyle laboratory that broke all the old rules – although some traditional gender roles still held sway. Respite from polluted cities and consumerist culture was sought in the country and in the desert, where free spirits could live autonomously from the state. Cultures that had lived simple, at-one-with-nature lives for centuries, such as the Native Americans, provided inspiration – from Navaho hogans to basket weaving *(opposite, top right)*. Tao Design Group's Earth House *(opposite, bottom left)* aimed 'to challenge the Modernist concept of function', says co-creator Charles Harker. Subverting Le Corbusier's idea of the house as a machine for living, the Earth House was based on the notion of a 'soft machine', a reference to the nurturing environment of the mother's womb.

GOIN' UP THE COUNTRY

The move back to nature began with the American counterculture. Thousands had fled the cities in the late 1960s with the commercialization of such hippie heartlands as San Francisco's Haight Ashbury, and in November 1969 the *New York Times* reported that concern for the environment was 'on its way to eclipsing student discontent over the war in Vietnam'. Both hippies and students were enlightened by the *Whole Earth Catalog*, the countercultural bible that since 1968 had been spreading the eco message, as well as providing 'access to tools' in the shape of information, equipment and ideas, enabling the reader to 'find his own inspiration, shape his own environment, and share his adventure with whoever is interested'.

This emphasis on the power of the individual was key. The affluence of the post-war boom afforded an unprecedented freedom of choice among young, middle-class Americans, emboldening them to reject what they saw as the materially rich, spiritually poor world of their parents' generation and to seek alternative lifestyles. Pivotal to this rebellion was the psychedelic phenomenon of the late 1960s; LSD helped free young minds from the hang-ups of 'social conditioning' and opened them to new possibilities in a journey of self-discovery. 'Psychedelics brought on the experimentation,' remembers Alexandra Jacopetti Hart, one of the organizers of the 1966 Trips Festival in San Francisco, the coming-out party of the counterculture. 'They gave us a window into what was possible and showed us all manner of avenues into the future.'

By the early 1970s one such avenue was the well-trodden path away from the polluted, soulless cities, as more people chose to drop out and live in harmony with nature, free from the restrictions and persecutions of the state. In 1970, the 'Back to the Land' issue of the *Mother Earth News* provided a 'blueprint that has already set thousands free', which included features on 'finding a place in the country, laying out your homestead, building a house, raising your own food', along with a contacts list of people who were setting up communes. Like the American pioneers of the previous century, these neo-homesteaders wanted to start from scratch, 'recreating a lifestyle from the bottom up'.

GIMME SHELTER

And the first thing to do was make a nest. The back-to-the-land movement sparked a self-build revolution, while the desire to express oneself led to innovation, often unfettered by building regulations. The trend had kicked off in 1965 with Drop City in Colorado, a commune housed in geodesic domes inspired by a lecture given by Buckminster Fuller. Fuller himself had been a hippie hero in the 1960s, and his cost-effective, no-frills living spaces offered the last word in democratic communal dwelling. But with the growing ecological awareness of the 1970s, his vision of technology as the solution to society's ills had begun to lose its allure, and the new pioneers began looking back in time for inspiration, to buildings that utilized traditional skills and natural materials. 'We have discovered that there is far more to learn from wisdom of the past: from structures shaped by imagination, not mathematics,' observed Lloyd Kahn, an editor of the *Whole Earth Catalog*, who documented this new direction in his 1973 book, *Shelter*.

WELCOME TO THE SOFT MACHINE

Fuller's vision, like Le Corbusier's, of the house as a standardized machine for living was also at odds with the decade's anti-rationalist approach to architecture, which manifested itself in increasingly experimental self-builds. In 1971 the Tao Design Group bought six acres of land in Austin, Texas, to utilize as a 'building workshop'. Reacting against urban architecture, which was seen as hard-edged, impersonal and divorced from both human needs and the natural environment, the group produced free-form 'habitable sculptures' that integrated with their rural surroundings and made for a more nurturing psychological relationship between people and their living spaces. Like many of their countercultural contemporaries, the group drew ideas from primitive cultures. In their use of flexible, state-of-the-art polyurethane foam, however, like Fuller they were happy to harness the potential of modern technology where appropriate.

Believing that they would 'never achieve any concrete evidence about the effect of our cultural environment upon our perception' until experimenting within 'our cultural bounds', Tao invited the public to the site to examine the 'interaction of mankind, architecture and nature'. They came in droves to check out the structures, which were intended to 'alter or expand basic patterns' in the lifestyles of the inhabitants by challenging ideas about form, function and space.

Similar ideas were being explored by radical Italian architects. In 1973 Michele De Lucchi formed the Cavart group, which debated such issues as ecology, urban decay, and the dehumanization of architecture via the media of happenings, performances, films and competitions. One such event in 1975, entitled Culturally Impossible Architecture, allowed students and architects to propose a number of alternative projects for housing that challenged the 'architectural models that imprison mankind within the standard patterns of everyday life'. De Lucchi proposed breaking these patterns with a vertical house, a theme he expanded on with a series of tall, skinny floorless and stairless buildings over the next few years, in which tired old notions of living spaces would be redefined by, among other things, the need to climb up and down the structure, Tarzan-style. Such speculative architecture was intended to open up a debate about the architect's role in defining the quality of people's lives. 'I was disturbed by the idea that there existed some rules that enabled designers…to present products designed exclusively to satisfy an aesthetic formalism, when

they were beautiful, or a scientific formalism, when they were functional,' he wrote in 1978. 'I asked myself if there was really nothing else to be done…to see if by any chance it was possible to design to different rules, new or at least more interesting and amusing.'

By the 1970s it was no longer enough for architecture and design to look good, a concept that had been blasted away by the Modernist backlash and social shake-up of the late 1960s, as well as by environmental concerns. In 1972, their new role was explored via a diverse range of groundbreaking ideas about living environments in the exhibition Italy: The New Domestic Landscape at the Museum of Modern Art in New York. 'Many designers are expanding their traditional concern for the aesthetic of the object to embrace also a concern for the aesthetic of the uses to which the object will be put,' observed the exhibition's curator, architect Emilio Ambasz, in his introduction to the catalogue. 'Thus the object is no longer conceived as an isolated entity…but rather as an integral part of the larger natural and sociocultural environment.' The exhibition included designs that acknowledged 'new forms and patterns of use emerging as a result of changing lifestyles,

SUPERNATURE

THE WAY WE LIVE NOW Michele De Lucchi's *Abitazione a cubo conficcato per un vertice* (Housing as a cube embedded by a corner) of 1975 was just one of his speculative architectural models that raised questions about form, function and social conditioning *(opposite, left)*. Alessandro Becchi's Anfibio convertible couch *(opposite, right)* responded to demands for more flexible furniture to suit increasingly informal lifestyles, and anticipated the sofa bed. Designed in 1970, it is still in production today. Environmental architect David Wright and his wife Barbara in their solar-heated adobe brick house, built in Santa Fe, New Mexico, in 1973 *(right)*. The house – along with those of a growing number of alternative energy enthusiasts – was photographed by Jon Naar for the 1976 book *Design For a Limited Planet*, which he and co-author Norma Skurka were prompted to write after learning of 'the public's insatiable curiosity about solar energy'.

more informal social and family relationships', such as Alessandro Becchi's Anfibio convertible couch and Mario Bellini's Camaleonda cushion system, both blueprints for the sofa beds and modular seating that would become ubiquitous in the second half of the decade.

THE GREENING OF AMERICA

Although it recognized the needs of the present, the Museum of Modern Art show also acknowledged the innovations of the technocratic 1960s, and investigated the potential of synthetic materials. In 1972 plastic was still being explored as a means of making design more democratic, but a year later, when oil prices quadrupled owing to the exports embargo imposed by OPEC countries in the wake of the Arab-Israeli war, it would no longer be such an economical option. The ecology lobby had been warning about the earth's dwindling resources for some time, but the debilitating shortages caused by the oil crisis were a call to arms for the conservation of fuel and research into renewable energy sources, forcing governments and public institutions to take action. Architectural innovations had previously been explored – notably Paolo Soleri's Arcosanti project, a compact, highly integrated town in the Arizona desert that proposed a 'lean alternative' to the wasteful urban sprawl – but the events of 1973 triggered a surge of development in this field in the US, which saw experimentation with everything from solar and wind power to the use of recycled materials, in both municipal and domestic spheres.

The harnessing of renewable energy sources for homes often went hand in hand with self-sufficiency. This was given a currency beyond the counterculture by the economist E.F. Schumacher, whose book *Small is Beautiful: Economics as if People Mattered*, published in the same year as the oil embargo, voiced growing concerns about the effects of mass-production methods on both the planet and its inhabitants. As an alternative, Schumacher proposed 'the technology of production by the masses', or intermediate technology, using smaller working units that harnessed local resources, simpler, more energy-efficient equipment, and a larger workforce, thereby saving natural resources, reducing pollution and unemployment, and, in some cases, returning man to 'the type of work which modern technology is most successful in reducing…skilful, productive work of human hands, in touch with real materials'. This 'technology with a human face' would 'serve the human person instead of making him the servant of machines'.

THE HUMAN TOUCH

The importance of human input was reflected in the decade's crafts revival. The reappraisal of the hand-made had roots in the countercultural requisites of DIY, retrospection and the

use of natural materials, and received a boost with the eco backlash against planned obsolescence. Another reason for the move towards crafts, suggests potter and crafts writer Emmanuel Cooper, was that 'people felt alienated by hard-edged conceptual art in the late 1960s, and wanted to turn to something more human. People hungered after skill.' Furniture designer and craftsman John Makepeace adds to the argument: 'The things being produced industrially weren't very inspiring. There was a desire for self-expression in the 70s.'

In 1971, Makepeace co-founded the Crafts Council in the UK as a response to the 'rising generation of people wanting to make things'. As well as creating a forum for crafts and drawing together people who worked in remote rural areas, it helped develop a new arena for the medium. 'Before this, ceramics had been seen as a functional thing,' says Cooper. 'Now ceramicists were allying themselves with fine art rather than traditional craft, and the Crafts Council promoted this renaissance. That said, traditional craft continued to appeal because it symbolized an escape from the rat race.'

A further strand of the crafts revival drew from the abundant creative heritage that lived on in cultures untainted by mass-production, an influence originally picked up on the hippie trail. 'I would buy African robes with tie-dye and resist dye, Indian bedspreads, Chinese robes,' says textile artist Kaffe Fassett. 'What I loved about knitting was the idea of being able to pour some of this wonderful influence into it.' The global village also provided rich pickings for Terence Conran, an early fan of hand-crafted goods from around the world. 'I was always looking for products that could be exclusive to Habitat,' he recalls, 'so we wanted to find small craft manufacturers. One of my great sources was India. The craftsmanship didn't have a mass-produced feel; you could get qualities of manufacture and colour in particular that were just wonderful.'

NATURAL HABITAT

Post-oil crisis, nearly every home boasted a lovingly constructed macramé owl as environmental awareness – and the quest for self-fulfilment – entered the zeitgeist, popularizing crafts and all things 'natural' and rustically rendered. Ironically, the latter were largely promoted by industry. 'The crafts field expanded hugely because industry began to recognize its appeal and got in on the act,' says Cooper. 'Companies started to adopt a hand-made look.'

As a result, the natural vibe flourished in the second half of the decade. Back in the late 1960s, Conran had pioneered the Provençal-kitchen look, partly inspired by cookery writer Elizabeth David, which complemented the laid-back, low-fuss Habitat lifestyle. By 1977 the Habitat catalogue, a reliable barometer of the decade's changing tastes, bristled with natural fibres and stripped-pine everything. Other stores followed suit, and soon it was hard to find a toaster that didn't have a dormouse motif stamped on it.

Habitat's love affair with rural France took its followers back in time, too, fuelling the 19th-century nostalgia beloved of the hippie homesteaders and influencing fashion and interiors on both sides of the Atlantic. But it was Britain's Laura Ashley (who'd been dabbling in Victoriana since the 1950s) who became synonymous with the trend, offering via her stores

FIELD TRIP Laura Ashley pioneered the pioneer look in Britain, and prevísaged fashion and interiors' love affair with all things rustic and retro *(right)*. Natural fibres abounded at Habitat *(opposite, right)*, and this was the decade in which crafts flourished, although it wasn't all about earthy earthenware. Carol McNicoll's ceramics *(opposite, left)* were part of a new wave of crafts associated more with fine art than with functionality. But although her designs incorporated unconventional ideas about form and pattern, McNicoll says, 'I wanted to make stuff that was usable and available – democratic – rather than just art.' Some of her designs were mass-produced and sold in London shops like Strangeways and Designers Guild. 'Democratic' was a 70s buzzword, in furniture epitomized by the beanbag, the low-price, laid-back chair of choice among students. As well as being organic in form, Habitat's Sagbag of 1973 was covered in canvas or denim *(below)*.

a whole lifestyle and inspiring countless imitators. 'If you can make people feel they're living in the country when they aren't, it's very helpful,' Ashley said, explaining her enormous appeal. 'It's rejecting an industrial society, going back to sanity.' And although she commuted in a private jet between her house in France, eighty-five shops and seven factories, it was company policy for the factories to be in rural areas, in order to promote 'the continuance of their roots in village life'.

CHEAP CHIC

The back-to-nature bug also inspired a number of earthy, at-one-with-the-elements fashion trends, kicking off in the early 1970s with the peasant look, the hippie fancy for ethnic country clothing being co-opted by high-end and high-street labels alike. The Russian peasant vogue came courtesy of French designers Cacharel, Daniel Hechter and, later, Yves Saint Laurent. Its cold-country piling on of clothes evolved into the layered look that prevailed in the mid-1970s, in which Peruvian knitwear, rugged fisherman's sweaters and blanket capes were added to the mix. This adoption of practical, no-nonsense staples not only complemented the decade's outdoorsy inclinations (such get-ups were perfect for a walk in the country), it also made sense mid-decade as the recession dug in. Although designers like Dorothée Bis and Jean-Charles de Castelbajac had latched on to the look, a lot of its components were available at non-designer prices from Scottish knitwear specialists and import shops like London's Inca. The second half of the decade similarly reappraised the tweedy apparel

RUGGED GOOD LOOKS This 1974 shot from *Nova* is part of a story inspired by 'the traditional knitwear of people from cold countries', which mixed rainbow-hued Peruvian knitwear with items such as traditional Hebridean fishermen's sweaters *(below)*. *Nova*'s Caroline Baker was one of the first fashion editors to zero in on the potential of cheap but well-made and good-looking basics, which is also demonstrated in her 1971 story using regulation army surplus from London outlet Badges & Equipment *(right)*. The utility trend, which became huge as the decade progressed, was paralleled in interiors by the High-Tech movement. Architect Michael Hopkins's house, built in 1976, bears all the hallmarks, from its steel frame and metal decking to its open-plan, flexible layout *(opposite)*.

available from traditional country outfitters, with women increasingly adopting men's hacking jackets, shirts, ties, tweed caps and jodhpurs.

Another source of humble but well-made classics was utility clothing, originally liberated from the workplace in the late 1960s as a countercultural anti-fashion statement, but which found currency beyond the campus when Yves Saint Laurent began turning out designer versions of navy pea coats and safari jackets. Not that this stopped people from buying the originals. 'If we're disillusioned with the high cost of uptown basics, we can track down lovely, inexpensive army surplus and work clothes,' proclaimed Caterine Milinaire and Carol Troy in their influential tome, *Cheap Chic*. 'Their functional style', the authors added, 'evolved from a long line of anonymous designers and the demands of their hard work. They've got integrity, stamina and good looks.'

Milinaire and Troy reasoned that since these items were never designed to be in fashion, they could never go out of style. But by the time the book came out in 1975, khaki was a major craze, and a year later the designer jumpsuit ruled.

HIGH-TECH: THE NEW DOMESTIC LANDSCAPE

Utility chic's reclamation of the cheap and unsung, but good-looking and functional, was paralleled by the High-Tech movement, which reutilized inexpensive industrial materials for the home. Scaffolding and slotted-angle metal strips were used to construct shelves, beds and partitions, while trestle tables, factory lamps and filing cabinets replaced traditional furniture and Pyrex laboratory flasks became vases.

In his foreword to Joan Kron and Suzanne Slesin's 1978 book *High-Tech: The Industrial Style and Source Book for the Home*, Emilio Ambasz outlined the philosophy behind High-Tech, which reprised the eco and sociological concerns addressed by Ambasz's 1972 exhibition at the Museum of Modern Art. 'Many industrial objects are...unencumbered by the artificial need to reflect status,' he wrote. 'Created outside the realm of the consumer society, they are honest in their ability to render good service (often with minimum cost to our personal economy and to that of the ecological environment). They can be used to satisfy the necessity people have for creating their own habitat according to their own needs... They may also be used to express our wish not to follow social patterns imposed by those who manipulate culture, invent desires and shape fashions.'

The look dovetailed with the rise of loft-living, kick-started in New York's SoHo district and beloved of the designers fast colonizing London's old Covent Garden market in the late 1970s. But High-Tech also lent itself to smaller homes and new needs brought about by the social revolution, such as the rise of one-room living, with clever space-saving devices like mezzanines and beds built atop study areas.

But it wasn't long before, as Ambasz had feared, High-Tech became co-opted by consumerism. By 1980 Habitat had launched its Tech range, and 'hard edge', a pared-down appropriation of the look that favoured designer industrial fixtures and status-symbol Bauhaus pieces, heralded the black-leather-and-chrome bachelor pad cliché of the greed-is-good decade. High-Tech's classic good looks and practical nature, however, ensured that it never went away. Indeed, its legacy lives on in the open-plan houses, stainless-steel kitchens, sisal carpets and flat-pack furniture of today.

FAR OUT

The counterculture was key to the back-to-nature movement, leading the way out of the polluted, dehumanized cities and into a simple, self-sufficient life in the clean air and spiritually nurturing environment of the countryside. These disaffected baby boomers looked for alternatives to the 'straight' world's plastic consumerism in everything from dwellings to diets, and subverted traditional ideas about the family with communal living. Their free and easy attitude to sex and nudity was another form of rebellion, although this libertarianism, together with a love of all things natural, was quickly co-opted by the mainstream.

HOME SWEET HOMESTEAD The no-frills lives of pioneers and the Native Americans provided inspiration to those turning their backs on environmentally unfriendly consumerist culture. Navaho-style hogans and log cabins *(opposite, top)* were cheap and easy to build, especially with the help of autonomous living handbook, the *Whole Earth Catalog (opposite, bottom)*. Furniture designer Rupert Williamson lived the 'commune hippie lifestyle' with his family and three other couples in a farmhouse in Kent *(above)*, while American brothers Craig and Gregory Sams opened their macrobiotic restaurant Seed in London in 1968, from which grew their influential wholesalers, Harmony Foods *(top, right)*. Actor Terence Stamp, seen on the cover of their magazine in 1972 *(right)*, was an early devotee of macrobiotics, turning down films if his dietary requirements couldn't be met. An anti-Vietnam War demonstrator in San Francisco, 1971 *(far right)*.

SUPERNATURE
123

FAR OUT

NATURAL HIGH Getting back to nature in 1971 at the Wheeler's Ranch commune, in California *(right)*. The previous year, a survey by the *New York Times* reported that there were as many as 2,000 communes in the US, although some claimed that the figure was nearer 3,000. Ubiquitous displays of nudity went hand in hand with loosened-up ideas about sex. 'It was in the 1970s, not the 1960s,' wrote Tom Wolfe in *Life* magazine, 'that the ancient wall around sexual promiscuity fell.' Nudity equalled natural, and was accessorized with scrubbed skin and hair that was allowed to do its own thing. Folk singer Joni Mitchell *(below, right)* and activist Angela Davis *(below)* model the two most popular hairstyles of the early 1970s. Hippies often aligned themselves with the civil rights movement, seeing blacks as fellow outsiders, although many young blacks would have welcomed the privileges that the hippies were rejecting *(opposite)*.

FAR OUT

SUPERNATURE

FAR OUT

PRIVATE EYE

No. 323
Friday
3 May '74

12p

"When I want your advice on family planning I'll ask for it"

POLICE BALL SENSATION

SUPERNATURE

FAR OUT

GIVE NUDITY A CHANCE During the 1970s, advertisers and the media took full advantage of the more libertarian climate. Naked women were used to sell everything from jeans *(bottom, left)* to tampons, and British tabloid the *Sun*'s first Page Three girl made her debut in 1970. The streaking craze that swept America's campuses and the UK's sports pitches showed that nudity could still cause consternation *(opposite)*, but the *British Medical Journal* countered that it was healthy and natural, the 'antithesis of flashing'. 'Natural' became the marketing men's magic word to sell all manner of beauty products, but more ethical entrepreneurs included Martha Hill, who began concocting her herbal formulas in the 1950s *(bottom, centre)*, and the Body Shop's Anita Roddick, who encouraged her customers to refill their used plastic bottles rather than throw them away *(bottom, right)*. Meanwhile, in *Nova*, natural meant remaining the way that nature intended *(below)*.

KEEP YOUR HAIR ON all of it...

From puberty onwards most women spend hours every week shaving, plucking and waxing pubic, facial, leg and underarm hair, believing it – despite it's natural inevitability – to be unhygienic, ugly and unattractive to men. We've established our independence liberated ourselves from our inhibitions about sex and nudity, so perhaps now is a good time to reconsider our attitude to body hair. From her book *Hair*, published this month by Aldous Books Ltd, Wendy Cooper prepared this feature for *Nova*. Photograph by Harri Peccinotti

As a rule, about the strange, baby or blah before modern understanding of endocrinology revealed the vital role the sex hormones play in triggering the growth of body hair, man had quite simply accepted its obvious connection with sexual maturity. The arrival of facial, axillary and chest hair in the male was a clear sexual signal, and pubic hair in both male and female served also as a sexual cynosure.

In fact, it was probably more. In a sense it baited the trap, for both axillary and pubic hair grow in areas where the skin contains scent glands, whose secretions need exposure to air to develop their full odour. Hair provides a holding surface for this oxidation, which releases a distinctive scent that serves, or at least once served, as a recognition signal and a stimulant to sexual excitement.

Evolution may not be much of a planner, but it is far too good an opportunist not to recognise and favour anything which serves such sexual ends. So, when shrinking forests forced man down from the trees to become a daylight hunter on hot tropical plains and it became important to keep sweat cooler and retained those special areas of dense hair growth serving purposes they favoured survival.

The pubic hair on the male, together with a good growth of body hair, served yet another purpose as part of the threat display in the struggle for sexual dominance. The well-endowed human male, displaying his strong hair growth, was more likely to frighten off his more scantily equipped rivals, and emerge the victor in any struggle for a mate. In evolutionist jargon such hair growth, because of its link with sexual dominance, is called epigamic hair, and even today, when expensive cars, well-filled wallets and well-cut suits have become in many cultures the contemporary symbols of sexual dominance, there are still some men who can display a growth of epigamic hair that would not disgrace a gorilla.

Clearly, epigamic hair would serve no purpose in the female, who was the prize rather than the protagonist in sexual sorties, so woman was permitted to lose her chest and facial hair, thus highlighting the areas of remaining hair and increasing their simple instinctual responses became overlaid by conscious and conditioned beliefs and attitudes. The sexual aura surrounding body hair was transferred, by what the modern analyst would term 'displacement' to apply also to head hair and, together with its apparently magic power to regenerate itself, this made all hair a positive symbol of virility and fertility. As such it was sacrificed throughout the ancient world as a substitute for life itself, and even for chastity. This direct sexual symbolism of hair sacrifice was made most explicit in the rites at the temple of Astarte, Phoenician goddess of fertility, at Byblus. There, at the annual mourning for the dead Adonis, women had the choice of shaving off their hair or prostituting themselves to strangers. The goddess was prepared to accept the sacrifice of chastity or of hair, because both represented fertility.

Deeply rooted in this age-old belief in the sexual power of hair, two parallel myths have emerged. The best known one, that hairiness indicates virility in men, is echoed in the lesser known idea that strong body-

miss Levi's

martha hill
BEAUTY CARE
The way nature intended.

SUPERNATURE
127

NATURE AND NURTURE Lloyd Kahn's 1973 book *Shelter* celebrated the integrity and diversity of what Bernard Rudofsky termed 'non-pedigreed architecture' *(bottom)*, while Charles Harker's Bloomhouse *(bottom, right)* revisited ideas about the house as 'a machine that increasingly is human', first explored in his Earth House. Michael Carmichael's 'armadillo' house *(right)*, built in 1978 in Santa Barbara, evolved organically, fed by the artistic input of the twenty-two people who helped build it. Once a symbol of countercultural rebellion, by the late 1970s geodesic domes were being produced commercially to meet a growing demand among America's middle classes *(below)*. Alessandro Mendini described his 1975 straw-bale chair *(opposite, top)* as 'a hypothesis of a primitive piece of furniture: archaic, monumental, ecological and inexpensive.' Michele De Lucchi's Portantina chair of 1976 played with such ancient ideas as nomadism to shake up a debate about the problems of modern living *(opposite, bottom)*.

SUPERNATURE
128

NEW MACHINES FOR LIVING

The back to the land movement, along with the rejection of Modernist rationalism, prompted an explosion of experimental architecture. One strand was the self-build phenomenon of do-it-yourself, do-your-own thing shelters, from geodesic domes and funky log cabins to nurturing organic forms that examined the relationship between man, architecture and nature. Another was radical architecture, which also challenged worn-out ideas about function and aesthetics to explore the effect of man's environment on his quality of life. 'There was the idea of "back to nature", far from the city,' says Alessandro Mendini, 'to find an environment and a culture that were uncontaminated.'

GLOBAL PILLAGE

By the early 1970s, the rise of electronic media and forays down the hippie trail had shrunk the globe, forcing different cultures to collide and providing inspiration for counterculturalists and fashion designers alike. While spiritual enlightenment was sought via Eastern mysticism, the antidote to homogenous, mass-produced clothing was found in the intricately hand-made native costumes of Afghanistan, Guatemala, India and Morocco. The one-off nature of much ethnic clothing made it another means of asserting one's individuality in an era defined by self-expression. But in order to make a garment truly one's own, only tender, loving customization would do. A new folk art was born.

MARRAKECH EXPRESSIVE *Nova* saluted the timeless good looks of ethnic costume with this fashion story shot in Morocco in 1973 *(top, left)*, which showcased the rich pickings available at a snip from import shops back home in Britain. High-end French fashion house Chloé hits the hippie trail in Afghanistan in 1970 *(top, right)*. Alexandra Jacopetti and Jerry Wainwright's cult book *Native Funk and Flash* of 1974 documented the 'emerging folk art' of the San Francisco Bay Area *(left and above)*. 'Many of us have hungered for a cultural identity strong enough to produce our own versions of the native costumes of Afghanistan or Guatemala,' Jacopetti wrote. The customization craze is captured in Jean-Paul Goude's illustration for *Nova* in 1970 *(opposite)*.

SUPERNATURE

GLOBAL PILLAGE

FUNKY FOLKSY Artist Judith Weston, seen wearing a crocheted cape in the promotional poster for the 1974 Native Funk and Flash exhibition at Oakland's Mills College Art Gallery *(below)*. 'I never was the sort of person to want to be rubber-stamped,' Weston said. 'I wanted to stand out.' This painting of an ikat by Susan Collier of textile-design duo Collier Campbell *(right)* is from 1971, when Susan was the design and colour consultant for Liberty, and would trawl London's markets looking for things to inspire her. 'Finding the ikat was part of the way we had been living,' she says. 'We went to Brick Lane every Sunday for years. We were always discovering things and painting them.' The artwork later became the basis for a textile design, printed on a silk dress fabric.

SUPERNATURE

GLOBAL PILLAGE

HIPPIE DELUXE Like Susan Collier, fashion designer Zandra Rhodes drew inspiration from various countries and cultures. Her 1970 textile design Chevron Shawl *(right)* nods to the tasselled fringing and 'simple, peasant flowers' of ethnic shawls. The print also determined the shape of the garments, including diaphanous silk chiffon dresses, that were fashioned from it. Rhodes cut around the printed fringes and added turquoise and aluminium feathers to the tips. 'This was revolutionary in 1970!' Leatherworker Robert Lusk opened his shop Yak in West London in the early 1970s *(below)*. 'It was the time of Afghan things,' he says. 'I was selling textiles, kelims, belts and jewelry alongside my hand-made leather bags and shoes, as well as clogs from Denmark.' Yak was also *the* outlet for Earth shoes, Birkenstocks and the must-have American Frye boot; by 1978, the shop had evolved into the Natural Shoe Store.

SUPERNATURE
133

CLEAN LIVING Architect and designer Claus Bonderup followed a tradition of earth-sheltered building that dates back to the Vikings for his 1979 house in Denmark *(bottom, right)*. The windows were positioned to collect warmth from the low-standing sun in winter. In New Mexico, designer Steve Baer's house, built in 1971, also featured south-facing windows, behind which water-filled metal drums collected heat in winter *(bottom, left)*. The glass façade of Douglas Kelbaugh's New Jersey house, completed in 1975, collected heat while a concrete Trombe wall at the back retained it *(below)*. Members of the tenant-owner cooperative of 519 East 11th Street in Manhattan stand on the roof and survey their handiwork *(opposite)*. Having renovated this once-condemned tenement, they also equipped it with New York's first operating solar collectors to heat water. Six months later, these were followed by a wind generator to provide the building with electricity.

SUPERNATURE
134

FEELING THE HEAT

The shortages and price hikes caused by the oil crisis of 1973 were a wake-up call to the West, which for too long had been relying on the OPEC countries to fuel its massive energy consumption. The ensuing challenge to conserve resources, together with concerns about the polluting effect of fossil fuels, gave a huge boost to the development of eco architecture, particularly in the US, where projects were springing up in the cities as well as in the countryside. As people continued to experiment with solar energy, there was a shift away from the clunky mechanical hardware of active heating systems towards passive ones, which incorporated both heat collectors and thermal storage within the structure of the building.

SUPERNATURE

LEAN AND GREEN Arcosanti, Paolo Soleri's still-evolving prototype town in Arizona, is based on his concept of 'arcology' – the fusion of architecture with ecology – which advocates the minimum use of energy, materials and land, and promotes interaction with the natural environment. At Arcosanti, no space is wasted: the bell-making foundry seen here, built between 1972–74, also contains housing. Sales of the bells help finance the project, with the foundry furnace providing heat during the winter months.

THE GREAT OUTDOORS

Post-oil crisis, heightened environmental awareness inspired a more widespread appreciation of the natural world, and everyone was urged to do their bit to help preserve it. There were pandas to be saved, trees to be planted, and litter to be picked up. Even fashion rallied round, calling upon everyone to get outside and embrace the elements, whether in takes on traditional English country tweeds, chunky Peruvian-inspired knitwear or voluminous layers.

COOL CLIMATE The layered look was embraced by urbanites, too. This autumn 1979 collection by Roy Peach – whose designs were sold at hip London boutiques Howie, Roxy and Bombacha – added fake fur and mannish dressing for women to the mix.

HUNTIN', FISHIN' FASHION Roger Saul and his wife Monty seen taking the air in suitably outdoorsy attire *(top, right)*. Saul founded Mulberry in 1971, making belts for designers like Ralph Lauren until a visit to an agricultural show in 1975 inspired him to do the 'English hunting, shooting and fishing look' that ruled in the later 1970s. The clashing of cultures was key to Kenzo's designs, and in 1973, the designer combined three big trends in one: menswear for women, prairie-girl flounces and peasant-style layering *(top, left)*. Jean-Charles de Castelbajac designed his first blanket coat in 1967; his 1976 version channelled the Peruvian vibe that peaked around then *(above, left)*. The layered look is given a futuristic spin courtesy of Claude Montana *(above, right)*.

SUPERNATURE

ARTY CRAFTY

The onslaught of the ecology crisis also called into question the notion of planned obsolescence. In a reaction against the consumerist culture's polluting production line of soulless goods came a big revival of crafts, which, made by hand with heart and using natural materials and ancient skills, as well as offering a means of self-expression, had long been championed by the counterculture. The latter, who valued time over money, also turned on to the communal aspect. 'If you couldn't afford to go and see a movie,' remembers designer Kaffe Fassett, 'you'd invite your friends round and do your crafts.' And there was a lot more staying in during the recession-hit 1970s.

LET YOURSELF SEW Designer Sue Rangeley in her studio at Fosseway House, in Gloucestershire, where she lived and worked with thirteen other craftspeople *(above)*. The studios, set in idyllic rural surroundings, were founded by Michael Haynes – who also set up 401 Studios, one of the first studio complexes in London – in 1975. Rangeley is shown working on a quilted airbrushed jacket for an exhibition at Hugh Ehrman's London gallery, which also exhibited the work of Kaffe Fassett. She developed the technique in the late 1970s, while freelancing for Bill Gibb. 'It grew out of my watercolour sketches and captured the gentle palettes of English cottage gardens,' she says. Gibb also loved the 3D appliqué of Rangeley's water-lily waistcoat *(left)*, inspired by the oriental robes at the Victoria & Albert Museum. The pair collaborated on the designer's spring/summer 1977 collection, for which Rangeley created delicate quilted silk jackets.

TO HAVE AND HAVE KNOTS Macramé as a total environment in Bolinas, California *(above)*, co-created in 1973 by Alexandra Jacopetti *(right)* – surely one of the most imaginative uses of this rediscovered craft that swept through homes in the 1970s. Joel Philip Myers, an innovative figure in the American Studio Glass movement that kicked off in the 1960s, gives a glass-blowing demonstration at a glass symposium in 1974, held at the California College of Arts and Crafts in Oakland *(top, right)*.

ARTY CRAFTY

GO WITH THE FLOW Glass artist Marvin Lipofsky's *California Loop Series No. 21* of 1971 embodies both the form-challenging ideas that were prevalent at the time and craft's move away from the purely functional to the aesthetic and expressive *(below)*. 'My work was very organic and loose, and mirrored the free-flowing times,' says Lipofsky, who taught at the University of California at Berkeley in the 1960s and early 70s. 'Most glass-blowers were still making heavy, not-too-skilful pieces, mostly related to traditional craft. I thought glass had more to offer, and wanted to give it negative as well as positive space. This piece represents the fluid quality of glass – what it does when you allow it to drip, sag, and use gravity to form it.' The experimental nature of the work extends to its surface, where Lipofsky used flocking to add colour and texture.

EAGER WEAVERS The Crafts Council's magazine was launched in 1973, and, along with the Council's gallery in London's Waterloo, it provided a showcase for this increasingly diverse genre. The cover of the 1976 issue *(above, left)* features a weaving by Maggie Riegler. Bookbinding was another strong strand of the crafts revival. This copy of George Bernard Shaw's play *Saint Joan* was bound by Chris Hicks in the mid-1970s in black morocco leather with an inlaid pattern of woven material *(above)*. The design represents curtains on a stage, reflecting the theatrical origins of the work.

SUPERNATURE

ARTY CRAFTY

AS NATURE INTENDED Bespoke furniture maker John Makepeace's Vine chair *(top, right)* and Standing Stones table *(opposite, bottom)*, both from the late 1970s, drew from natural forms. The table was inspired by the flat pebbles found on Chesil Bank, along the Dorset coastline. Like many of the decade's creatives, Makepeace wanted to put the human element back into design. 'I was reacting against the Modernist aesthetic, its cold look,' he says. 'I wanted to enrich the language of furniture, which I felt was impoverished.' The desire for more organic, expressive forms in the wake of the Modernist backlash no doubt prompted Spanish furniture company Bd Barcelona Design in 1976 to reissue Antoni Gaudí's Calvet armchair *(above)* and chair *(right)*, both designed in 1902.

SUPERNATURE
143

PRAIRIE POSE Laura Ashley's nostalgic English look epitomized the 70s' love affair with the rural past and inspired a new fashion genre – 'milkmaidism' – with its sprigged smocks, puffed sleeves and pinafores. This fashion shot from the early 1970s, featuring an antique Welsh dresser and crockery, hints at the furniture empire to come *(left)*. Meanwhile, America's homesteader heritage travelled far afield, as this advert for Italian jeans brand Crash demonstrates *(below)*. The TV series *Little House on the Prairie* was huge on both sides of the Atlantic, and Laura Ingalls Wilder-style pin-tucked frocks came courtesy of Jessica McClintock's Gunne Sax label. But those who really wanted to go back in time could make their own with the help of Folkwear, an American company that still specializes in patterns of historic costumes from around the world *(opposite, top)*. The pioneer/outlaw look was also a favourite with the folk music fraternity, from Crosby, Stills, Nash and Young to Steeleye Span *(opposite, bottom)*.

RUSTIC RETRO

A nostalgia for the rural past was the counterpart of the back-to-nature trend. American would-be pioneers looked to the simple lives of the prairie homesteaders and the outlaw cachet of the Wild West for inspiration. In France, the Provençal peasant played muse, while in England, a rose-tinted take on the Victorian era and the romance of the Pre-Raphaelite Brotherhood piqued the national consciousness. Such revivalism flourished in tandem with the technology backlash and the deepening recession as many sought solace in eras that predated mass-production. Ironically, however, the trend also helped to oil the wheels of industry. Rustic retro fashion and interiors were big business.

Folkwear 201 — Prairie Dress

PATTERNS FROM TIMES PAST

PATTERN • SEWING INSTRUCTIONS • FEATHERSTITCHED APRON

Individually... & Collectively

Steeleye Span

KLÆDEDRAGTER I KIØBENHAVN
41 PEMBRIDGE RD., W.11.
727 9193
YAK·FOR·CLOGS
20 NORTH END RD., W.14.
603 6017

RUSTIC RETRO

PEASANT PASTORALE Yak was the place to go for genuine Danish clogs, the footwear of choice for the hippies who kicked off the peasant look *(opposite, top)*. French designer Chantal Thomass and her sister-in-law Anne parody Jean-François Millet's painting *L'Angelus* in 1971, dressed in clothes from Thomass's shop Ter et Bantine *(opposite, bottom)* and seen against a backdrop of Sanderson's cross stitch wallpaper, which echoed the embroidery adorning many a cheesecloth smock *(opposite, background)*. London's premier fabric destination, Liberty, offered a plethora of printed cottons for the urban peasant *(left)*, while Yves Saint Laurent's take on the Russian peasant look was showcased in Italian *Vogue* in 1976 *(below)*.

Di Saint Laurent queste fantasie da Balletto Russo, scomponibili in nuovi pezzi classici

SUPERNATURE
147

RUSTIC RETRO

FAR FROM THE MADDING CROWD
David Inshaw's *The Badminton Game* of 1972–73 *(above)* perfectly evokes the artist's love affair with the English countryside, which began after a girlfriend gave him a copy of Thomas Hardy's *Tess of the D'Urbervilles*. In 1975, Inshaw formed the Brotherhood of Ruralists with a group of artists, including Peter Blake, who shared his unashamedly romantic notion of going back to nature. Edith Holden's 'Nature Notes for 1906' was repackaged in 1977 as *The Country Diary of an Edwardian Lady* and became a bestseller *(right)*. A Peter Blake nymph graces *Deluxe* magazine, also in 1977 *(opposite, top)*, while designer Sue Rangeley is seen 'indulging in the pleasure of living and working in the countryside' the following year *(opposite, bottom)*. A stencil by Lyn Le Grice channels the textile designs of William Morris *(opposite, background)*.

SUPERNATURE

DELUXE
NEW FASHION MAGAZINE

£1

FIRST ISSUE

RUSTIC RETRO

AGA SAGAS The kitchen of Lyn Le Grice, in the medieval Gloucestershire barn that she converted in the 1970s *(opposite)*. Londoners, too, could enjoy the rustic vibe with a trawl around the French food market at Big Biba *(right)*. Like Terence Conran, Barbara Hulanicki was a fan of Elizabeth David, and even tried (unsuccessfully) to get the food writer to do the food for the store's restaurant. Conran had more luck, persuading David to select a *batterie de cuisine* for his Habitat catalogue. Indeed, Conran was as influential as David when it came to introducing the Brits to pepper mills, garlic crushers and wine racks – and no doubt drinking wine with dinner *(top, right)*. Designer David Mellor also believed that things should look good and work well. His first kitchen shop, selling his own designs alongside British domestic crafts, opened in London's Sloane Square in 1969 *(above)*. Natural floor coverings, as available from Habitat *(opposite, background)*.

SUPERNATURE

LOW-FUSS HIGH-TECH

The reappraisal of architecture's relationship with the natural environment also informed the High-Tech movement, which, in its reutilization of inexpensive industrial materials outside the workplace, ticked both eco-friendly and anti-consumerist boxes. Being both practical and good looking, the trend lent itself to everything from DIY solar housing to cutting-edge shops during the second half of the 1970s. Its functionalism gave a nod to Modernism, but High-Tech was a lot more playful in its celebration of the nuts and bolts of construction.

SUPERNATURE

LOW-FUSS HIGH-TECH

PRACTICAL STYLING American artist and designer Michael Jantzen was an early adopter of industrial materials for domestic purposes and a major innovator in the exploration of solar architecture. The shape of this partially insulated greenhouse from 1972 *(left)* was designed to minimize the space necessary for the gardener, and therefore required less heat. The super-High-Tech window display of Fiorucci's New York store, seen here styled by Kit Grover, circa 1978 *(below, left)*; inside, soft furnishings and other frills were banished in favour of hard oak flooring, metal shelves and naked light fixtures. Paul Howie's second Covent Garden shop, designed by Ben Kelly and completed in 1977, was housed in a large ex-industrial building *(below)*. High-Tech's reutilization of such materials for anti-consumerist, pro-ecological ends was also key to the 'anti-architecture' of Frank Gehry. In 1977, Gehry customized the exterior of a suburban house with corrugated metal, chain-link fencing and plywood *(opposite)*. But unlike functional High-Tech, the effect is uncompromisingly chaotic, thanks to its raw-edged materials and skewed angles. *Previous pages:* Joseph Paul D'Urso defined the decade's High-Tech, loft-living look, and his design for the Esprit store in Los Angeles heralded the movement's endorsement by the mainstream in the 1980s. Michael Leonard's homoerotic *Passage of Arms* from 1979 chimed with the locker-room aesthetic common to both High-Tech and gay culture's switch from camp to blue-collar butch in the late 1970s – as personified by David Hodo, the construction-worker alter ego from the Village People.

SO REFINERY Inspired by the exposed-structure architecture of such 'ugly' industrial buildings as Joseph Paxton's Crystal Palace, Richard Rogers and Renzo Piano borrowed the idea for their Centre Georges Pompidou in Paris (1971–77). The building's workings, including the water, air-conditioning and heating pipes, and zig-zagging escalator tubes, are all part of the design.

LOW-FUSS HIGH-TECH

SUPERNATURE
158

LOW-FUSS HIGH-TECH

LOCKER-ROOM BOOM Helen Robinson sports a New Wave *Annie Hall* ensemble amid the ultra-High-Tech environs of her shop, PX *(above)*. The look was quickly appropriated by such on-trend stores as Habitat; its flexibility and functionality lending itself to the decade's social shift towards one-room living, as conveyed in this shot from the 1979 catalogue *(right)*. Designers Peter Saville and Ben Kelly collaborated in 1979 on this design for Orchestral Manoeuvres in the Dark's eponymous album, which was released the following year *(opposite)*. A major inspiration for Saville was Kelly's front-door design for the Howie shop, which featured perforated sheet steel behind the glass.

SUPERNATURE
159

KNOWING THE DRILL Diane Keaton and
Woody Allen in his film *Annie Hall* of 1977 *(above)*,
which propelled the mannish/layered/utility look
into the mainstream. This *19* magazine fashion story
of the same year demonstrated how the *Cheap Chic*
look had become appropriated by designers *(top)*.

SUPERNATURE

UP THE WORKERS

Even after Yves Saint Laurent produced his luxe version of the navy pea coat in the late 1960s, people didn't stop hankering after the real thing during the decade that followed. After all, why sink hundreds into a designer number when you could buy something equally stylish at a snip from your local army and navy outfitters? But the trend soon inspired fashion designers all over again. 'Ever since Marie Antoinette played peasant at Versailles, it has been a fashionable preoccupation with the rich to ape whatever workers wear,' the *Sunday Times* observed in 1976. 'Nowadays even the far-from-rich enjoy looking a great deal more workman-like than they actually are. The latest fad is for overalls like those worn by mechanics.'

OVERALL WINNERS Architect and interior designer Ian Deacon wears a flying suit by Yvonne Swindon *(left)*, designer for hip label Hoofer and an early proponent of the utility look. Swindon frequented London's army surplus mecca Laurence Corner for ideas, but the inspiration for the Hoofer fatigues beloved of Bryan Ferry in his GI phase and the Canvey Island crowd mid-decade were 1930s and 40s American films. Military uniforms from this era also formed the basis of Globe, the Paris shop of Gerard Decoster, who says that utility was 'a natural extension of the nostalgia trend'. Like utility clothing, the coupe sauvage – created here by Ricci Burns, circa 1975 *(top)* – was laid-back and low-maintenance. 'You could towel-dry it, so it was practical,' says Burns. 'It was about freedom.' Cult French actor Patrick Dewaere dresses down for *L'Uomo Vogue* in 1977 *(above)*.

UP THE WORKERS

UP THE WORKERS

WORKING WARDROBE In 1970, *Rags* magazine dedicated an issue to work wear *(right)*, which featured an article by Mary Ann Crenshaw (with illustrations by Richard Giglio) on the fashion designer's debt to America's army and navy stores *(below, right)*. This *L'Uomo Vogue* shoot from 1973 mixes real army surplus with designer versions *(below)*. The magazine revisited the theme in 1977 with a special issue dedicated to military dress. One of the stories was set in a Milanese barracks with real soldiers set alongside models wearing 'imaginary' uniforms by Giorgio Armani, which, it was suggested, 'could be used by the Armed Forces in the future if military service was to be conceived in a more democratic and modern way'. A poster design for Hoofer by Yvonne Swindon *(opposite)* evokes the early hip-hop vibe of late-1970s New York. 'People were wearing dungarees in the 70s called Big Macs,' she says, 'but you could only buy them in New York.'

SUPERNATURE

AVANT GARDE

'During the late 1960s, I felt like a fish out of water. As the rest of my generation babbled about peace and love, I stood back, puzzled, and fantasized about the beginning of the "hate generation". Violence was this generation's sacrilege, so I wanted to make a film that would glorify carnage and mayhem for laughs.' So quipped film-maker John Waters who wreaked his revenge on, as he saw it, the drippy hippie mentality in a series of deliberately trashy, unapologetically low-budget films which savaged a whole raft of taboos – homosexuality, incest, abortion, even coprophagy – and ridiculed the pieties of the American Dream. Waters was way ahead of his time, his anti-hippie spleen prefiguring punk's by some years. Circa 1975, the catchphrase 'never trust a hippie' was coined, and it would soon appear on button badges up and down the UK. At the time, Johnny Rotten was hanging out at Malcolm McLaren and Vivienne Westwood's shop Sex, which touted rubber fetish gear as fashion, in a Pink Floyd T-shirt – with the group's eyes gouged out and 'I hate' scrawled across their logo – and a green, electric-shock haircut. Rotten's attitude so impressed McLaren's assistant Bernard Rhodes that he asked the scrawny scamp to audition as frontman for the Sex Pistols.

NURTURE NOT NATURE

It would be simplistic to say that punks and hippies had nothing in common. Indeed, both rebelled against 'straight' society, its spoonfed consumerism and enslavement to corporate culture. Yet while the hippies sought relief from stultifying conformity in a return to nature and the quest for emotional authenticity, the more cerebral avant-garde, who tended to be resolutely urban and urbane, deployed other weapons, chiefly irony and the cults of kitsch and artifice.

To many avant-gardesters, the hippies were deluded in their belief that they were at one with nature, while weekend hippies contented themselves with a watered-down travesty of it. 'In the 1970s, artier types were into artifice because they were revolting against the mainstream,' recalls Duggie Fields, 'which was a sea of blue denim and supposedly natural make-up. In fact, it was inches of make-up made to look like you weren't wearing any.' Moreover, while hippie culture tended to be patriarchal and sexist, the avant-garde, who cultivated sexual ambiguity and were often gay, were less so.

The cult of artifice was boosted by a fascination at the turn of the decade with kitsch, a term originally meaning 'trash' or 'cheap finery', thanks in particular to the publication of two landmark books: Gillo Dorfles's academic tome *Kitsch: The World of Bad Taste* (1969), and Jacques Sternberg's *Kitsch* (1972). Dorfles, however, viewed kitsch as an aberration, defining it as anything that is divorced from its original source and is thus inauthentic (a reproduction Mona Lisa, for example), and blamed the phenomenon on mass-production. Even lifestyles could be kitsch if they had become commodified and hackneyed. In Dorfles's eyes, this included the counter-culture. 'Before long (and even now)...we will witness the anti-family kitsch, the kitsch of hippies,' he wrote, illustrating the point with a photograph of a naturist family. But Dorfles was fighting a losing battle: in the 1970s, when the barriers between high and low art, good and bad taste, were dissolving, kitsch massively influenced avant-garde fashion and interiors.

THE IMPORTANCE OF BEING FLIPPANT

As early as 1964, Susan Sontag intuited this sea change in taste in her essay 'Notes on Camp', which expounded on the new 'modern sensibility'. 'Camp', she wrote, 'makes no distinction between the unique object and the mass-produced object... Camp taste turns its back on the good-bad axis of ordinary aesthetic judgment.' And, taking this further, she declared that the ultimate camp statement was 'it's good *because* it's awful.' The quip later became a compliment among the avant-garde from Waters to McLaren, who praised the New York Dolls' music thus on first encountering the band.

Sontag maintained that the essence of 'camp is its love of... artifice. It incarnates a victory of style over content, aesthetics over morality, irony over tragedy.' Peppered with such apposite quotes as Oscar Wilde's epigram 'to be natural is such a very difficult pose to keep up', from his play *An Ideal Husband* – and stating that 'the androgyne is one of the great images of Camp sensibility' – the piece presciently anticipated the avant-garde's obsessions with androgyny, flippancy, kitsch, artifice and irony, as endorsed by, Waters aside, David Bowie, Roxy Music crooner Bryan Ferry, Lou Reed and the New York

SCHLOCK-FEST *Kitsch* by Gillo Dorfles *(opposite, right)* sparked a frenzy of media interest in the subject. Anthony Haden-Guest expounded on the subject for *Harpers & Queen* in 1970, while other writers celebrated California's ultra-kitsch Madonna Inn, the Hollywood Tiki hotels, Liberace and cult movie *Pumping Iron*, starring Arnold Schwarzenegger. Rhapsodizing about Big Biba's 'Kitch' department *(opposite, left)* in the *Sunday Times* in 1973, Bevis Hillier lauded its 'ashtrays like miniature loos, school of Tretchikoff paintings and urinating cupids'. Andrew Logan's studio cum home in Hackney, London, seen here in the early 1970s *(right)*, featured a wardrobe fronted by Astroturf, a mannequin torso as a fountain (kitsch-loving Thems adored dismembered shop-window dummies), a plaster Alsatian, and his own sculpture of a Snake's Head Fritillary flower. Logan also created outsize flowers for Thea Porter's shop and Big Biba's roof garden.

Dolls, as well as sculptor Andrew Logan, whose Alternative Miss World contest, a surreo-kitsch pageant inspired by the Crufts dog show, was open to 'either gender, all sexes and any sexuality'.

Camp's gender games, as Sontag pointed out, included an irony-laden 'relish for the exaggeration of sexual characteristics…the corny, flamboyant female-ness of Jayne Mansfield [and] Jane Russell; the exaggerated he-man-ness of…Victor Mature'. This was again prophetic: a sub-theme of the burgeoning kitsch craze (which paralleled pop style's assault on 'good' taste) was a 1940s and 50s revival, which, early in the decade, mainly paid homage to the ultra-artificial glamour and pneumatic sexuality of Alberto Vargas's pin-ups or recalled the Charles Atlas-like beefcake of Richard Hamilton's collage, *Just What Is It That Makes Today's Homes So Different, So Appealing?* (Incidentally, Ferry had studied painting at Newcastle University under Hamilton, who was interested in Hollywood movies from the 1940s and described his own urbane brand of Pop Art as 'multi-allusive'.) Waters and his leading lady, the acid-tongued drag queen Divine, idolized Mansfield, while Roxy Music's costumier, fashion designer Antony Price, dreamt up the Vargas-esque usherette outfit worn by model Kari-Ann Muller on the cover of Roxy Music's eponymous debut album of 1972. 'In the 70s, I liked curvaceous, womanly women,' says Price.

According to Sontag, camp was the antithesis of essentialism, along with its reactionary belief in the authentic, the natural, and the idea that gays, straights, men, women and different races are innately different: 'Camp sees everything in quotation marks. It's not a lamp, but a "lamp"; not a woman, but a "woman". To perceive Camp…is to understand Being-as-Playing-a-Role. It is the farthest extension, in sensibility, of the metaphor of life as theatre.'

LOOKS, LOOKS, LOOKS

In the 1970s, the ultra-mercurial, fashion-obsessed David Bowie and Bryan Ferry, who affected a dizzying succession of musical styles and personae (Bowie as Major Tom, Ziggy Stardust, The Thin White Duke; Ferry as futuristic Teddy Boy, 40s GI, white-tuxedoed Bogart in *Casablanca*), embodied an anti-essentialist interest in role play and reinvention. 'In Roxy Music you could have personae, rather than a group of hippies doing this hippie thing that they were stuck with,' remembered Nick de Ville, art director of many of Roxy Music's and Ferry's own album sleeves, in Michael Bracewell's history of Roxy Music, *Re-make/Re-model*. 'There was the idea that you could be something, then something else, then something else.'

Sontag's take on camp, therefore, presaged the rise of Postmodernism in the 1970s – in the sense of stylistic

eclecticism and the sophisticated quoting of styles, which Roxy helped pioneer. 'The early songs were very collage-like… I'd throw different styles of music into the same song,' Ferry said in *Re-make/Re-Model*, adding 'I wanted each sleeve, album or song to have a different mood.' Roxy Music's fascination with artifice also manifested itself in keyboard player Brian Eno's experimentation with synthesizers and his antipathy to the 'sincerity' of the blues. Wrote Bracewell, 'Eno identified that Roxy…stood in opposition to the taste for musical, stylistic "authenticity" which prevailed during the early 70s.'

Bowie and Ferry's relentless turnover of images (a mood captured by Bowie's 1971 single 'Changes', as well as Sparks' 1975 hit, 'Looks, Looks, Looks'), and the use of electronic effects by both Brian Eno and Bowie (who collaborated on the latter's Kraftwerk-inspired albums *Low*, *Heroes* and *Lodger*), anticipated the New Romantic movement of the late 1970s. Its straddling of past and present – the plundering of pre-20th century fashions juxtaposed with futuristic synth-pop – was surely inspired by Roxy's retro-futuristic music and stage wear.

Such an existentialist manipulation of image might at first have seemed arcane, but it quickly rubbed off on young fans, inculcating in a new generation an acutely self-conscious appreciation of style – and the freedom to dress exactly as they chose. 'What my generation learned from Bowie was the idea of rotating one's own image,' remembers graphic designer Peter Saville. 'We were no longer what God told us to be – we could engineer our own identity.'

BOTTLE-BLONDS HAVE MORE FUN

The paragon of camp was Andy Warhol, whom avant-gardesters, in particular Bowie, considered the acme of cool. In his peroxide fright wig, Warhol was a human beacon of artifice, once intoning, 'I don't know where the artifice stops and he real starts.' A pop artist who had reacted against the soul-searching sincerity peddled by the Abstract Expressionists, Warhol was no solitary, earnest artist, but gregarious and worldly, creating artworks that invoked a production line, not blood, sweat and tears. He and other members of his studio, The Factory, convened almost nightly at über-hip New York joint Max's Kansas City and later at the Dionysian disco, Studio 54. During the 1970s, Warhol swapped his boho image for an anti-romantic, entrepreneurial agenda. 'I started as a commercial artist and I want to finish as a business artist,' he said. 'Making money is art…and good business is the best art.'

By consorting with drag queens – from Jackie Curtis to Holly Woodlawn (namechecked on 'Walk on the Wild Side') – Warhol championed a super-stylized androgyny. He was obsessed with self-reinvention and the (ironic) fabrication of

FIFTIES FANCIERS Having moved to Paris in 1970, Donna Jordan's brash Hollywood-starlet sexiness thrilled the city's beau monde *(opposite)*. She hung out with Karl Lagerfeld, hip illustrator Antonio Lopez, and – snapped by Guy Bourdin – modelled for French *Vogue*. Malcolm McLaren and Vivienne Westwood in their shop Let It Rock *(right)*, which opened in 1971. Simulating a living room from the 1950s, Let It Rock was a seminal example of the revival of that decade. Westwood wore drainpipes, winkle-pickers and mohair sloppy-joe jumpers, while the shop supplied the clothes for rock 'n' roll tribute movie, *That'll Be the Day* (1973). Initially inspired by the British Teddy Boy subculture, McLaren and Westwood sold vintage 1950s togs, but soon became disillusioned with the movement's conservatism. In 1972, they renamed the shop Too Fast to Live, Too Young to Die in celebration of a raunchier facet of the 1950s: James Dean and Britain's 'ton-up boys' (leather-clad bikers).

fame, and anointed several Factoryites 'Superstars', including the models Jane Forth and Donna Jordan, fast-tracking them to Hollywood-style stardom. Alabaster-skinned Forth plucked her eyebrows so severely that only two antennae-like dots grew back, while Jordan acquired an albino-white 'do overnight and squeezed into skintight dresses like her idol, Marilyn Monroe.

Bowie wrote a song about Warhol on his album *Hunky Dory*, and was a huge fan of the New York production of Warhol's play, *Pork*. Its cast of freaks – including the cross-dressing Wayne County and Cherry Vanilla (both future punk stars) – inspired Bowie, aided and abetted by his bottle-blond, fashion-forward wife Angie, to drop his fey, long-haired image for his ultra-glam, overtly ambisexual alter ego, Ziggy Stardust. Waters, too, was a massive fan; the weirdo members of his company, Dreamland Films, recalled Warhol's far-out Factoryites.

SISTERHOOD IS POWERFUL! GAY IS GOOD!

Such loosening of gender stereotypes could not have occurred without the radical social changes spearheaded by the women's and gay liberation movements. In the early 1970s, gay men and lesbians allied themselves with feminists in solidarity against sexism, which they believed perpetuated patriarchy. Indeed, the women's movement was in large part sparked by a realization that traditional women's roles had not been altered by sexual liberation. 'I began asking "Whose liberation was it?"' remembers the artist Margaret Harrison. 'Women were still washing the dishes, making the coffees during the revolution.'

'Echoing women's liberation, the lesbian and gay liberation movement – which emerged in the wake of the Stonewall riots in New York in 1969 – identified straight male machismo as a source of oppression and challenged it,' says gay rights activist Peter Tatchell, who in 1971 joined the UK's militant Gay Liberation Front, which was formed in 1970. The black civil rights movement was another influence on gay liberation: 'Inspired by the Black Power slogan "black is beautiful", we came up with a little slogan "gay is good", which was hugely self-affirming, challenging the dominant view that homosexuality was mad, sad and bad.'

Biological determinism, with its view that traditional gender differences were shaped solely by nature, not conditioning, was considered increasingly suspect. After the social shake-up of the late 1960s, the nuclear family held less sway. Platonic relationships between members of the opposite sex were more common. As evidenced by a widespread fascination with Bowie's unapologetic androgyny and alleged bisexuality, a dawning acceptance of gay culture could be felt in mainstream, heterosexual culture – even among such ostensibly laddish glam-rock bands as Sweet and Slade.

SEMIOTICS AND STYLE

In the 1970s, the nurture-not-nature argument was validated by a burgeoning interest in semiology. It was hardly surprising, since this field of linguistics believed that the relation between words and the things they described was arbitrary and artificial, as Ferdinand de Saussure had posited early in the century. *Mythologies*, a landmark book on the subject by the Marxist literary critic and social theorist Roland Barthes, was translated into English in 1972, thereby bringing semiology to a much wider audience. Barthes argued that the assumption that language is natural masks the fact that it is ideologically loaded, upholding bourgeois values, and analyzed how apparently innocent aspects of pop culture (like toys and fashion) covertly endorsed gender-stereotyping or racism. Like fellow semiotician Umberto Eco, Barthes encouraged the convergence of academia and pop culture, which in turn opened the floodgates to the trend for cultural studies. Judith Williamson's *Decoding Advertisements* (1978), for example, unpicked the ideological messages underlying supposedly neutral adverts.

Simultaneously, street fashion and style were seen as worthy of academic study or intellectual discussion. In 1975, London's Institute of Contemporary Arts held a 'Fashion Forum', where

UNPICKING THE PIN-UP Margaret Harrison's lithograph *Take One Lemon* (the title referenced a catchphrase from the popular radio programme, *The Jimmy Young Show*) was informed by the comic books of Eric Stanton and Robert Crumb and examined 'preconceptions of fixed sexuality and the media's equation of women with food' *(opposite, left)*. Not exactly feminist but equally conscious of the idea of a constructed and artificial sexuality was the cover of Roxy Music's debut album *(opposite, bottom)*. Two out and proud men at the 1975 Castro Street Fair in San Francisco's unapologetically gay district *(opposite, right)*. The fair was founded in 1974 by Harvey Milk, the first openly gay person to be elected to public office in California; Milk was later assassinated in 1978, along with San Francisco Mayor George Moscone. An illustration from the early 1970s by Kasia Charko for Biba bridges the Deco and 50s revivals *(right)*.

ultra-conceptual fashionistas McLaren and Westwood, Rae Spencer-Cullen of the label Miss Mouse, and Paul Howie, co-owner with Lynne Franks of Covent Garden boutique Howie, pontificated about their clothes. In his 1979 book *Subculture: The Meaning of Style*, sociologist and media theorist Dick Hebdige subjected various trends, including punk, to semiotic scrutiny.

LE TOUT PARIS, LONDRES, MILAN ET NEW YORK

In 1976, Peter York wrote an article called 'Them' for *Harpers & Queen* – a wry, trenchant survey of London's achingly arty elite, or 'Thems'. Jack Hazan's cult film *A Bigger Splash*, a 1974 documentary on the life of David Hockney, incorporated footage of *the* mandatory Them get-together, the Alternative Miss World contest. Judges of the 1975 pageant included the crème de la crème of Them society: Hockney, Celia Birtwell and scenester Gerlinde Costiff (wife of designer Michael Costiff). Other Thems included Rae Spencer-Cullen, Zandra Rhodes, Bryan Ferry, Duggie Fields, model Amanda Lear, painter Luciana Martinez, actress Little Nell and interior designer John Stefanidis.

Paris had its Thems, too (Yves Saint Laurent, his muse Loulou de la Falaise, Paloma Picasso, Karl Lagerfeld), as did Italy (Walter Albini, Anna Piaggi). By the late 1970s, New York was the world's hippest city; among its own in-crowd numbered Warhol, Liza Minnelli, Bianca Jagger, Halston. York's analysis of Thems tallied with Sontag's observation: 'Camp is esoteric… a private badge of identity even among small urban cliques.' Describing Thems as 'part of a mysterious aesthetic conspiracy',

York mused that if the different groups were to encounter each other, 'each would have read the other's code… Thems are excessively literate in the language of style.' He attributed this rarefied sensibility to 'the art school bulge' – stating that between the early 1960s and the early 70s the numbers of students attending art school rose by 70 per cent, and to the newly exalted status of fashion.

The one-step-ahead-of-the-pack look of the Thems provided an infallible barometer as to which fashions were about to become the dernier cri. As York pointed out, Thems prided themselves on their 'stylistic originality', which was ironic given how hip Postmodernism was at the time (although Thems would have claimed to have been the first to have alluded to this or that past style). Yet in the 1970s, the mainstream and avant-garde were so polarized that it took years for ideas to filter through. 'The media was less sophisticated then,' says York. 'There were fewer structures to communicate new ideas. There were also less cool-hunters.'

York divided Thems into two types: 'Exquisites', who were preternaturally well-dressed, more chic than out to shock (they favoured minimalism and Chinoiserie), and 'Peculiars', whose edgier looks bridged kitsch and punk. The latter were proof that punk had been bubbling up for years. In the early 1970s, tell-tale signifiers of the proto-punk style were fake leopard-print, cat's-eye sunglasses and stilettos, drainpipes, luridly dyed hair, jelly sandals. The Peculiars' ultra-artificial demeanour broadcast their distaste for mainstream hippiedom. They 'didn't go for Martini people's tans', wrote York, and they made 'the supreme sacrifice: to look sexy rather than interesting'.

COGNOSCENTI OF KITSCH

Kitsch partly thrived because the decade's art school-educated sophisticates had left behind their middle-class backgrounds and acquired an independence that allowed them to re-evaluate their parents' stock-in-a-time-warp, post-war taste. They saw the comic side of Tretchikoff paintings and flying ducks. (Woolworths was a favourite Them shop.) 'I've always loved kitsch for its humour – such a relief from serious design,' says Dan Klein, a glass-art specialist who collected glass from the 1950s when hardly anyone else did. 'The 70s kitsch cult was a form of inverted snobbery.'

Certainly there was an element of inverted snobbery to it. But just as the Fluxus and Arte Povera movements of the 1960s and 70s made art out of cheap, throwaway materials, the kitsch craze sprung from keeping an open mind about aesthetics. 'In the late 1960s, I was trying to avoid the then fashionable Art Nouveau revival,' says Duggie Fields. 'I wanted to challenge my taste. The things that caught my eye, that stood out, happened to be from the 1950s.'

Bevis Hillier's 1975 book *Austerity/Binge* about the applied arts of the 1940s and 50s and kitsch helped put these revivals on the map, although only a minority appreciated them since they were more 'difficult' than the straightforwardly elegant Bibataste. 'It was a harder aesthetic for people to accept,' says Hillier, calling the look 'spiky'. Yet, according to Hillier, its roots were more populist that those of Art Deco: 'Fifties culture was more about what came from below, as opposed to 1920s and 30s taste, which was dictated from on high. With 50s culture, young people were setting the tone rather than a designer dictating from above.' For John Waters, it was the white-trash aspect of 50s style that appealed.

FROM JUNK TO PUNK

Punk, too, was tinged by inverted snobbery, but what made this international movement seem new was that it was relatively realist and grounded in the present; it rejected the escapism of the Deco revival and the back-to-nature movement. 'Punk was about saying yes to the modern world,' said Mary Harron, a journalist for *Punk* magazine, in Jon Savage's history of the movement, *England's Dreaming*. 'Punk, like Warhol, embraced everything cultured people and hippies detested: plastic, junk food, B-movies, advertising, making money.'

Punk was an urban phenomenon. Savage, in his book *Punk – No One is Innocent*, explored the link between punk and 1970s London, when the recession had stalled the city's regeneration. 'The hippies had advocated removing themselves to the country: the very early punks celebrated the dead cities that they would revive through the force of their vision.' Punk's genesis had fetishized working-class subcultures as well as the marginalized, and thus created a social context for the trash aesthetic described by Hebdige in *Subculture*.

SLASHED AND DECONSTRUCTED Seen on the cover of his 1977 album *(opposite, left)*, Richard Hell sports the choppy haircut which, according to Malcolm McLaren, influenced the Sex Pistols' style, along with Hell's slashed, safety-pinned clothes and body daubed with doom-laden poetry. His look derived from the notion of the *poète maudit* associated with Verlaine and Rimbaud (Hell took his name from Rimbaud's *A Season in Hell*). A T-shirt from McLaren's boutique Sex *(opposite, right)*, lambasted the mutually congratulatory world of 1960s has-beens, while Patti Smith's men's ties and dishevelled hair helped pave the way for the androgyny of female punks *(left)*. In 1977, *L'Uomo Vogue* featured this suit for the 'modern man' by Giorgio Armani, a stylist for the magazine and one of the new stars of Italian fashion *(right)*. Its loose, unstructured style paralleled the *Annie Hall* look and anticipated Richard Gere's Armani-designed wardrobe in *American Gigolo* (1980).

Having changed the name of their boutique from Let It Rock to Too Fast to Live, Too Young to Die, McLaren and Westwood sold biker-inspired T-shirts bizarrely incorporating chicken bones, zips and bike tyres. The startlingly synthetic look and delinquent-chic ethos of the shop's next baldly named incarnation, Sex, created a haven for misfits who felt alienated from (or bored by) dully mainstream hippiedom. Punk was a magnet for gays, rent boys, fashion victims and assertive, eccentric women – witness the Warholian, style-obsessed Bromley Contingent, hardcore Sex Pistols fans who included Siouxsie Sioux and the androgynous teenager, Berlin.

Hebdige's use of the term 'self-conscious' to describe punk style is key. Early punk style was contrived, considered, arty. It was articulately inarticulate: punk clothing – as modelled by the Sex Pistols, who were dressed by Sex and its successor, Seditionaries – embraced a collage of unrelated images (Karl Marx, gay porn, swastikas, anarchy symbols), which, to the uninitiated, were bafflingly cryptic.

In the hands of McLaren and Westwood, punk was media-aware, confrontational, and aimed to be epoch-making. It sought to differentiate itself sharply from the past by lambasting the sacred cows of the day. In 1974, McLaren, Westwood and future Clash manager Bernard Rhodes created a T-shirt that boasted 'you're gonna wake up one morning and know what side of the bed you've been lying on!' – a take-no-prisoners proto-punk manifesto that spelled out the pet hates and likes of the McLaren/Westwood camp in no uncertain terms. Aptly, given punk's nihilism, the list of hates was far longer than the list of likes. The former took potshots at Deco revivalism and many Thems, whom they considered cultural dinosaurs. Their heroes, a roll-call of outlaws and minorities, included Ronnie Biggs (the Great Train Robber), Jamaican rude boys (an acknowledgment of punk's passion for reggae), Valerie Solanas (the radical feminist who shot Warhol), and gay playwright Joe Orton.

McLaren, who had attended a string of art schools, had soaked up the ideas of the Situationists, who in the 1950s and 60s had railed against institutionalized leisure and the commodification of culture, and whose anti-capitalist slogans had been adopted by Parisian students in May 1968. McLaren was particularly in thrall to a British scion of Situationism called King Mob, which was inspired by Dada, as were New York's punk fraternity. While British punk iconography focused mainly on working-class subcultures, gritty urban imagery and 20th-century anarchists, New York's artier punks were obsessed with the late 19th-century Decadent, Aesthetic and Symbolist movements, which deemed artifice superior to nature: Patti Smith, her one-time lover Tom Verlaine, and Richard Hell idolized poets Paul Verlaine and Arthur Rimbaud, as well as Joris-Karl Huysmans, author of the novel, *A rebours*.

But for all its elitism and artiness, punk was swiftly democratized by its bands and their fans. Not only were punk musicians not expected to be technically proficient, but punk's DIY style of dress was egalitarian: easily accessible, cheaply reproducible. 'Westwood and McLaren were elitist, but not in a class way,' remembers Savage. 'It was about what you could bring to the table in a creative sense. The idea was to do something that hadn't been done before.'

KITSCH PICKINGS Duggie Fields in his flat in London's Earl's Court in the mid-1970s *(left)*. Originally shared with Pink Floyd's Syd Barrett, the flat had an original 1950s sherbet-yellow bathroom, mannequin legs used as vases filled with pre-Dame Edna gladioli, lino floors with Jackson Pollock-style drip patterns, artist's palette-shaped coffee tables, and lampshades adorned with gambolling poodles. Fields scoured jumble-sales (a craze among his friends) and Portobello Road market for 50s paraphernalia. The London home of Zandra Rhodes and her then boyfriend Alex McIntyre, who co-created the corrugated plastic table and column *(below, left)*. Rhodes's pad also included plastic wisteria, a PVC-encased television, a fake parrot and an apple-shaped ice bucket. *The Rocky Horror Show*'s set designer, Brian Thomson, championed kitsch in his home, with its (partially askew) Hilda Ogden-style flying ducks *(opposite)*. The Union Jack details were part of the anti-Silver Jubilee mickey-taking that was rife in 1977 among London's arty brigade.

MONDO TRASHO

In defiance of hippie culture's insistence on the natural and homespun, and bent on pushing boundaries in terms of style, many a 70s hipster embraced brassy artifice and kitsch. This iconoclastic trash aesthetic was celebrated in a book devoted to left-field homes, *Underground Interiors*, which quoted Marshall McLuhan's observation in his own, earlier work, *Through the Vanishing Point*, that 'good taste is the first refuge of the non-creative'. Avant-gardesters were early adopters of an accompanying, nascent 1950s revival – evident in such films as *American Graffiti* and *Badlands* and in bands like rock 'n' roll revivalists Sha Na Na (who, ironically, performed at Woodstock) – which relished the tawdry but vibrant vulgarity of post-war materialism so despised by hippies. The proto-punk trends for 50s retro and kitsch were lapped up by dedicated followers of avant-garde fashion and interiors.

MONDO TRASHO

TASTE-SHAKERS Trevor Myles, the first retailer to import used American clothing to the UK, seen outside his shop, Paradise Garage, which he opened in 1970 after parting company with his Mr Freedom partner, Tommy Roberts *(left)*. The Tiki bar-style exterior, tiger-print Mustang parked outside, 50s gasoline pump and vintage American clothing (Hawaiian shirts and *straight-legged* Levi's) influenced Malcolm McLaren, whose Let It Rock occupied the same premises the following year. Andrew Logan (in top hat), model Cindy White and stylist Sharman Forman with London hairdresser Keith Wainwright *(below)*, who, from 1969, revolutionized hairdressing with his unisex salon Smile, ditching rollers in favour of more relaxed hairstyles and introducing the idea of half-hour appointments. Roxy Music's Brian Eno sports an extravagant cockerel feather ruff made by his then girlfriend, the ceramicist Carol McNicoll *(below, left)*.

MONDO TRASHO

QUEENS OF SLEAZE Divine as Babs Johnson in the 1972 film, *Pink Flamingos (left)*. Babs, who lived in a trailer with plastic pink flamingos outside, ate poodle poo to stake her claim as 'The Filthiest Person Alive'. Her rivals, Connie and Raymond Marble, sported proto-punk red and blue hair. 'I've always tried to…satisfy an audience that thinks they've seen everything,' wrote director John Waters, 'to force them to laugh at their ability to still be shocked.' In 1973, stylist Pru Walters put together this look *(above)*, featuring a T-shirt made of a 'Kandinsky-inspired' fabric by Duggie Fields for Courtaulds. The whole ensemble – ripped clothing, beret (later sported by Johnny Rotten), cat's-eye specs and shock value – was extraordinarily ahead of its time.

AVANT GARDE

MONDO TRASHO

"If you don't see what you want, ask for it"

TO DYE FOR Out-there haircuts by Keith Wainwright at Smile, who pioneered the use of Crazy Colour (willing guinea pigs included his client Elton John), inspired by the 'reflections of coloured light on people's hair seen on *Top of the Pops*' *(far left)*. The dauntless extrovert Zandra Rhodes, seen here in 1975 *(top, left)*, herself had her hair coloured countless shades (fuchsia, petrol blue, shocking pink) by Daniel Galvin at in-crowd crimpers, Leonard. Warhol 'superstars', the albino-haired Donna Jordan and Pat Cleveland *(left)*. The late 1970s saw a fad for postcards – sold notably at Fiorucci – which relished an ultra-camp aesthetic *(above)*. Little Nell – who played the groupie Columbia in the stage production of *The Rocky Horror Show* from 1974, and later in its celluloid version – in her favourite early 70s gear: the rubber fetish wear-as-fashion sold at Sex *(opposite)*. Normally sporting a lairy Titian bob, she also modelled for Zandra Rhodes.

AVANT GARDE

MONDO TRASHO

AVANT GARDE
179

40S SWEETHEARTS, 50S VAMPS

The ultra-hip embraced the strict silhouette of 1940s fashion, including Paloma Picasso, who shopped at Johnny Moke's Hollywood Clothes Shop, which sold 40s-style, 'square-shouldered' clothes, and was said to have influenced Yves Saint Laurent's 1940s-inspired collection of 1971. Post-Mr Freedom, Tommy Roberts's boutique City Lights Studio stocked wedges and mannish suits. For many, the Second World War was still within living memory, and a raft of books and films fuelled the fascination. The late 1970s saw a revival of cinched-waist suits, pillbox hats and court shoes (think Elaine Paige in *Evita*), while 50s fever went mainstream, propelled partly by the death of Elvis Presley in 1977 and the release of *Grease* in 1978. Cue high-street versions of spray-on jeans, stiletto mules and bobby sox.

Long distance? Depends how I feel
Satin and lace bra and matching French knickers, by Janet Reger, £3.70 each

MAY THE FORCES BE WITH YOU Top fashion photographer Hans Feurer parodied Vargas in *Nova* in 1972 *(left)*. Bette Midler's 1973 album *(above)* featured a cover version of the Andrews Sisters' hit 'Boogie Woogie Bugle Boy'; the star of New York's gay Continental Baths was partial to 40s sweetheart necklines. Cockette Rumi Missabu in Michael Kalman's 40s-retro underground movie, *Elevator Girls in Bondage*, in 1971 *(opposite, top left)*. An early 70s jacket by Antony Price *(opposite, right)*, whose military style echoes Bryan Ferry's 1975 GI look. Wartime fashions also featured in this 1974 collection by Bill Gibb *(opposite, bottom left)*. This 1975 textile is by Argentinian-born, Barcelona-based graphic designer America Sanchez, and was created for the city's design shop, Vinçon *(opposite, background)*.

AVANT GARDE

40S SWEETHEARTS, 50S VAMPS

VIVE LE ROCK Jean-Bernard Cardon and Alain Ménard's cult shop Les Messageries *(opposite)*, in Paris's Les Halles, one of many vintage stores (another was Pendora de Luxe) that colonized the area when its fruit and veg market moved out in 1971. It sold 1940s and 50s American vintage clothing, pinball machines and jukeboxes. (Sotheby's in London began auctioning the latter in the 1970s.) 'Our customers included Paloma Picasso and Katharine Hamnett,' remembers Cardon, 'and Saint Laurent sent his assistants to buy things.' Paris had a vintage car-loving subculture: in 1978, French *Elle* reported on a monthly market that sold 1950s Cadillacs and Ford Thunderbirds on the Place de la Concorde. Teds rock around the clock at the Skinner's Arms pub in Kennington, London, in 1975 *(above)*, while in Paris, a young hipster sports 50s gear from Les Messageries *(left)*. A 1974 poster designed by Philippe Morillon for a musical comedy, set in the 1950s, by François Wertheimer *(far left)*.

40S SWEETHEARTS, 50S VAMPS

FIFTIES DELUXE Duggie Fields's passion for 1950s fashion and design also permeated his canvases of the 1970s, which were filled with 50s vamps and homoerotic studs, as seen in his *Acquired Mannerisms* of 1973 *(top)*. Its title spoke volumes about the avant-garde's infatuation with artifice. His jumbling of high-art influences (Miró, Mondrian, Arp) with pop culture prompted *Artscribe* magazine to dub him a Postmodernist. Karl Lagerfeld's ladylike 50s-inspired spring/summer 1979 collection for Chloé, published in *Stern* magazine, in a story about the influence of artists such as Henri Matisse and Oskar Schlemmer on the collections that year *(right)*. It was shot by Peter Knapp, who was French *Elle*'s dynamic art director for much of the 1970s, commissioning photographers like Fouli Elia and Oliviero Toscani. As early as 1972, the 50s-looking stiletto made a comeback, courtesy of Manolo Blahník *(above)*, sounding the death knell for clodhopper platforms.

AVANT GARDE
184

40S SWEETHEARTS, 50S VAMPS

HOMAGE TO HITCHCOCK Roxy Music's 50s-phile Bryan Ferry, who had a photograph of Kim Novak (the star of Hitchcock's film *Vertigo*) on his piano, in 1973 *(above)*. In 1972, the *Guardian* reported on Roxy: 'They come on – with reference to Sha Na Na and Dan Dare – in gold lamé trousers, mock leopardskin and Brylcreem,' and quoted Ferry, who said that the band's look was inspired by '50s science fiction movies like *The Day the Earth Stood Still*'. A photograph from Cindy Sherman's 1978 series, *Untitled Film Stills (right)* – an example of the interplay between feminism and Postmodernism in the 1970s – in which she impersonated the stereotypical female roles of 1950s B-movies.

AVANT GARDE

ANDROGYNE SCENE

Androgyny and sexual ambiguity thrived on an international scale as rigid sexual stereotyping was increasingly flouted. The movie *Performance* flagged up the phenomenon; *The Rocky Horror Show* aired the still taboo subject of transvestism; and the film *Dog Day Afternoon* and regular press profiles on sex-change icons April Ashley and Tula, a future Bond girl, drew attention to transsexualism. Rock and pop stars helped legitimize the new epicene chic, from David Bowie and the New York Dolls to Patti Smith and Amanda (is she Martha or Arthur?) Lear. Even the token camp exhibitionists in firmly blokeish bands like Mud, Sweet and Slade were lavish with the lip gloss and glitter. In the US, the Cockettes and Cycle Sluts donned kitsch, unorthodox drag, while Paris had its hip drag posse, Les Gazolines.

GENDER-BLENDERS The back cover of Lou Reed's 1972 *Transformer* album *(top, left)* hammed up extreme gender stereotypes: the woman was model Gala Mitchell, the man one Ernie Thormahlen, posing as a Tom of Finland-esque caricature of masculinity. The New York Dolls, seen here on the cover of their 1973 album *(top, right)*, sported trashy, trannie make-up, teased bouffant hairdos and Spandex pedal pushers. Singer David Johansen, when asked if he was bisexual, quipped, 'no, man, I'm trisexual, I'll try anything.' Mick Jagger as the androgynous, bisexual rock star Turner in the 1970 film, *Performance (above)*. Cockette member Wally, who starred in the troupe's 1971 show, *Tinsel Tarts in a Hot Coma (left)*. Tim Curry as Dr Frank N. Furter in *The Rocky Horror Show* in 1974 *(opposite)*.

AVANT GARDE

ANDROGYNE SCENE

CROSS-DRESSED TO IMPRESS French transsexual Marie-France in 1973 at the Paris launch of Guy Peellaert and Nik Cohn's *Rock Dreams*, which featured fantasy portraits of rock 'n' roll legends *(left)*. She impersonated Marilyn Monroe at the city's drag venue, L'Alcazar, and was part of Les Gazolines, who bought their 50s drag from Pendora de Luxe; other members included Maud Molyneux, Hélène Hazéra and Michel Cressole. Crop-haired Grace Jones, seen here on the back cover of her 1978 album, *Fame (opposite, top)*, had a huge gay following at New York club, Les Mouches. Amanda Lear in 1973, on the cover of Roxy Music's album *For Your Pleasure (opposite, bottom)*, was said to have been born a man. Lear didn't shy away from the myth, archly doing a striptease for a piece called 'How to undress in front of your man' for *Nova* in 1971. Some suggested that her name contained a clue: A Man, Dear. Artist Eddie Cairns with drag queen-about-town Jasper in London in 1977 *(below)*.

ANDROGYNE SCENE

AVANT GARDE

OUT OF THE CLOSET, INTO THE STREET

In the 1960s, gay and lesbian liberation was dominated by the polite reformism of such organizations as America's Mattachine Society. It wasn't until the following decade, in the wake of the Stonewall riots, that the movement truly took off. On the world's first Gay Pride Day, in 1970, around 10,000 gay men and lesbians marched up New York's Sixth Avenue. By 1971, gay liberation groups had sprung up worldwide, from FHAR in France to F.U.O.R.I! in Italy. For those who had spent decades in the closet, 'coming out' – with its self-affirming slogans like 'Avenge Oscar Wilde' and 'Lesbians ignite!' – was seen as a potent antidote to repression and an expression of much-needed solidarity.

OUT AND PROUD Artist Delmas Howe's *Study for the Flagellation*, which he began painting in the early 1990s, is based on memories of gay orgies that took place in the 1970s in New York's West Village *(top, left)*. The San Francisco's Gay Men's Chorus, which was founded in 1978, at the city's Gay Pride parade the following year *(top)*. Jubilantly self-affirming Dykes on Bikes *(above)* – the term was coined in 1976 and put into practice in 1977, the year this picture was taken at the Gay Pride parade. Gay leather men at London's Rainbow Theatre in the late 1970s *(left)*; one of the most popular leather bars in London was the Coleherne. Jobriath, the world's first openly gay pop star *(opposite, top)*, whose naked torso was sprawled across a billboard in Times Square. Alternative, satirical, political drag group Bloolips, founded by Bette Bourne and Paul Shaw in the late 1970s, performing in London *(opposite, bottom)*. In drag made out of junk, they debunked conventional gender roles and criticized the arms race and mindless consumerism.

AVANT GARDE

IN WITH THE IN-CROWD

A tight-knit community of ultra-glamorous aesthetes – in London, Paris, New York and Milan – trailblazed the decade's key trends. This multicultural style elite's influence was proof that in the 1970s these cities were becoming more cosmopolitan and less insular and xenophobic. A new wave of Japanese fashionistas, including Kenzo Takada, Kansai Yamamoto and Issey Miyake, challenged the age-old hegemony of home-grown Paris fashion, while the so-called 'Beautiful People' (dubbed 'Thems' by Peter York) embodied the increasingly permissive spirit of the decade, partying at such hangouts as Club Sept, Régine's and Le Palace in Paris, Studio 54 in New York, and Yours or Mine and The Embassy in London, their sybaritic lifestyles chronicled in magazines like Andy Warhol's *Interview* and UK style rags *Ritz* and *Deluxe*.

THEM

WHAT'S THIS? WHO'S THEM?
Well, you know one when you've seen one.
THEMs are a happy breed of aesthetes who live by style.
They wear clothes that knock your eye out.
They are born out of Art School by Rock Generation.
They are nearly all (men and women) twenty-nine years old.
They work in the art trade or the rag trade,
making clothes or music or money.
PETER YORK, whose observance of style is getting beyond a joke,
tells you everything you need to know about THEM

CRÈME DE LA THEM An early 1970s Themmy get-together, photographed by Ulla Larson-Styles, one of the decade's 'Beautiful People' *(opposite)*. Guests included Andrew Logan, Ossie Clark (in bow tie), Manolo Blahník, fashion designer Edina Ronay, Bianca Jagger and textile designer Eric Boman, also an illustrator and photographer for *Vogue* and *Ritz*. A soirée at Mr Chow, a Them mecca in London's Knightsbridge, in 1975 *(top)*. At the party were Tim Street-Porter, Andrew Logan, Zandra Rhodes, Duggie Fields and, on the far right, Blahník. Argentinian-born, London-based fashion duo Pablo and Delia *(left)*, whose romantic clothes were championed by *Vogue* fashion editor Grace Coddington and stocked by London boutique, Boston 151. Artist Kevin Whitney in front of a portrait of his friend and fellow artist, the late Luciana Martinez, an ultra-flamboyant icon of the 1970s, who sported black rubber catsuits and white fur stoles *(far left)*. Punks loved Luciana, who also starred in Derek Jarman's film, *Jubilee*: 'The Sex Pistols would come round to our house in Earl's Court for dinner,' remembers Whitney. Peter York's seminal article, which detailed the minutiae of these aesthetes' recherché taste *(above)*.

AVANT GARDE

IN WITH THE IN-CROWD

ace goodbyes

We ruled the Glitter Decade 1975-1984. Thanks to all you wonderful sparkling Lords and Ladies of the night.

MARIANNE FAITHFUL THE VESTEYS PRINCESS OF WALES ROMAN POLANSKI JOAN COLLINS NED RYAN LIZ BREWER JERRY HALL PRINCESS MARY OBLENSKY LYNSEY DE PAUL LULU JACQUELINE BISSET CATHERINE OXENBURG RUPERT DEEN JOANNA LUMLEY ROBIN ANDERSON JILL MELFORD PRINCESS ELIZABETH OF YUGOSLAVIA MICHAEL WHITE DAVID OLIVESTONE DIANA RIGG PRINCESS JACKIE HOHENLOHE ARLENE PHILLIPS LADY EDITH FOXWELL LADY SARAH SPENCER-CHURCHILL BILLY IDOL THE JACK DELLAL FAMILY MARQUIS OF BLANDFORD DENISE, LADY KILMARNOCK MARIA AITKEN LORD PATRICK BERESFORD KNIGHT OF GLIN FIONA FULLERTON MICHAEL PEARSON BRYAN FERRY BARONESSES FIONA AND FRANCESCA THYSSEN EARL JERMYN DAVID BOWIE ANITA HARRIS SUE LLOYD KITTY & JOHN BENTLEY BRYAN FORBES EARL OF LUCAN (NOT RECENTLY!) RICHARD NEWPORT JOHN CONTEH TERENCE STAMP MYNAH BIRD FRANCOISE PASCAL RICHARD BURTON GENEVIEVE DE LA MOTTE NICKY HASLAM ROD STEWART MICK JAGGER CHANTAL D'ORTHEZ DR S.R. GOLDING AVA GARDNER LEGS & CO SUZI KENDALL POLLY WILLIAMS VICKI HODGE PETER O'TOOLE DAVID ESSEX BERNIE CORNFELD BRITT EKLAND ANGIE BEST LEIGH LAWSON OLIVER TOBIAS ANOUSKA HEMPEL JILL BENNET YOKO ONO MICHAEL WITHERS ANDREW LOGAN TESSA DAHL CILLA BLACK THIN LIZZY LESLEY-ANNE DOWN LORD KAGAN MARLON BRANDO JANE & JOHNNY GOLD DIANA QUICK EDNA O'BRIEN RODDY LLEWELLYN DUDLEY MOORE BARRY SHEENE LUCY FOX DAVID NIVEN BRITT EKLAND GARY

STRIKING A RHODES POSE Little Nell, modelling a Zandra Rhodes dress, with top 70s hairdresser Leonard *(above)*, who did the hair for Rhodes's 1977 catwalk show at the Pillar Hall in London's Olympia. The Pillar Hall was a key venue for promoting cutting-edge British ready-to-wear fashion, and for attracting foreign buyers. From the late 1970s, the Individual Clothes Show, co-organized by Lesley Goring and Wendy Booth, mounted catwalk shows there for designers like Swanky Modes, Roy Peach, Betty Jackson and Fred Spurr. Andrew Logan, bisexually bisected into a circus-themed 'host and hostess' at the 1978 anti-beauty pageant, Alternative Miss World *(right)*. Contestants went by such heavily ironic monickers as 'Miss Wolverhampton Baths' and 'Miss Crêpe Suzette' (film-maker Derek Jarman, the overall winner in 1975). An ad in *Ritz* magazine to mark the closing of Peter Golding's Ace boutique namechecks many of its jet-set clients *(background)*.

AVANT GARDE
194

IN WITH THE IN-CROWD

COOL AND THE GANG Celia Birtwell and Ossie Clark pictured in their Notting Hill home, in David Hockney's *Mr and Mrs Clark and Percy (top, left)*, the decade's most emblematic Them painting. The boho, pre-gentrification enclave of Notting Hill was home to many a Them in the early 1970s: Manolo Blahník, Mick and Bianca Jagger, and Hockney himself. Hockney and Birtwell were judges at the 1975 Alternative Miss World pageant *(above)*, which was held at Andrew Logan's home in a former warehouse in Butler's Wharf, East London. A previous contest was filmed by director Jack Hazan, who used the footage as a sequence in his arch-Them movie about Hockney and his entourage, *A Bigger Splash* (1974). A Bill Gibb fashion show at the Royal Albert Hall, London, in 1977 *(left)*. Gibb was a guest at the 1975 Alternative Miss World, which York sardonically dubbed a 'hand-knitted Satyricon' in his 'Them' article for *Harpers & Queen*.

IN WITH THE IN-CROWD

CLUB SEPT — 7 Rue Saint-Anne

Club 7 where you can find Yves St. Laurent, Andy Warhol, Rudolf Nureyev, Jackie O, Diana R., Sophia + Karl L., Paloma P., Helmut B., David and Lina B. and many other vedettes.

Claude — Fabrice's right hand man — Runs the show downstairs

Fabrice — Estelle proprietor of the best place "Comme ça" in Paris — "thinks Punk"

Guy — the best disc stylist in Paris

Alexis

Eloy de Llanos Puerto Rican millionettes

"Billy Hall" — Show girl Par Excellence

"Michael Denard" Star of Zizi's New show at the Opera

"Lilian Montevecchio" Folies Bergères answer to Casino's — Zizi's team maire

"Josephine Baker" Now appearing at Bobino

CLUB 7

AVANT GARDE

IN WITH THE IN-CROWD

LA CLIQUE, C'EST CHIC A flyer by Antonio Lopez for Club Sept *(opposite)*. Owned by Fabrice Emaer, it was *the* nightspot in Paris in the early 1970s, but it was democratic: at the bar, the rich were expected to pay for the poor. 'You could be dancing with Yves Saint Laurent, Loulou de la Falaise, Lagerfeld, Kenzo,' remembers Philippe Morillon. Paloma Picasso and playwright Rafael López Sánchez on their wedding day in Paris in 1978 *(above)*. Picasso flitted seamlessly between factions, from London's Notting Hill (Blahník, Hockney) to Paris (Saint Laurent, Lagerfeld) and New York (the Studio 54 set). French style magazine *Façade*, shown here with Catherine Deneuve gracing its cover *(right)*, often featured the scenesters of Emaer's next club, Le Palace, which opened in 1978 and was Paris's answer to Studio 54. Jerry Hall modelling Miyake in 1979 *(far right)*. An über-Them model, her cool status was hugely enhanced by her relationship mid-decade with Bryan Ferry.

AVANT GARDE
197

IN WITH THE IN-CROWD

LE BEAU MONDE Jean-Charles de Castelbajac with Farrah Fawcett-Majors *(left)*; he designed her 'XXS' micro-sportswear in the television series, *Charlie's Angels*. Castelbajac was part of a new generation of prêt-à-porter stars whose work was showcased by the dynamic organization Créateurs et Industriels, founded by designer Andrée Putman and entrepreneur Didier Grumbach, which breathed new life into a hitherto couture-dominated Paris. Other hot designers of the time included Dorothée Bis, Anne-Marie Beretta and Sonia Rykiel. Chantal Thomass and husband Bruce outside their hip Parisian boutique, Ter et Bantine, which opened in 1969 *(below, left)*. Yves Saint Laurent posing outside the London outpost of his Rive Gauche boutique empire, with muses Betty Catroux, on the left, and Loulou de la Falaise *(below)*. A ready-to-wear pioneer since the late 1960s and an advocate of trousers for women, he helped knock the stuffiness out of Paris fashion. Fashion designer Emmanuelle Khanh and her then husband, fellow designer Quasar Khanh in 1979 *(opposite)*. Quasar wowed Paris in the early 1970s with such ideas as a transparent cuboid car. The Khanhs' ultra-functionalist home eschewed fussy detail. The bedroom – a platform carpeted in shocking pink – had sunken areas to denote different functions (for dressing and sleeping), rather than conventional furniture. Emmanuelle's fashions were more romantic: quilted cotton jackets and Romanian-inspired embroidered skirts, stocked by Rykiel's Parisian shop, Laura. Her ivory-coloured glasses, a favourite with 70s chicsters, were her trademark.

AVANT GARDE

AVANT GARDE
200

MINIMAL EFFORT

Often associated with the 1980s and 90s, minimalism in fashion and design was first cultivated in the 1970s. New York arty types pioneered loft-living, occupying clutter-free, former industrial spaces in SoHo, while Andrew Logan and Derek Jarman lived in disused warehouses in East London. Interior designer Ben Kelly, who created the ultra-plain, opaque façade of Westwood and McLaren's boutique, Seditionaries, in 1976, was hugely interested in minimalist art at the time: 'For me, Donald Judd was the big daddy.' Fashion had its minimalists, too, from Jean Muir to Halston. The term was also applied to music circa 1970 by composer Michael Nyman, and was used to describe Brian Eno's 'soundscapes' and the pared-down songs of the Ramones. Even gastronomy went minimalist with chef Michel Guérard's low-cal *cuisine minceur*.

ECONOMY OF MEANS Peter Saville's 'cool' aesthetic underpinned the enigmatic minimalism of Joy Division's 1979 album, *Unknown Pleasures* *(opposite, top left)*. Italian fashion designer Nanni Strada's one-size-fits-all 1973 Pelle dress – sported by top model Marie Helvin *(opposite, top right)* – was minimalist for feminist, anti-capitalist reasons: it decried 'fashion that conforms to an ideal body shape'. Strada's UK counterpart, Jean Muir, also championed minimalism *(opposite, bottom left)*. Interior designer Ward Bennett's pared-down New York apartment in 1979 was a harbinger of the monochrome-loving 1980s *(below)*.

RIP IT UP AND START AGAIN

Punk was part of a slow-burn backlash against psychedelia and its prog-rock legacy: the vainglorious virtuosity of musicians and a tired iconography. The new trend cross-pollinated New York and London outsider chic: Richard Hell's choppy haircut and ripped clothes wowed Malcolm McLaren, while Lou Reed shopped at McLaren's avant-garde boutique, Sex. Originally touting fairly literal versions of Teddy Boy togs, McLaren and Vivienne Westwood soon took a more lateral approach, collaging a ragbag of elements from different contexts and eras in a fresh and innovative way: 1950s 'brothel creepers', winkle-pickers from the 60s, S&M fetish wear, army trews, tartan. But this multilayered, postmodern, androgynous look soon unravelled, splintering into various post-punk styles from neo-Mod to New Romantic.

ANTI-MONARCHY IN THE UK The Queen's Silver Jubilee provided the perfect excuse for anti-royalist piss-taking by Thems and punks alike. Andrew Logan, Duggie Fields and Logan's boyfriend Michael Davis stand before Fields's painting of a semi-beheaded Queen *(above)*, while on the wall behind Johnny Rotten is Jamie Reid's anti-royalist graphic for the Sex Pistols' 1977 single, 'God Save the Queen' *(right)*. The Pistols knew Logan and co (the band performed at Logan's Valentine's Ball in 1976), but, as journalist Jon Savage recalls, 'the two factions were polarized'. Indeed, Sex's 'you're gonna wake up…' T-shirt lambasted many of Logan's ilk. Even so, Peter York wrote in *Harpers & Queen* that the latter 'were much more tied into punk's beginnings than any punk apologists would admit for years'. Street graffiti from 1977, photographed by Jane England *(background)*.

AVANT GARDE

JUBILEE

ALL THE YOUNG PUNKS Derek Jarman's casting Polaroids for his 1977 film, *Jubilee (right)*, which starred punk icon Jordan and featured music by Adam and the Ants. The strong visual identity of The Clash *(above)* was largely created by designers Alex Michon and Krystyna Kolowska. Their tight, paramilitary designs combined distressed blackout fabric and zips. Punk hipster Soo Catwoman *(top, right)* sports a haircut by Smile.

RIP IT UP AND START AGAIN

GENERATION SEX Sid Vicious, who ran with the Bromley Contingent before becoming the Sex Pistols' bass player from 1977, brought his own fashion sense to the band *(left)*. His T-shirt from Sex, complete with homoerotic Tom of Finland-style image, illustrates gay culture's influence on punk, as do the S&M accessories beside Sex staffer Jordan, shown posing in the shop *(below)*. Jordan, Siouxsie Sioux and Gene October of punk band Chelsea frequented lesbian bar Louise's and gay clubs Masquerade, Sombrero and Chaguaramas, which would later become punk venue, The Roxy. Other members of the Sex posse – including Chrissie Hynde, future lead singer of the Pretenders (seen third from left) – pose for sex magazine, *Forum (opposite)*. Westwood's polemic was to challenge the hypocrisy of fetish wear only worn in private: 'I'm interested in people wearing our sex gear to the office.' Jordan did, scandalizing passengers on her commute to London from Sussex in her black vinyl leotards, fishnets and platinum Mr Whippy beehive.

AVANT GARDE

RIP IT UP AND START AGAIN

OH BONDAGE! UP YOURS! William Broad, aka Billy Idol, lead singer of Generation X *(above)*, was one of the Kentish coterie of Sex Pistols followers dubbed the 'Bromley Contingent', which also included Siouxsie Sioux and Steve Severin (of Siouxsie and the Banshees), Philip Sallon, Debbie Juvenile and Bertie 'Berlin' Marshall *(below)*. The group found some notoriety in 1976, after a few of them appeared alongside the Sex Pistols in the tabloid-scandalizing broadcast of Thames Television's *Today* programme, in which Johnny Rotten uttered the word 'shit' and all hell broke loose. An ad for Zandra Rhodes's 1977 Conceptual Chic collection *(right)*, which featured slinky dresses in silk jersey, strategically slashed and pinned with beaded safety pins. Rhodes was accused of jumping on the punk bandwagon, yet had been into this idea after seeing Elizabethan satin bodices with their delicate slashes at the V&A in the early 1970s. Punk fashion's DIY element made it accessible to all, or at least to those with the front to carry it off. Gay London punk Dario *(opposite)* customized a traditional but ripped jacket with a plastic hose, chains, safety pins and nihilism-chic graffiti.

I chose Olympia's Pillar Hall for my June 78 show because it is one of the most beautiful I have ever seen.

LONDON FASHION EXHIBITION, EARLS COURT AND OLYMPIA, LONDON TELEPHONE 01-385 1200

AVANT GARDE
207

AVANT GARDE

DRESSED RIGHT FOR A BEACH FIGHT

The neo-Mod movement was just one strand of a revival of post-war subcultures that exploded in the wake of punk. *Quadrophenia*, the film based on The Who's 1973 album *(opposite, bottom)*, was released in 1979, with some of the clothes supplied by original Mod, Lloyd Johnson, seen here outside his shop Johnson's Modern Outfitters *(right)*. Sixties retro was in the air as early as 1974, as documented by Paris-based scenester Edo Bertoglio, in Ibiza *(opposite, top)*. The late 1970s also witnessed a Ska revival, which paralleled the punk/reggae crossover. Photographer Dennis Morris (who introduced punk band The Slits to reggae producer Dennis Bovell) remembers the punky reggae parties in Ladbroke Grove in the 1970s. 'There was a unity,' he says of the scene. 'The National Front didn't like it. They wanted to create a division.' This interracial solidarity was at the heart of Rock Against Racism, supported by bands like The Specials *(below)*.

SPECIALS

- A MESSAGE TO YOU RUDY
- DO THE DOG
- IT'S UP TO YOU
- NITE KLUB
- DOESN'T MAKE IT ALRIGHT
- CONCRETE JUNGLE
- TOO HOT

- MONKEY MAN
- (DAWNING OF A) NEW ERA
- BLANK EXPRESSION
- STUPID MARRIAGE
- TOO MUCH TOO YOUNG
- LITTLE BITCH
- YOU'RE WONDERING NOW

2 TONE RECORDS

NEW ROMANTIC, NEOCLASSICAL

Towards the end of the decade, those po-faced poseurs, the New Romantics (former Bowie, Ferry and punk fans), perfected their sartorial manoeuvres in the dark in London clubs like Billy's, Blitz and Club for Heroes. More eclectic in their taste than punks, their theatrical attire looked beyond the 1920s and 30s for inspiration, raiding history's dressing-up box for medieval, 18th-century and Victorian ensembles. Celluloid influences on the trend included Stanley Kubrick's 1975 film, *Barry Lyndon*, and Queen Elizabeth I in *Jubilee*. Vivienne Westwood began researching her influential Pirates collection in 1979, which again looked back to the distant past. Romanticism also made a comeback in art and interiors in the late 1970s: neo-expressionist painting usurped conceptual art, while opulent neoclassical furnishings supplanted minimalism, anticipating the 80s vogue for the chintzy and froufrou.

TEUTONIC TONIC Bewitched by Teutonic culture, David Bowie recorded his 'Berlin trilogy' of albums while living in the city under the spell of Kraftwerk. The albums' icy melancholia and bombast influenced much New Romantic music. On *Heroes* (1977), Bowie poses like a figure drawn by his idol, artist Egon Schiele, about whom he planned to make a film in 1978 *(above)*. Bowie wore a haircut like Trevor Sorbie's influential 1974 'do, the 'Wedge' *(above, left)*, in *The Man Who Fell to Earth* (1976). New Romantics and soul boys and girls alike were fans of its swooping fringe. German, New York-based singer Klaus Nomi (a backing singer for Bowie during a 1979 performance on *Saturday Night Live*) cultivated an otherworldly image, belting out operatic songs with synthesizers and donning ultra-stylized, Russian Constructivist-inspired tuxedos *(top, left)*.

CLUBS FOR HEROES Steve Strange at gay club Billy's in London's Soho *(right)*, where he ran a Tuesday-nighter in 1978 with musician and DJ Rusty Egan long before the media coined the term 'New Romantics' (at first they were dubbed 'the cult with no name'). Before that, Strange created artworks for Malcolm McLaren, worked at Covent Garden shop PX and held 'Bowie nights' at different clubs. In 1979, he opened Blitz, which was notorious for its Studio 54-style door policy – Strange barred Mick Jagger, but let Bowie in. Self-expression, the more self-consciously outlandish the better, was a key obsession there – as these two ice maidens testify *(above)*. Regulars included Boy George and singer Marilyn *(far right)*, milliner Stephen Jones (then a fashion student), film-maker John Maybury, jeweller Judy Blame, fashion designer Stephen Linnard, writer and photographer Paul Hartnett and nightclub queen Scarlett.

AVANT GARDE
211

NEW ROMANTIC, NEOCLASSICAL

HISTORIANS OF STYLE The romanticism of the late 1970s was the apotheosis of the Modernist backlash – and the height of Postmodernism. 'Vivienne Westwood had moved away from punk and showed that you could be new by rediscovering the old,' recalls Sue Timney, who with Grahame Fowler formed textile and wallpaper company Timney Fowler in 1979; its first brochure incorporated swatches of their fabric *(opposite, below)*. Timney admired Piranesi, neoclassical architect Robert Adam, Jean-Michel Basquiat's graffiti art and Picasso, 'another vulture who picked up on Greek mythology and African tribal art'. Blitz fixture and fashion designer Melissa Caplan sported a tribal-looking hairdo in the late 1970s *(opposite, top)*. Make-up artist Elisabeth Challis began collecting period hats mid-decade; this tifter – very 40s-meets-Ancient-Rome – reflects the embryonic vogue for neoclassicism *(right)*. Many New Romantics drew inspiration from high fashion: Jasper Conran, then a fashion student, channelled two late 1970s Kenzo looks – tin soldier and Nehru *(above)*. One forerunner of the style was the vintage craze; this woman at Chelsea Antiques Market in 1973 *(top, right)* predated Billy's chic by five years.

AVANT GARDE
212

NEW ROMANTIC, NEOCLASSICAL

AVANT GARDE

MANHATTAN BOOGIE WOOGIE

If Manhattan had a negative image in the early 1970s, in the second half of the decade it was the world's coolest city. 'The US economy got better then,' remembers Glenn O'Brien, editor of Andy Warhol's magazine *Interview* for much of the 70s. 'There was a creative renaissance: the art world doubled in size, the club scene exploded.' Many major trends coalesced here: loft-living; punk, with music venue CBGB's as its HQ; disco, whose anything-goes nightspots included Studio 54, Xenon, Mudd Club, Régine's, Infinity and Les Mouches; graffiti art and its accompanying musical genre hip hop, first popularized by the Sugarhill Gang's 1979 hit, 'Rapper's Delight'. Manhattan's Fiorucci store was, second to Studio 54, the city's hippest hangout for ultra-celebs like the Warhol gang.

HALSTON, GUCCI, FIORUCCI French punk icon Edwige, with artist and stylist Maripol – who influenced the looks of Grace Jones and Debbie Harry – and Bianca Jagger at Studio 54 in 1979 *(above)*. Dionysian excess ruled at Steve Rubell and Ian Schrager's divinely decadent discothèque: popping Special K and Quaaludes was the norm, and such was the amount of copulation on the balcony, according to Steven Gaines in *Simply Halston*, that it was covered with rubber so it could be washed down easily. *(Opposite, clockwise from top left)* Debbie Harry and Edwige at 54 in '79; model Toukie, seen wearing the clothes of New York fashion designers Willi Smith (her brother) and Stephen Burrows; an invite for a Fiorucci fashion show at Enchanted Garden, Rubell and Schrager's pre-54 venture out in Queens; an out-and-proud clone at Studio 54; Liza Minnelli in Halston at the venue's first birthday party with Steve Rubell, Bianca Jagger, Andy Warhol and, seated, Halston; the designer's lover and window-dresser, Victor Hugo; Truman Capote at Fiorucci; the store's sassy staff.

Enchanted Garden
Discotheque
Cordially invites you to
Fiorucci's Fantasy
see for the first time the newest
Disco Fashion on Parade
"The Best of the Sweet Life"
Tuesday Evening
January 25, 1977
Ten o'clock

63-20 Marathon Parkway
Douglaston, N.Y. 11362

MANHATTAN BOOGIE WOOGIE

KEEPING THE FAITH New York's graffiti culture was codified in Jon Naar's 1974 book, *The Faith of Graffiti*, with an introduction by Norman Mailer. Tagging became more visible, due partly to spending cuts in maintenance of the New York subway system, brought on by a fear of inflation and rising energy prices *(below)*. In 1978, textile designer Ian Simpson dreamt up his Graffiti fabric, which Fred Spurr used to create this ensemble *(right)*. It was sold that year by UK fashion chain Miss Selfridge, showcased against complementary spray-painted walls, as well as at New York department store, Macy's. The New Wave-meets-kitsch apartment of artist Dan Friedman, in 1979 *(opposite)*. Friedman was part of the circle of New York artists that included Jean-Michel Basquiat, Johnny Sex, Tseng Kwong Chi, Kenny Scharf and fellow graffiti artist Keith Haring, who started out doodling in the city's subway stations and decorated Friedman's amphora, seen in the foreground. They were known for partying hard in such Big Apple nightspots as the Mudd Club and Paradise Garage.

AVANT GARDE

MANHATTAN BOOGIE WOOGIE

BOOGIE SHOES Music writer Nik Cohn's 1975 article in *New York* magazine, entitled 'Tribal Rites of the New Saturday Night', inspired producer Robert Stigwood to make the Brooklyn-set movie, *Saturday Night Fever (right)*. Cohn told *Melody Maker* in 1978 that its portrait of working-class hedonist Tony Manero (played by John Travolta) was a reaction against the 'ethic of 60s middle-class kids pretending to be street kids'. New York disco, Le Jardin, where black, white and Hispanic clubbers freely mingled in the early 1970s, also fuelled the trend, as did underground gay clubs and the northern soul phenomenon at the Wigan Casino in the UK. Photographer Guy Bourdin's sublime evocation of disco for a 1979 Charles Jourdan ad campaign *(below)* – a case of Satin Night Fever? Fashion designer Betsey Johnson's Manhattan apartment fused sparsely furnished, open-plan loft-living (plus roller-disco boots) with the New Wave/disco palette of her eponymous clothing label, founded in 1978 *(opposite)*.

NOTES

INTRODUCTION

6 Italian architect and designer Nigel Whiteley, *Pop Design: Modernism to Mod* (London, 1987).

6 The UK's Gay Liberation Front Peter Tatchell, interview with the authors.

7 Lesbians – who sometimes allied Julie Bindel, 'My sexual revolution', in *The Guardian* (30 January 2009).

7 Writing in the Sunday Times Rick Sanders, in *The Sunday Times* (9 October 1977).

7 This social shake-up Tom Wolfe, 'The Sexed-up, Doped-up, Hedonistic Heaven of the Boom-Boom '70s', in *Life* (December 1979).

7 Norma Skurka, in her cult Norma Skurka and Oberto Gili, *Underground Interiors: Decorating for Alternate Life Styles* (New York, 1972), 3.

9 By the 1970s, Esalen had inspired scores Tom Wolfe, 'The Me Decade and the Third Great Awakening', in *New York* (23 August 1976).

9 'The dream of the preponderance of students' Fiona MacCarthy, *British Design Since 1880: A Visual History* (London, 1982), 170.

9 'I wanted to look in the mirror of my times' Linder, interview with the authors.

10 'Because people were frightened that oil prices' Michael Jantzen, interview with the authors.

11 Fittingly, the movement, which saluted Joan Kron and Suzanne Slesin, *High-Tech: The Industrial Style and Source Book for the Home* (1978; New York, 1980), x.

11 Design, according to Papanek, had to be Victor Papanek, *Design for the Real World: Human Ecology and Social Change* (1971; New York, 1973), 343.

11 Aesthetics had been 'deposed by social' Kathryn B. Hiesinger and George H. Marcus, *Landmarks of Twentieth-Century Design: An Illustrated Handbook* (New York, 1993), 250.

11 The thrifty High-Tech look in interiors '1975: A Year to Hang on the Wall', in *Sunday Times Magazine* (December 1975).

11 According to Lloyd Johnson, owner of Lloyd Johnson, interview with the authors.

11 'It was an age, sartorially speaking' Angela Carter, 'Fashion: A Feminist View', in *Sunday Times Magazine* (1 October 1978).

12 As Tom Wolfe observed in 1979 Wolfe, *Life*.

12 'What he did to teenage style in the 70s' Peter York, *Style Wars* (London, 1980), 48.

12 One former student, interior designer Ben Kelly, interview with the authors.

12 'We were interested in how things looked' Peter Saville, interview with the authors.

12 'Not only was Bowie' Dick Hebdige, *Subculture: The Meaning of Style* (1989; London, 1991), 61.

13 Bowie's comment that he believed Cameron Crowe, *Playboy* (September 1976).

13 The presence of so many artists Antony Price, interview with the authors.

13 'Business wasn't a priority' Mattia Bonetti, interview with the authors.

13 Today's celebrity culture didn't exist Ricci Burns, interview with the authors.

13 Photographer Dennis Morris notes that Dennis Morris, interview with the authors.

13 'Hedonism wasn't vigorously opposed' Peter York, interview with the authors.

13 In 1979, he commented on the *Style Wars*, 154–55.

POP TO POSTMODERNISM

15 Once inside this rainbow-hued pleasure-dome Jon Wealleans, interview with the authors.

16 'We assumed an anthropological definition' Lucy R. Lippard, *Pop Art* (1966; London, 1991), 36.

17 Italian architect and designer Barbara Radice, *Ettore Sottsass: A Critical Biography* (London, 1993), 148.

18 The controversial picture of the couple Geoff Marshall, interview with the authors.

18 'Less is a bore' was American architect Robert Venturi, *Complexity and Contradiction in Architecture* (1966; Northamptonshire, 1990), 16.

18 'Prior to Mr Freedom, I'd done Union Jack' Pamla Motown, interview with the authors.

18 In 1971, as a Mr Freedom-inspired uniform Georgina Howell, ed., *In Vogue: Six Decades of Fashion* (1975; London, 1979), 322.

18 The following year, magazine-of-the-moment David Hillman and Harri Peccinotti, *Nova: 1965–1975* (London, 1993), 140.

18 Vogue stepped into the fray Howell, 322.

19 'The eclectic style was very much what I wanted' Terence Conran, interview with the authors.

19 20 'We were trying to say, if you've inherited' Stafford Cliff, interview with the authors.

20 'We wanted the people shopping at Habitat' Terence Conran, interview with the authors.

20 'We were on a mission against conservatism' Geoff Marshall, interview with the authors.

20 'The remains should have a preservation order' Charles Jencks, *The Language of Post-Modern Architecture* (London, 1977), 9.

20 Architect Robert Venturi had already warned Venturi, 104.

20 In his 1972 book Learning From Las Vegas Robert Venturi, Denise Scott Brown and Steven Izenour, *Learning from Las Vegas: The Forgotten Symbolism of Architectural Form* (Cambridge, Massachusetts, 1972).

20 21 In 1977, Jencks codified the rise Jencks, 6.

21 'Form was very important to Johnson' Alan Ritchie, interview with the authors.

21 He asked how many more' Ibid.

21 'The Bauhaus was rational' Alessandro Mendini, interview with the authors.

22 Believing that it was no longer possible Peter Weiss, ed., *Alessandro Mendini: Design and Architecture* (Milan, 2001), 61.

22 As well as giving old styles new meanings Alessandro Mendini, interview with the authors.

22 His furniture designs for Alchimia Radice, 142–43.

22 The latter prompted a media storm Ibid., 216.

22 Indeed, times and tastes were changing Eve Babitz, *Fiorucci, the Book* (New York, 1980).

22 'We visited the whole world' Elio Fiorucci, interview with the authors.

23 'I came from a revolutionary culture' Ibid.

23 'Gucci is a no-freedom concept' Babitz.

24 'The 70s were all about pastiche' George Hardie, interview with the authors.

28 This exuberant fantasy footwear Thea Cadabra, interview with the authors.

36 'There was an explosion of this style' Hilary Hayton, interview with the authors.

38 'The 1970s were the beginning' Terence Conran, interview with the authors.

41 'We believed and adopted anything' Michael English and Deborah Torrens, *3D Eye: The Posters, Prints and Paintings of Michael English, 1966–1979* (Surrey, 1979).

43 'I wanted to achieve the sensual effect' James Rooke, interview with the authors.

46 'Sports clothes are built for speed' Caterine Milinaire and Carol Troy, *Cheap Chic* (New York, 1975), 105.

58 Described as a 'bizarre and garish' John Krevine, *Boy Blackmail* (London, 1980).

66 'The moment Pop Art arrived' George Hardie, interview with the authors.

66 'Artists were suddenly free to plunder' Mick Haggerty, interview with the authors.

66 West Coast artist April Greiman echoes April Greiman, interview with the authors.

67 'I was always crazy for anything visual' Mick Haggerty, interview with the authors.

BELLE EPOQUE

69 A three-piece orchestra, consisting of Barbara Hulanicki, *From A to Biba* (1983; London, 1984), 114.

70 'These are the earliest images I produced' Milton Glaser, interview with the authors.

70 'Beardsley had a big influence' Michael Rainey, interview with the authors.

71 'The decadent sinuosities of Mucha' Bevis Hillier, *The Style of the Century: 1900–1980* (London, 1983), 209.

72 Occupying the painstakingly refurbished Peter York, 'Them', in *Harpers & Queen* (October 1976).

73 'The late 60s looked bedraggled' Peter Saville, interview with the authors.

73 'I wanted to claw back my parents' golden age' Bevis Hillier, interview with the authors.

73 London's Deco-influenced Mr Freedom boutique Paul Gorman, *The Look: Adventures in Pop and Rock Fashion* (2001; London, 2006), 128.

73 Surprisingly, Hulanicki claims today Barbara Hulanicki, interview with the authors.

74 'As a purist Art Deco historian' Bevis Hillier, interview with the authors.

74 Hillier relished its rampant Bevis Hillier, in *The Sunday Times* (9 September 1973).

74 'When we started buying Deco stuff' Michael Costiff, interview with the authors.

74 Now, indifferent to such Wolfe, *New York*.

75 'There was a big anti-American sentiment' Philippe Morillon, interview with the authors.

75 A 1971 article in Rolling Stone Maitland Zane, 'Les Cockettes de San Francisco', in *Rolling Stone* (14 October 1971).

76 'One was watching those films for the first time' Duggie Fields, interview with the authors.

77 'All the sales girls…are made to dress' Gordon Carr, in *Observer Magazine* (13 July 1975).

77 By the late 1970s, this view seemed Peter York, *Modern Times* (London, 1984), 18.

77 Writing about this syndrome Ibid., 23.

79 Its style was a paean to fin-de-siècle exotica Antony Little, interview with the authors.

81 That year, Williamson was commissioned Rupert Williamson, interview with the authors.

83 'People dined on lobster and champagne' Antony Price, interview with the authors.

84 A 'Modernism-inspired' shelving unit Keith Gibbons, interview with the authors.

84 Zanzibar, the ultra-hip cocktail bar Julyan Wickham, interview with the authors.

84 Noted Vogue that same year Leslie Redlich, in *Vogue* (August 1976).

88 'This haircut was modelled after a Cecil Beaton' Ricci Burns, interview with the authors.

88 An early example of flapper fashion Molly Parkin, interview with the authors.

88 A 'Beardsley-inspired' fashion sketch Adeline André, interview with the authors.

88 Birtwell's fabrics were inspired by Deco Celia Birtwell, interview with the authors.

88 Clark's own clothes, with their satin *The Sunday Times* (11 January 1970).

92 'A big influence was The Great Gatsby' Lloyd Johnson, interview with the authors.

103 Maureen Bampton in her vintage clothing Maureen Bampton, interview with the authors.

103 'The stock was a mishmash of old and new' Paul Reeves, interview with the authors.

108 To prepare for her role in the movie Lesley Hornby, *Twiggy: An Autobiography* (1975; St Albans, 1976), 109.

108 Tim Hauser of Manhattan Transfer Tim Hauser, interview with the authors.

111 San Francisco, too, had its Hal Aigner, 'Raggedy Robin Raggedy Jane', in *Rags* (December 1970).

SUPERNATURE

114 Thousands had fled the cities Gladwin Hill, in *The New York Times* (30 November 1969).

114 Both hippies and students The Last Whole Earth Catalog (Menlo Park, California, 1971), 3.

114 'Psychedelics brought on' Alexandra Jacopetti Hart, interview with the authors.

114 Tao Design Group's Earth House Charles Harker, interview with the authors.

114 Like the American pioneers Alexandra Jacopetti Hart, interview with the authors.

114 'We have discovered' Lloyd Kahn, *Shelter* (Bolinas, California, 1973), 112.

115 Believing that they would Charles Harker, *Supramorphics*. http://web.me.com/charker/TAO_Design_Group/Tao_Design_Group.html.

115 Tao invited the public to the site Charles Harker, interview with the authors.

115 They came in droves Harker, *Supramorphics*.

115 One such event in 1975 Fiorella Bulegato and Sergio Polano, *Michele De Lucchi: From Here to There and Beyond*, trans. Richard Sadleir (Milan, 2005), 25.

115–16 'I was disturbed by the idea' Ibid., 27–28.

116 'Many designers are expanding' Emilio Ambasz, ed., *Italy: The New Domestic Landscape, Achievements and Problems of Italian Design*, catalogue, exhibition, Museum of Modern Art, New York, 26 May–11 September 1972, 11.

117 The house – along with those Norma Skurka and Jon Naar, *Design for a Limited Planet: Living with Natural Energy* (New York, 1976).

117 As an alternative E. F. Schumacher, *Small is Beautiful: Economics as if People Mattered* (1973; London, 1974), 128.

118 Another reason for the move towards crafts Emmanuel Cooper, interview with the authors.

118 Furniture designer and craftsman John Makepeace, interview with the authors.

118 'I would buy African robes with tie dye' Kaffe Fassett, interview with the authors.

118 'I was always looking for products' Terence Conran, interview with the authors.

119 But although her designs challenged Carol McNicoll, interview with the authors.

119 'If you can make people feel they're living' *TV Times* (11 December 1976).

119 And although she commuted in a private jet *Woman's Weekly* (26 April 1980) and *Evening News* (21 April 1977).

120 This 1974 shot from Nova is part of a story *Nova* (November 1974).

120 'If we're disillusioned with the high cost' Milinaire and Troy, 169.

120 'Their functional style' Ibid., 178.

121 'Many industrial objects are … unencumbered' Kron and Slesin, x.

123 Actor Terence Stamp, seen on the cover Gregory Sams, interview with the authors.

124 The previous year, a survey Robert Houriet, *Getting Back Together* (New York, 1971).

124 'It was in the 1970s, not the 1960s' Wolfe, *Life*.

127 The streaking craze that swept *The British Medical Journal* (23 March 1974).

128 Charles Harker's Bloomhouse (bottom, right) Harker, *Supramorphics*.

128 Alessandro Mendini described his 1975 Alessandro Mendini, interview with the authors.

129 'There was the idea of "back to nature"' Ibid.

131 'Many of us have hungered' Alexandra Jacopetti and Jerry Wainwright, *Native Funk and Flash: An Emerging Folk Art* (San Francisco, 1974), 5.

132 'I never was the sort of person' Ibid., 55.

132 'Finding the ikat was part of the way' Susan Collier, interview with the authors.

133 Rhodes cut around the printed fringes Zandra Rhodes, interview with the authors.

133 'It was the time of Afghan things' Robert Lusk, interview with the authors.

139 Saul founded Mulberry in 1971 Roger Saul, interview with the authors.

140 'If you couldn't afford to go and see a movie' Kaffe Fassett, interview with the authors.

140 'It grew out of my watercolour sketches' Sue Rangeley, interview with the authors.

142 'My work was very organic and loose' Marvin Lipofsky, interview with the authors.

143 'I was reacting against the Modernist aesthetic' John Makepeace, interview with the authors.

161 'Ever since Marie Antoinette' Meriel McCooey, in *The Sunday Times* (4 April 1976).

161 Military uniforms from this era Gerard Decoster, interview with the authors.

161 'You could towel-dry it' Ricci Burns, interview with the authors.

163 'People were wearing dungarees' Yvonne Swindon, interview with the authors.

AVANT GARDE

165 'During the late 1960s' John Waters, *Shock Value: A Tasteful Book About Bad Taste* (1981; New York, 2005), 62.

166 'In the 1970s, artier types were into artifice' Duggie Fields, interview with the authors.

166 'Before long (and even now)' Gillo Dorfles, *Kitsch: The World of Bad Taste* (New York, 1969), 130.

166 'Camp', she wrote Susan Sontag, 'Notes on Camp', in *The Partisan Review*, 1964.

166–67 *Peppered with such apposite* Andrew Logan:
An Artistic Adventure, catalogue, exhibition,
Ruthin Craft Centre, Ruthin, Denbighshire, 2008.
167 *Rhapsodizing about Big Biba's 'Kitch'*
Hillier, *The Sunday Times*.
167 *Incidentally, Ferry had studied painting*
Michael Bracewell, *Re-make, Re-model: Art,
Pop, Fashion and the Making of Roxy Music,
1953–1972* (London, 2007), 60.
167 *'In the 70s, I liked curvaceous, womanly women'*
Antony Price, interview with the authors.
168 *'What my generation learned from Bowie'*
Peter Saville, interview with the authors.
168 *In his peroxide fright wig* Michael O'Pray, ed.,
Andy Warhol: Film Factory (London, 1989).
168 *'I started as a commercial artist'*
Andy Warhol, *The Philosophy of Andy Warhol:
From A to B and Back Again*
(New York, 1975).
169 *'I began asking "Whose liberation was it?"'*
Margaret Harrison, interview with the authors.
169 *'Echoing women's liberation'*
Peter Tatchell, interview with the authors.
171 *Margaret Harrison's lithograph* Take One Lemon
Margaret Harrison, interview with the authors.
171 *Describing Them as 'part of a mysterious'*
York, *Harpers & Queen*.
171 *'The media was less sophisticated then'*
Peter York, interview with the authors.
171 *They 'didn't go for Martini people's tans'*
York, *Harpers & Queen*.
172 *'I've always loved kitsch for its humour'*
Dan Klein, interview with the authors.
172 *'In the late 1960s, I was trying to avoid'*
Duggie Fields, interview with the authors.
172 *'It was a harder aesthetic for people to accept'*
Bevis Hillier, interview with the authors.
172 *'Punk was about saying yes'*
Jon Savage, *England's Dreaming: Sex Pistols
and Punk Rock* (London, 1991), 133.
172 *'The hippies had advocated removing'*
Jon Savage, Thomas Miessgang and Matt
Gerald, *Punk – No One is Innocent: Art, Style,
Revolt* (Vienna, 2008).
173 *'Westwood and McLaren were elitist'*
Jon Savage, interview with the authors.
175 *This iconoclastic trash aesthetic*
Skurka and Gili, 52.
177 *'I've always tried to … satisfy an audience'*
Waters, 2.
177 *In 1973, stylist Pru Walters*
Duggie Fields, interview with the authors.
178 *Out-there haircuts by Keith Wainwright*
Keith Wainwright, interview with the authors.
181 *The ultra-hip embraced the strict silhouette*
Johnny Moke, interview with the authors.
183 *'Our customers included Paloma Picasso'*
Jean-Bernard Cardon, interview with the authors.
185 *In 1972, the Guardian reported* Robin Denselow,
in *The Guardian* (9 October 1972).
187 *Singer David Johansen, when asked* Savage, 60.
190 *For those who had spent decades* Stephen M.
Engel, *The Unfinished Revolution: Social
Movement Theory and the Gay and Lesbian
Movement* (Cambridge, 2001).
193 *Punks loved Luciana, who also starred*
Kevin Whitney, interview with the authors.
197 *'You could be dancing with Yves Saint Laurent'*
Philippe Morillon, interview with the authors.
201 *Interior designer Ben Kelly, who created*
Ben Kelly, interview with the authors.
201 *Italian fashion designer Nanni Strada's*
Nanni Strada, interview with the authors.
202 *The Pistols knew Logan and co*
Jon Savage, interview with the authors.
204 *Westwood's polemic was* to Savage, 181.
209 *'There was a unity,' he says of the scene*
Dennis Morris, interview with the authors.
212 *'Vivienne Westwood had moved away from punk'*
Sue Timney, interview with the authors.
214 *'The US economy got better then'*
Glenn O'Brien, interview with the authors.
214 *Dionysian excess ruled*
Steven Gaines, *Simply Halston: A Scandalous
Life* (New York, 1993), 161.
218 *Cohn told Melody Maker in 1978*
Stanley Mieses, in *Melody Maker* (1 April 1978).

BIBLIOGRAPHY

'1975: A Year to Hang on the Wall', in *Sunday Times Magazine* (December 1975).
Aigner, Hal. 'Raggedy Robin Raggedy Jane', in *Rags* (December 1970).
Ambasz, Emilio, ed. *Italy: The New Domestic Landscape, Achievements and Problems of Italian Design*, catalogue, exhibition, Museum of Modern Art, New York, 26 May–11 September 1972.
Andrew Logan: An Artistic Adventure, catalogue, exhibition, Ruthin Craft Centre, Ruthin, Denbighshire, 2008.
Babitz, Eve. *Eve's Hollywood* (New York, 1989).
Barthes, Roland. *Mythologies* (1957), trans. Annette Lavers (London, 1972).
Bindel, Julie. 'My sexual revolution', in *The Guardian* (30 January 2009).
'Blueprint for Survival', special issue, *The Ecologist* 1:2 (January 1972).
Bracewell, Michael. *Re-make, Re-model: Art, Pop, Fashion and the Making of Roxy Music, 1953–1972* (London, 2007).
Brown, Rita Mae. *Rubyfruit Jungle* (Plainfield, Vermont, 1973).
Bulegato, Fiorella, and Sergio Polano. *Michele De Lucchi: From Here to There and Beyond*, trans. Richard Sadleir (Milan, 2005).
Carr, Gordon. *Observer Magazine* (13 July 1975).
Carson, Rachel. *Silent Spring* (Boston, 1962).
Carter, Angela. 'Fashion: A Feminist View', in *Sunday Times Magazine* (1 October 1978).
Cohn, Nik, and Guy Peellaert. *Rock Dreams* (London, 1974).
Crowe, Cameron. *Playboy* (September 1976).
Denselow, Robin. *The Guardian* (9 October 1972).
Dorfles, Gillo. *Kitsch: The World of Bad Taste* (New York, 1969).
Ebert, Wolfgang M. *Wahnsinn Wohnen* (Cologne, 1987).
Engel, Stephen M. *The Unfinished Revolution: Social Movement Theory and the Gay and Lesbian Movement* (Cambridge, 2001).
English, Michael, and Deborah Torrens. *3D Eye: The Posters, Prints and Paintings of Michael English, 1966–1979* (Surrey, 1979).
Gaines, Steven. *Simply Halston: A Scandalous Life* (New York, 1993).
Gorman, Paul. *The Look: Adventures in Pop and Rock Fashion* (London, 2001).
Greer, Germaine. *The Female Eunuch* (1970; London, 1972).
Harker, Charles. *Supramorphics*. http://web.me.com/charker/TAO_Design_Group/Tao_Design_Group.html.
Hebdige, Dick. *Subculture: The Meaning of Style* (1989; London, 1991).
Hiesinger, Kathryn B., and George H. Marcus. *Landmarks of Twentieth-Century Design: An Illustrated Handbook* (New York, 1993).
Hill, Gladwin. *The New York Times* (30 November 1969).
Hiller, Bevis. *Austerity Binge: The Decorative Arts of the Forties and Fifties* (London, 1975).
———. *The Style of the Century: 1900–1980* (London, 1983).
———. *The Sunday Times* (9 September 1973).
Hillman, David, and Harri Peccinotti. *Nova: 1965–1975* (London, 1993).
Hornby, Lesley. *Twiggy: An Autobiography* (1975; St Albans, 1976).
Houriet, Robert. *Getting Back Together* (New York, 1971).
Howell, Georgina, ed. *In Vogue: Six Decades of Fashion* (1975; London, 1979).
Hulanicki, Barbara. *From A to Biba* (1983; London, 1984).
Huysmans, Joris-Karl. *A rebours* (1895), trans. Robert Baldick (London, 2003).
Jacopetti, Alexandra, and Jerry Wainwright. *Native Funk and Flash: An Emerging Folk Art* (San Francisco, 1974).
Jencks, Charles. *The Language of Post-Modern Architecture* (1977; London, 1978).
Kahn, Lloyd. *Shelter* (Bolinas, California, 1973).
Krevine, John. *Boy Blackmail* (London, 1980).
Kron, Joan, and Suzanne Slesin. *High-Tech: The Industrial Style and Source Book for the Home* (1978; New York, 1980).
Lippard, Lucy R. *Pop Art* (1966; London, 1991).
MacCarthy, Fiona. *British Design Since 1880: A Visual History* (London, 1982).
Margetson, Stella. *The Long Party: High Society in the Twenties and Thirties* (Farnborough, Hampshire, 1974).
McGooey, Meriel. *The Sunday Times* (4 April 1976).
McFadden, Cyra. *The Serial: A Year in the Life of Marin County* (New York, 1977).
McLuhan, Marshall. *Through the Vanishing Point: Space in Poetry and Painting* (New York, 1968).
Meadows, Donella H., et al. *The Limits to Growth* (Cambridge, Massachusetts, 1972).
Mieses, Stanley. *Melody Maker* (1 April 1978).
Milinaire, Catherine, and Carol Troy. *Cheap Chic* (New York, 1975).
Naar, Jon. *The Faith of Graffiti* (New York, 1974).
O'Pray, Michael, ed. *Andy Warhol: Film Factory* (London, 1989).
Papanek, Victor. *Design for the Real World: Human Ecology and Social Change* (1971; New York, 1973).
Radice, Barbara. *Ettore Sottsass: A Critical Biography* (London, 1993).
Redlich, Leslie. *Vogue* (August 1976).
Sanders, Rick. *Sunday Times* (9 October 1977).
Savage, Jon. *England's Dreaming: Sex Pistols and Punk Rock* (London, 1991).
Savage, Jon, Thomas Miessgang and Matt Gerald. *Punk – No One is Innocent: Art, Style, Revolt* (Vienna, 2008).
Schumacher, E. F. *Small is Beautiful: Economics as if People Mattered* (London, 1973).
Skurka, Norma, and Oberto Gili. *Underground Interiors: Decorating for Alternate Life Styles* (New York, 1972).
Skurka, Norma, and Jon Naar. *Design for a Limited Planet: Living with Natural Energy* (New York, 1976).
Sontag, Susan. 'Notes on Camp', in *The Partisan Review* (1964).
Sternberg, Jacques. *Kitsch*, trans. and ed. Marina Henderson (1971; London, 1972).
The Last Whole Earth Catalog (Menlo Park, California, 1971).
Venturi, Robert. *Complexity and Contradiction in Architecture* (1966; Northamptonshire, 1990).
Venturi, Robert, Denise Scott Brown and Steven Izenour. *Learning from Las Vegas: The Forgotten Symbolism of Architectural Form* (Cambridge, Massachusetts, 1972).
Warhol, Andy. *The Philosophy of Andy Warhol: From A to B and Back Again* (New York, 1975).
Waters, John. *Shock Value: A Tasteful Book About Bad Taste* (1981; New York, 2005).
Weiss, Peter, ed. *Alessandro Mendini: Design and Architecture* (Milan, 2001).
Whiteley, Nigel. *Pop Design: Modernism to Mod* (London, 1987).
Williamson, Judith. *Decoding Advertisements: Ideology and Meaning in Advertising* (London, 1978).
Wolfe, Tom. 'The Me Decade and the Third Great Awakening', in *New York* (23 August 1976).
———. 'The Sexed-Up, Doped-up, Hedonistic Heaven of the Boom-Boom '70s', in *Life* (December 1979).
York, Peter. *Modern Times: Everybody Wants Everything* (London, 1984).
———. *Style Wars* (London, 1980).
———. 'Them', in *Harpers & Queen* (October 1976).
Zakas, Spiros. *Furniture in 24 Hours* (New York, 1976).
Zane, Maitland. 'Les Cockettes de San Francisco', in *Rolling Stone* (14 October 1971).

ACKNOWLEDGEMENTS

Our thanks to all those who kindly agreed to be interviewed for this book, and to those who lent images from their archives. Without their generosity, the project would not have been possible. Our special thanks go to James, Jim and Margaret Hislop; Beatriz, Marcus and Martin Lutyens; Jefferson Smith, Paul Wood and Yannick Aubinais.

Thanks also to Adeline André, the Antique Collectors Club for the images of Biba from *Welcome to Big Biba*, by Steven Thomas and Alwyn W. Turner; Sarah Bailey, David Baldwin, Maureen Bampton, Robyn Beeche, Manfredi Bellati, Piera Berardi, Edo Bertoglio, Mark Betty, Malcolm Bird, Celia Birtwell, John Bishop, Manolo Blahnik, Michael Bracewell, Jean-Charles Brosseau, Ricci Burns, Kate Burvill, Andy Butcher, Thea Cadabra, Melissa Caplan, Paul Caranicas, Jean-Bernard Cardon, Chloé Cheese, Susan Collier and Sarah Campbell, Keith Collins, Terence Conran, *Crafts*, Mary Ann Crenshaw, Jean-Charles de Castelbajac, Wendy Dagworthy, Michele De Lucchi, Justin de Villeneuve, John Dove, Roja Dove, Paul Dunford, Victoria Eden, Edwin Co Ltd, Jane England, Michael English, Bernard Faucon, Hans Feurer, Duggie Fields, Elio Fiorucci, Lynne Franks, Val Furphy, Joe Gaffney, Nicola Gard, Malcolm Garrett, Keith Gibbons, Grant Gibson, Richard Giglio, Oberto Gili, Milton Glaser, Peter Golding, Hazel Gomes, Paul Gorman, Jean-Paul Goude, Piers Gough, April Greiman, Kit Grover, Mick Haggerty, George Hardie, Charles Harker, Margaret Harrison, Martin Harrison, Nigel Harrison, Alexandra Jacopetti Hart, Paul Hartnett, Fayette Hauser, Tim Hauser, Hilary Hayton, Susanna Heron, Ashley Hicks, Chris Hicks, Steve Hiett, Bevis Hillier, David Hillman, Will Hodgkinson, Haro Hodson, Delmas Howe, Patrick Hughes, Barbara Hulanicki, David Inshaw, Dominique Jackson, Michael Jantzen, Angela Jeffery, Lloyd Johnson, Lloyd Kahn, Anita Kaushal, Ben Kelly, Peter Knapp, Krystyna Kolowska, Claude and François-Xavier Lalanne, Natacha Ledwidge, Roger and Carole Lee, Lyn Le Grice, Michael Leonard, Marvin Lipofsky, Andrew Logan, Nicholas Logsdall, Robert Lusk, Serge Lutens, John Makepeace, Juliet Mann, Franco Marabelli, Likrish Marchese, Patxi Marrodan, Geoff Marshall, Kate Mathews, Jean McNeil, Carol McNicoll, Alessandro Mendini, Alex Michon, Sam Millar, David Miller, Rumi Missabu, Philippe Morillon, Stevie Morrish, Pamla Motown, Trevor Myles, Daniel Nelson, Mary O'Sullivan, Liz Owen, Molly Parkin, Roy Peach, Harri Peccinotti, Steven Phillips, Antony Price, Barbara Radice Sottsass, Sue Rangeley, Christopher Redfern, Paul Reeves, Zandra Rhodes, Patricia Roberts, Paul Robinson, James Rooke, Stephen Rothholz, Raina Sacks, Craig Sams, Gregory Sams, Mustafa Sami, Maha Sarkis, Roger Saul, Jon Savage, Peter Saville, Kenny Scharf, Gretchen Schields, Ian Simpson, Tim and Fiona Slack, Andy Sotiriou, Fred Spurr, John Stefanidis, Roger Stowell, Sheila Teague, Nanni Strada, Tim Street-Porter, Yvonne Swindon, Steven Thomas, Chantal Thomass, Storm Thorgerson, Sue Timney, Cassandra Tondro, Lola and Oliviero Toscani, Christopher Vane Percy, Andrew Wade, Ginny Wain, Keith Wainwright, Willie Walters, Jon Wealleans, Molly White, Julyan Wickham, Dennis Wilhelm, Rupert Williamson, Craig Wilson, Sarah Wise, Gary Wright, Peter York.

INDEX

19 magazine, 27, 87, 90, 92, 160
401 Studios, 140
519 East 11th Street cooperative, 134
Aardvark's Odd Ark shop, 101
A Bigger Splash, 171, 195
Abitazione a cubo conficcato per un vertice, 117
A Clockwork Orange, 33
Ace shop, 62, 194
Acquired Mannerisms, 184
Adam and the Ants, 203
A Different Kind of Tension, 67
Agnès B, 10
Albini, Walter, 171
Aldridge, Alan, 36
Alice's Restaurant, 77
All Creatures Great and Small, 77
Allen, Woody, 108, 160
Alloway, Lawrence, 16
Alternative Miss World contest, 167, 171, 194, 195
Ambasz, Emilio, 11, 116, 121
American Gigolo, 173
American Graffiti, 175
André, Adeline, 88
Anello & Davide shop, 106
Anfibio sofa, 117
Angry Brigade, 76
A Night on the Town, 77
Annie Hall, 159, 160, 173
Antiquarius market, 74, 101, 103
Archigram, 9
Arcosanti, 117, 136
'Armadillo' house, 128
Armani, Giorgio, 143, 173
Art & Language, 44
Artscribe magazine, 184
Ashley, April, 186
Ashley, Laura, 11, 118, 119, 144,
Athena, 78
At Long Last Love, 108
AT&T building, 21

B-52's, 61
Babitz, Eve, 22, 23
Baby Teeth typeface, 70, 97
Badges & Equipment shop, 120
Badlands, 175
Badminton Game, The, 148
Baer, Steve, 134
Baker, Caroline, 27, 46, 103, 120
Bamalama, 99
Bampton, Maureen, 103
Barrett, Syd, 174
Barthes, Roland, 170
Basquiat, Jean-Michel, 212, 217
Batten, Ian, 92
Battersby, Martin, 75
Bau.Haus collection, 21
Bauhaus fabric, 84
Bd Barcelona Design, 43, 143
Beardsley, Aubrey, 70, 71, 73, 78, 79, 88
Beatles, 71
Beatty, Warren, 73
Becchi, Alessandro, 117
Behrens, Steven, 50
Belle Epoque, 99
Bellini, Mario, 117
Bennett, Ward, 201
Bentley/Farrell/Burnett, 97
Beretta, Anne-Marie, 198
Berkeley, Busby, 75, 105
Berlin (Bertie Marshall), 173, 207
Bertoglio, Edo, 209
Biba shop, 11, 13, 34, 46, 69, 70, 72, 73, 74, 76, 77, 78, 79, 81, 83, 87, 88, 90, 92, 97, 105, 148, 151, 167, 171, 172
Billy's club, 210, 211, 212
Bird, Malcolm, 79
Birkenstock shoes, 133
Birtwell, Celia, 88, 171, 195
Bis, Dorothée, 119, 198
Bishop, John, 90
'Black is Black', 99
Black, Misha, 11
Black Power, 106, 169
Blahnik, Manolo, 92, 101, 184, 193, 195, 197
Blake, Peter, 71, 148
Blakes hotel, 79
Blame, Judy, 211
Blanco shop, 90
Blitz club, 210, 211, 212
Blondie, 22
Bloolips, 191
Bloomhouse, 128
Body Shop, 127
Bogdanovich, Peter, 108
Bolan, Marc, 18, 106
Boman, Eric, 193
Bombacha shop, 10, 138

Bonderup, Claus, 134
Bonetti, Mattia, 13
Boney M, 105
Bonnie and Clyde, 72, 73
'Boogie Woogie Bugle Boy', 181
Booth, Pat, 41
Booth, Wendy, 194
Bossi, Ottorino, 92
Boston 151 shop, 193
Boulting, Ingrid, 88
Bourdin, Guy, 169, 218
Bourne, Bette, 191
Bovell, Dennis, 209
Bowie, Angie, 169
Bowie, David, 12, 13, 105, 111, 166, 167, 168, 169, 186, 210, 211
Boy Friend, The, 75, 94, 108
Boy George, 211
Bracewell, Michael, 167, 168
Branzi, Andrea, 21, 57
Bright and Bold paints, 39
Brooks, Mel, 111
Bromley Contingent, 173, 204, 207
Brosseau, Jean-Charles, 73
Brotherhood of Ruralists, 148
Brown, Rita Mae, 7
Browns shop, 10
Bubbles, Barney, 66, 67
Bugsy Malone, 77
Burns, Ricci, 13, 88, 161
Burrows, Stephen, 214
Bush, Kate, 111
Butler & Wilson, 103
Buzzcocks, 9, 67

Cabaret, 76, 77, 94
Cacharel, 119
Cadabra, Thea, 28, 41, 64
Cairns, Eddie, 188
CalArts, 67
California Loop Series No. 21, 142
Calvet chair and armchair, 143
Camaleonda cushion system, 117
Campbell, Sarah, 84
Campbell's Soup series, 34
Campus furniture range, 18
Canvey Island, 161
Caplan, Melissa, 212
Capote, Truman, 214
Cardon, Jean-Bernard, 183
Carmichael, Michael, 128
Carson, Rachel, 9
Carter, Angela, 11
Carter, Jimmy, 10
Cartier, 87
Car Wash, 105
Casabella magazine, 21
Castelli Ferrieri, Anna, 34
Catroux, Betty, 198
Catwoman, Soo, 203
Cavart group, 115
CBGB's, 214
Centre Georges Pompidou, 157
Chaguaramas club, 204
Challis, Elisabeth, 212
Charko, Kasia, 171
Charles Jourdan, 92, 218
Charlie's Angels, 198
Cheese, Chloë, 61
Che Guevara shop, 87
Chelsea Antiques Market, 101, 212
Cherchez shop, 101
Chevron Shawl print, 133
Chinatown, 77
Chloé, 131, 184
Chow, Michael, 193
Christian Dior, 45, 87
City Lights Studio shop, 181
Clark, Ossie, 88, 193, 195
Clash, The, 173, 203
Clendinning, Max, 81
Cleveland, Pat, 178
Cliff, Stafford, 19
Clowns, The, 111
Club for Heroes, 210
Club Sept, 192, 197
Cockettes, 75, 101, 106, 111, 181, 186, 187
Coddington, Grace, 103, 193
Cohn, Nik, 188, 218
Coleherne pub, 191
Collier, Susan, 84, 132, 133
Collier Campbell, 132
Colombo, Joe, 34
Colquhoun, Maureen, 7
Commission for Racial Equality, 13, 20
Componibili cupboard, 34
Conran, Jasper, 212
Conran, Terence, 18, 19, 20, 33, 38, 118, 151
Cook, Peter, 9
Cooper, Emmanuel, 118
Costiff, Gerlinde, 74, 171

Costiff, Michael, 74, 171
Countdown shop, 41
County, Wayne, 169
Coupe sauvage haircut, 161
Courrèges, André, 58
Crafts Council, 118, 142
Crash jeans, 144
Crawford, Michael, 94
Créateurs et Industriels, 198
Crenshaw, Mary Ann, 163
Cressole, Michel, 188
Crosby, Stills, Nash and Young, 144
Cross, Ros, 55
Crystal Tipps and Alistair, 36
Culturally Impossible Architecture, 115
Curry, Tim, 187
Curtis, Jackie, 168
Cycle Sluts, 186

Dagworthy, Wendy, 87, 103
Dali, Salvador, 43, 44
Damned, The, 67
Dance Centre, 62
Dario, 207
David, Elizabeth, 118, 151
Davis, Angela, 124
Davis, Michael, 202
Day of the Locust, The, 77
Deacon, Ian, 161
Death in Venice, 77
Death on the Nile, 97
De Beers Diamond Collection, 50
De Castelbajac, Jean-Charles, 48, 119, 139, 198
Decoster, Gerard, 161
De Havilland, Terry, 58, 64
Déjà Vu shop, 103
De la Falaise, Loulou, 171, 197, 198
De Lucchi, Michele, 21, 55, 57, 115, 116, 117, 128
Deluxe magazine, 148, 192
Deneuve, Catherine, 197
'Denis', 22
De Senneville, Elisabeth, 10
Designers Guild shop, 119
Detail shop, 58
De Ville, Nick, 167
De Villeneuve, Justin, 76, 108, 111
Dewaere, Patrick, 161
Dingemans, Jo, 27, 92
Divine, 167, 177
Dodo Designs, 44, 97
Dog Day Afternoon, 186
Donovan, Terence, 75
Dorfles, Gillo, 166, 167
Dormeuil, 99
Dove, John, 27, 41, 58
Dreamland Films, 169
Drop City, 114
Dunaway, Faye, 73
D'Urso, Joseph Paul, 154
Dury, Ian, 66
Dykes on Bikes, 191
Dylan, Bob, 12, 36

Earth Day, 9, 113, 114
Earth House, 114, 128
Earth shoe, 133
Easy Rider, 77
Eco, Umberto, 170
Ecologist magazine, 10
Ecology party, 10
Eclectic House Project, 57
Edelmann, Heinz, 36
Edward and Mrs Simpson, 77
Edwige, 214
Edwin International, 23
Egan, Rusty, 211
Ehrman, Hugh, 140
Elia, Albert, 24
Elia, Fouli, 184
Elle magazine (French), 47, 71, 183, 184
Elle shop, 10
Emaer, Fabrice, 197
Embassy club, 192
Emmanuelle films, 78
Emmerton, Adrian, 101
England, Jane, 202
English, Michael, 19, 36, 41
Eno, Brian, 168, 176, 201
Environmental Protection Agency, 10
Ernst, Max, 41
Erté, 73, 99
Esalen Institute, 9
Escalade shop, 10
Esprit shop, 154
Esquire magazine, 70
Estorick, Eric, 11
Everage, Dame Edna, 174
Every Picture Tells a Story, 77
Evita, 181

Façade magazine, 197
Fair Isle sweater, 94
Fame, 188
Farrell, Bobby, 105
Farrow, Mia, 99
Farrow, Robin, 97
Fassett, Kaffe, 118, 140
Fawcett-Majors, Farrah, 198
Fellini, Federico, 111
Female Eunuch, The, 41
Ferry, Bryan, 161, 166, 167, 168, 171, 181, 185, 197, 210
Feurer, Hans, 181
FHAR, 190
Fields, Duggie, 76, 166, 171, 172, 174, 177, 184, 193, 202
Fiorucci, 22, 23, 58, 62, 154, 178, 214
Fiorucci, Elio, 22, 23, 24, 58
Fitz-Simon, Stephen, 70
Folkwear pattern company, 144
Forman, Sharman, 176
Forth, Jane, 169
For Your Pleasure, 188
Fowler, Grahame, 212
Fox, Noosha, 108
Franks, Lynne, 171
Friedman, Dan, 217
Frye boot, 133
Fuller, Buckminster, 114, 115
F.U.O.R.I!, 190
Furphy, Val, 61

Gaffney, Joe, 87
Gaines, Steven, 214
Gallery Five, 88
Galvin, Daniel, 178
Garrett, Malcolm, 67
Gaudi, Antoni, 74, 143
Gay Liberation Front, 6, 169
Gay Men's Chorus, 191
Gay Pride Day, 190, 191
Gehry, Frank, 154
Geldzahler, Henry, 81
Generation X, 207
Georges Rech, 50
Gere, Richard, 173
Getty, Talitha, 103
Gibb, Bill, 140, 181, 195
Gibbons, Keith, 39, 84
Giglio, Richard, 163
Gili, Oberto, 81
Giulianova project, 57
Glaser, Milton, 36, 70, 97
Globe shop, 161
'God Save the Queen', 202
Golding, Peter, 62, 194
Goring, Lesley, 194
Goude, Jean-Paul, 131
Graffiti fabric, 217
Granny Takes a Trip shop, 70, 71, 75, 101
Gray, Joel, 77
Grease, 181
Great American Disaster, The, restaurant, 36
Great American Nude series, 24
Great Gatsby, The, 76, 92, 94, 99
Greer, Germaine, 41
Greiman, April, 66, 67
Grover, Kit, 154
Grumbach, Didier, 198
Gucci, 23, 214
Guérard, Michel, 201
Guerlain, 99
Guerriero, Adriana and Alessandro, 21
Gunne Sax fashion label, 144

Habitat shop, 18, 19, 20, 33, 34, 38, 39, 118, 119, 121, 151, 159
Haden-Guest, Anthony, 167
Haggerty, Mick, 55, 66, 67
Hall, Jerry, 197
Halston, 23, 171, 201, 214
Hamilton, Richard, 6, 16, 167
Hammock necklace, 43
Hamnett, Katharine, 183
Hapsash and the Coloured Coat, 36
Hard Rock Café, 36
Hardie, George, 24, 34, 66, 67
Harker, Charles, 114, 128
Haring, Keith, 217
Harmony Foods, 123
Harpers & Queen magazine, 167, 171, 195, 202
Harrison, Margaret, 169, 171
Harron, Mary, 172
Harry, Debbie, 22, 214
Hartnett, Paul, 211
Hauser, Tim, 108
Haynes, Michael, 140
Hayton, Hilary, 36
Hazan, Jack, 171, 195
Hazéra, Hélène, 188
Hebdige, Dick, 12, 171, 172, 173

Hechter, Daniel, 47, 119
Hell, Richard, 173, 202
Helvin, Marie, 201
Hempel, Anouska, 79
Heroes, 168, 210
Heron, Susanna, 58
'He's the Greatest Dancer', 23
Hicks, Chris, 142
Hicks, David, 33
Hill, Dave, 106
Hill, Martha, 127
Hillier, Bevis, 71, 73, 74, 75, 97, 167, 172
Hindenburg, The, 77
Hinge & Bracket, 106
Hipgnosis, 45
'Hit Me With Your Rhythm Stick', 66
Hockney, David, 84, 171, 195, 197
Hodo, David, 154
Hodson, Haro, 88
Holden, Edith, 148
'Hollywood Flashback', 105
Hollywood Clothes Shop, 181
Holmes, John, 41, 45
Hoofer fashion label, 161, 163
Hopkins, Michael, 120
Horrox, Jan, 58
Hot Gossip, 62
Hovis advertisement, 77, 94
Howe, Delmas, 191
Howell, Margaret, 103
Howie, Paul, 154, 171
Howie shop, 61, 138, 159, 171
Hughes, Patrick, 39
Hugo, Victor, 214
Hulanicki, Barbara, 11, 69, 70, 71, 72, 73, 79, 87, 88, 151
Hung on You shop, 70
Hunky Dory, 169
Hynde, Chrissie, 204

Idol, Billy, 207
If I Were Very, Very Rich I Would Confront Myself With My Complexes, 21
Inca shop, 119
Independent Group, 16
Indeterminate Façade showroom, 53
Individual Clothes Show, 194
Infinity club, 214
Inshaw, David, 148
Institute of Contemporary Arts, 170
International Style, 16, 17, 21, 52
Interview magazine, 192, 214
Italy: The New Domestic Landscape exhibition, 116, 117, 121
Izenour, Steven, 20

Jackson, Betty, 92, 194
Jacopetti Hart, Alexandra, 114, 131, 141
Jagger, Bianca, 62, 88, 171, 193, 195, 214
Jagger, Mick, 24, 88, 187, 195, 211
Jantzen, Michael, 10, 11, 154
Jarman, Derek, 193, 194, 201, 203
Jasper, 188
Jencks, Charles, 20
Jezebel shop, 101
Jobriath, 191
Johansen, David, 187
John, Elton, 76, 108, 178
Johnson, Betsey, 218
Johnson, Lloyd, 11, 92, 209
Johnson, Philip, 21
Johnson's Modern Outfitters, 11, 209
Jones, Allen, 33
Jones, Grace, 62, 188, 214
Jones, Stephen, 211
Jordan, 13, 203, 204
Jordan, Donna, 169, 178
Joseph shop, 10, 94
Joy Division, 201
Jubilee, 193, 203, 210
Judd, Donald, 201
Julia, 77
Just a Gigolo, 105
Just What Is It That Makes Today's Homes So Different, So Appealing? 16
Juvenile, Debbie, 207

Kahn, Lloyd, 114, 128
Kalman, Michael, 181
Kandinsky, Wassily, 22, 61, 67, 177
Kartell, 34
Keaton, Diane, 160
Kelbaugh, Douglas, 134
Kelly, Ben, 12, 154, 159, 201
Kemp, Lindsay, 108, 111
Key of Dreams, The, 44
Khanh, Emmanuelle, 10, 198
Khanh, Quasar, 198
Kitsch-22 shop, 58
Klein, Dan, 172
Klein, William, 18
Knapp, Peter, 184
Kolowska, Krystyna, 203

Kraftwerk, 168, 210
Kron, Joan, 121
Kubrick, Stanley, 210
Kuramata, Shiro, 55

Ladybird Books, 7
Lady Sings the Blues, 105
Lagerfeld, Karl, 61, 73, 169, 171, 184, 197
La Grande Eugène, 106
Lalanne, Claude, 43, 45
L'Alcazar, 188
Lambert, Vernon, 101
Lancaster, Osbert, 70
Larson-Stylee, Ulla, 103
Last Picture Book, The, chap. 76, 107
Laura shop, 198
Lauren, Ralph, 139
Lavalle à l'ombre shirt, 181
Lear, Amanda, 105, 171, 186, 188
Led Zeppelin, 103
Le Grice, Lyn, 79, 81, 148, 151
Le Jardin club, 218
Leonard, 178, 194
Leonard, Michael, 154
Le Palace, 192, 197
Les Deux Zèbres shop, 10
Les Gazolines, 186, 188
Les Messageries, 183
Les Mouches, 188, 214
Lester, Marshall, 24
Let It Rock shop, 73, 169, 173, 176
Levi's jeans, 176
Liberty department store, 84, 132, 147
Lichtenstein, Roy, 33, 34
Lillie, 77
Linder, 9
Linnard, Stephen, 211
Lipofsky, Marvin, 142
Little, Antony, 4, 79, 97
Little House on the Prairie, 144
Little, Jenny, 79
Little Nell, 171, 178, 194
Lodger, 168, 210
Logan, Andrew, 167, 176, 193, 194, 195, 201, 202
Long Party, The, 76, 77
Lonsdale, 46
'Looks, Looks, Looks', 168
Lopez, Antonio, 169, 197
López Sánchez, Rafael, 197
Lord Peter Wimsey, 77
Louise's bar, 204
Low, 168, 210
Lunar Loper shoe, 64
Lusk, Robert, 133
Lutens, Serge, 45, 87
LWS chair, 81
Lysistrata series, 71

MacCarthy, Fiona, 9
Macy's, 217
Magritte, René, 41, 43, 44, 45
Maid shoe, 41
Mailer, Norman, 217
Majera, Hélène, 99
Makepeace, John, 118, 143
Manhattan Transfer, 108
Man Who Fell to Earth, The, 210
Marceau, Marcel, 111
Margetson, Stella, 76, 77
Marie-France, 188
Marilyn, singer, 211
Maripol, 214
Marshall, Geoff, 18, 20
Martinez, Luciana, 171, 193
Masquerade club, 204
Mattachine Society, 190
Max, Peter, 36
Max's Kansas City, 168
Maybury, John, 211
Mayhew, Michael, 70
McClintock, Jessica, 144
McDermott, Mo, 84
McFadden, Cyra, 13
McGibbon, Paula, 97
McInnerney, Mike, 45
McIntyre, Alex, 174
McLaren, Malcolm, 73, 165, 166, 169, 171, 173, 176, 201, 202, 211
McLuhan, Marshall, 175
McNicoll, Carol, 119, 176
Mellor, David, 151
Memphis Group, 22, 57
Ménard, Alain, 183
Mendini, Alessandro, 21, 22, 55, 57, 128, 129
Merchant Ivory, 77
Mercury, Freddie, 101
Miami Design Preservation League, 72, 84
Michon, Alex, 203
Midler, Bette, 181
Milinaire, Caterine, 46, 120
Milk, Harvey, 171

Minnelli, Liza, 77, 108, 171, 214
Mintun, Peter, 106
Missabu, Rumi, 181
Miss Mouse fashion label, 171
Miss Selfridge, 217
Mitchell, Gala, 187
Mitchell, Joni, 124
Miyake, Issey, 10, 192, 197
Modo magazine, 21
Modulando cabinet, 55
Modzart fashion label, 58
Moke, Johnny, 181
Molyneux, Maud, 188
Montana, Claude, 64, 139
Moon, Sarah, 88
Moore, Shaheed, 80
Moreni, Popy, 10
Morellet, François, 71
Morillon, Philippe, 75, 183, 197
Morris, Dennis, 13, 209
Morris, William, 148
Morton, Peter, 36
Moscone, George, 171
Mother Earth News, 114
Motown, Pamla, 18, 24, 58
Mouche, model, 87
Mr and Mrs Clark and Percy, 195
Mr Chow, 193
Mr Feed'em, 33, 34
Mr Freedom shop, 16, 17, 18, 22, 23, 24, 27, 33, 46, 50, 73, 176, 181
Mr Freedom, 18
Mrs Howie shop, 58
Mucha, Alphonse, 70, 71, 77, 78, 99
Mud, 186, 217
Mudd Club, 214, 217
Mugler, Thierry, 64
Muir, Jean, 201
Mulberry fashion label, 139
Muller, Kari-Ann, 167
Music for Pleasure, 67
Myers, Joel Philip, 141
Myles, Trevor, 176
Myra Breckinridge, 105

Naar, Jon, 117, 217
Native Funk and Flash exhibition, 132
Natural Shoe Store, 92, 133
Nelson, Gaylord, 9
New York Dolls, 166, 186, 187
Nickelodeon, 108
Nomi, Klaus, 210
No, No, Nanette, 105
Nostalgia shop, 75
Nothing Rhymed, 94
Nova magazine, 18, 27, 41, 45, 46, 48, 70, 75, 88, 94, 103, 120, 127, 131, 181, 188
Nureyev, Rudolf, 88
Nutter, Tommy, 76, 108
Nyman, Michael, 201

O'Brien, Glenn, 214
O'Connor, Jim, 24, 27, 58
October, Gene, 204
Oldenburg, Claes, 15, 17, 39
OMK Design, 20
Orchestral Manoeuvres in the Dark, 159
'Orgasm Addict', 9
Orton, Joe, 173
Osborne & Little, 4, 79, 97
Osborne, Peter, 4
Osher, Tom, 101
O'Sullivan, Gilbert, 94

Pablo and Delia, 193
Page, Jimmy, 103
Paige, Elaine, 181
Pallisers, The, 77
Pamla Jim, 46
Panton, Verner, 17
Papanek, Victor, 11
Paper Moon, 76, 108
Paradise Garage club, 217
Paradise Garage shop, 27, 176
Parkin, Molly, 88
Passage of Arms, 154
Paulin, Pierre, 17
Peach and Cockle, 61
Peach, Roy, 138, 194
Peellaert, Guy, 188
Pelle dress, 201
Pendora de Luxe, 183, 188
Penguin books, 97, 99
Performance, 186, 187
Perspex Multiples, 58
Pesce, Gaetano, 6, 17, 57
Peter Robinson department store, 24
Philip Johnson/Alan Ritchie Architects, 21
Piaggi, Anna, 101, 171
Piano, Renzo, 157
Piazza d'Italia, 53
Picasso, Paloma, 24, 171, 181, 183, 197
Pierce, Charles, 106

Pierrot in Turquoise, 111
Pink Flamingos, 177
Pink Floyd, 45, 165, 174
Pin Ups, 111
Pirates collection, 210
Play It Again Sam, 108
Plaza shop, 64
Plum shop, 92
Pointer Sisters, 105
Pomme-Bouche sculpture, 43
Porchester Hall drag balls, 92
Pork, 169
Porter, Thea, 81, 108, 167
Poseur shop, 94
Presley, Elvis, 89, 181
Pretenders, 204
Prieur, Antoine, 181, 81, 82, 183, 188
Prima furniture, 39
Proust armchair, 21, 22
Pruitt-Igoe housing scheme, 20
Pumping Iron, 167
Punk magazine, 172
Purple Shop, 101
Putman, Andrée, 198
PX shop, 159, 211

Quadrophenia, 209
Quant, Mary, 16, 18, 46
Queen, 101
Quorum label and shop, 92

Radice, Barbara, 22
Radley, Alfred, 92
Raggedy Jane and Raggedy Robin, 111
Rags magazine, 6, 24, 163
Rainbow's End, 39
Rainey, Michael, 70
Ramones, 201
Rangeley, Sue, 140, 148
'Rapper's Delight', 214
Ray, Man, 43
Reagan, Ronald, 77
Redford, Robert, 92, 99
Reed, Lou, 166, 187, 202
Reeve, James, 75
Reeves, Paul, 103
Régine's, 81, 192, 214
Reid, Jamie, 202
Rhodes, Bernard, 165, 173
Rhodes, Zandra, 133, 171, 174, 178, 193, 194, 207
Riegler, Maggie, 142
Rio, model, 10
Ritchie, Alan, 21
Rive Gauche shop, 198
Ritz magazine, 192, 193, 194
Roberts, Patricia, 94
Roberts, Tommy, 18, 176, 181
Robinson, Helen, 159
Rock Against Racism, 13, 209
Rock Dreams, 188
Rocky Horror Picture Show, The, 41
Rocky Horror Show, The, 174, 178, 186, 187
Roddick, Anita, 127
Rogers, Richard, 157
Rolling Stone magazine, 75
Ronay, Edina, 193
Rooke, James, 41, 43
Ross, Diana, 105
Rothermel, John, 106
Rothholz, Stephen, 64
Rotten, Johnny, 165, 177, 202, 207
Roxy club, 204
Roxy Music, 12, 18, 166, 167, 168, 171, 176, 185, 188
Roxy shop, 138
Royal College of Art, 11, 12
Rubell, Steve, 214
Russell, Ken, 75, 108
Russell, Shirley, 75, 108
Rykiel, Sonia, 198

Sagbag beanbag, 119
Saint Joan, 142
Saint Laurent, Yves, 24, 43, 61, 73, 119, 120, 147, 161, 171, 181, 183, 197, 198
Saliva sofa, 43
Sallon, Philip, 207
Sams, Craig and Gregory, 123
Sanchez, America, 181
Sanders, Rick, 7
Sanderson, 147
Saturday Night Live, 210
Saturday Night Fever, 218
Saul, Monty and Roger, 139
Saunders, Sue, 92
Savage, Jon, 172, 173, 202
Saville, Peter, 12, 13, 73, 159, 168, 201
Sayer, Leo, 111
Scarlett, 211
Scharf, Kenny, 23, 217
Schrager, Ian, 214

Schumacher, E. F., 117
Schwarzenegger, Arnold, 167
Scott Brown, Denise, 20
Scott, Ridley, 85
Scott Lester fashion label, 24
Sea Cruise jacket, 92
Seditionaries shop, 173, 201
Seed restaurant, 123
Self-Portrait with Cadillac, 23
Severin, Steve, 207
Sex boutique, 13, 165, 173, 178, 202, 204
Sex, Johnny, 217
Sex Pistols, 165, 173, 193, 202, 204, 207
Sgt Pepper's Lonely Hearts Club Band, 71
Sha Na Na, 175, 186
Shaw, George Bernard, 142
Shaw, Paul, 191
Sheila and B. Devotion, 19
Sherman, Cindy, 185
Shilling, David, 88
'Show Must Go On, The', 111
Silent Movie, 111
Silver Jubilee, 174, 202
Simpson, Ian, 217
Sinvola lamp, 55
Siouxsie and the Banshees, 207
Siouxsie Sioux, 173, 204, 207
Sister Sledge, 23
Sit Down armchair, 57
SITE, 53
Skurka, Norma, 7, 117
Slade, 106, 169, 186
Slesin, Suzanne, 121
Slits, The, 209
Smile salon, 27, 176, 178, 203
Smith, Patti, 173, 186
Smith, Willi, 176
Solanas, Valerie, 173
Soleri, Paolo, 117, 136
Sombrero club, 204
Some Mothers Do 'Ave 'Em, 94
Sontag, Susan, 166, 167, 171
Sorbie, Trevor, 210
Sottsass, Ettore, 17, 21, 22, 33, 57
Sparks, 168
Specials, The, 209
Spencer-Cullen, Rae, 171
Spurr, Fred, 194, 217
'S-s-s-single Bed', 108
Stamp, Terence, 121
Standing Stones table, 143
Stardust, Ziggy, 13, 111, 167, 169
Steeleye Span, 144
Stefanidis, John, 33, 34, 171
Stein, Lea, 111
Stella, Frank, 39
Stereo illustration, 67
Stern magazine, 184
Sternberg, Jacques, 166
Stewart, Rod, 76, 77
Stigwood, Robert, 218
Sting, The, 77
Stirling Cooper fashion label, 92
Stonewall riots, 169, 190
Strada, Nanni, 201
Strand Palace Hotel, 81
Strange, Steve, 211
Strangeways shop, 119
Strawberry Studio, 61
Street-Porter, Janet, 73, 81
Street-Porter, Tim, 73, 81, 193
Streisand, Barbra, 73
Studio 54, 23, 62, 97, 168, 192, 197, 211, 214
Studio Alchimia, 21, 22, 55
Study for the Flagellation, 191
Sugarhill Gang, 214
Swanky Modes, 4, 62, 194
Sweet, 169, 186
Sweet Revenge, 105
Swindon, Yvonne, 161, 163

Table, Chair and Hat Stand sculptures, 33
Takada, Kenzo, 94, 139, 192, 197, 212
Take One Lemon, 171
Tao Design Group, 114, 115
Tatchell, Peter, 6, 169
Tatters shop, 101
Ter et Bantine shop, 147, 198
Thatcher, Margaret, 7
That'll Be the Day, 169
That's Entertainment!, 105
Thems, 167, 171, 173, 192, 193, 195, 197, 202
Thomas, Steven, 34
Thomass, Anne, 147
Thomass, Bruce, 198
Thomass, Chantal, 47, 147, 198
Thomson, Brian, 174
Thormahlen, Ernie, 187
Timney Fowler, 212
Timney, Sue, 212
Tinsel Tarts in a Hot Coma, 187

Today programme, 207
Tom of Finland, 187, 204
Tongue chair, 17
Too Fast to Live, Too Young to Die shop, 169, 173
Topley, Bill, 39
Top of the Pops, 178
Toscani, Oliviero, 47, 184
Toukie, 214
Transformer, 187
Travolta, John, 218
Troy, Carol, 46, 120
Trubek-Wislocki houses, 53
Tseng, Kwong Chi, 217
Tula, 180
Turquato, Oscar, 43
Twiggy, 74, 75, 76, 108, 111

Ultrafragola mirror, 33
Umbro, 46
Universal Witness shop, 103
Unknown Pleasures, 201
Untitled Film Stills, 185
Up furniture, 6
Upstairs, Downstairs, 77

Van der Rohe, Mies, 18, 21
Vanilla, Cherry, 62, 169
Vargas, Alberto, 99, 167, 181
Venturi, Robert, 18, 20, 21
Venturi Scott Brown and Associates, 53, 57
Venus and Mars, 66
Vertigo, 185
Vicious, Sid, 204
View magazine, 67
Village People, 13, 154
Vinçon shop, 181
Vine chair, 143
Virginia Slims, 13
Vogue magazine, 78; (British) 18, 77, 84, 103, 193; (French) 87, 169; (Italian) 48, 147; (*L'Uomo*) 48, 161, 163, 173

Wainwright, Jerry, 131
Wainwright, Keith, 27, 176, 178
Walker, Alexander, 77
Walkers shoes, 92
'Walk on the Wild Side', 168
Wally, Cockettes member, 187
Walters, Prudence, 177
Warhol, Andy, 12, 34, 71, 73, 74, 168, 169, 171, 172, 173, 178, 192, 214
Waters, John, 165, 166, 167, 169, 172, 177
Waymouth, Nigel, 36, 70, 101
Wealleans, Jon, 17, 18, 24, 33
Wedge haircut, 210
Wedge, James, 41
Wertheimer, François, 183
Wesselmann, Tom, 15, 24, 43
Weston, Judith, 132
Westwood, Vivienne, 58, 73, 165, 169, 171, 173, 201, 202, 204, 210, 212
Wheeler's Ranch commune, 124
White, Cindy, 176
White, Molly, 27, 41, 58
Whitmore-Thomas, 34
Whitney, Kevin, 193
Who, The, 209
Whole Earth Catalog, 114, 123
Wickham, Julyan, 84
Wigan Casino, 218
Wild Thing T-shirt, 27
Williamson, Judith, 170
Williamson, Rupert, 81, 123
Wines, James, 53
Wings, 66
Winsor & Newton, 36
Wish You Were Here, 45
Wolfe, Tom, 7, 9, 12, 74, 124
Women's Liberation Workshop, 7
Wonder Workshop, 27
Woodlawn, Holly, 168
Woodstock, 12, 175
Wright, Barbara and David, 117

Xenon club, 62, 214

Yak shop, 133, 147
Yamamoto, Kansai, 13, 47, 192
Yellow Submarine, 36
York, Peter, 12, 13, 72, 77, 171, 192, 193, 195, 202
Yours or Mine club, 192

Zakas, Spiros, 39
Zanzibar, 84
Zapata shop, 92
Zebedee shoe, 64

PICTURE CREDITS

Every effort has been made to trace the copyright owners of the images contained in this book and we apologize for any unintentional omissions. We would be pleased to insert an appropriate acknowledgement in any reprint of this publication.

Fiorucci, Fioruccino, Fiorucci Safety Jeans, Elio Fiorucci, Fiorucci Time and the 'angels' (figurative trademark) are trademarks registered and owned by Edwin Co Ltd. There are neither ownership nor licence connections between these trademarks and Mr Elio Fiorucci.

1 Antony Little for Osborne & Little; courtesy of Osborne & Little *osborneandlittle.com*; **2** Jake Wynter; courtesy of Willie Walters; **7** courtesy of B&B Italia; **8** © Tim Street-Porter; **9** courtesy of Stuart Shave/Modern Art; **10** Jane England; **11** © Kishin Shinoyama, 1971; **12** Bill Orchard/Rex Features; **13** © Sheila Rock; **14–15** courtesy of Osborne & Little; **16** courtesy of Jon Weallens; **17** (bottom) courtesy of Jon Weallens; (top) courtesy of Artifort; **18** (top) Peter Knapp; (bottom) Hans Feurer; **19** (top, left and right) Roger Stowell Partnership; courtesy of Habitat; (bottom) courtesy of Habitat; **20** (left) courtesy of Roberto Marossi; (right) Richard Payne FAIA; by kind permission of Philip Johnson/Alan Ritchie Architects; **21** courtesy of Atelier Mendini; **22** Sheila Rock; Chrysalis Records, 1978; **23** (top) © Edwin Co Ltd; (bottom) © Kenny Scharf; courtesy of Scharf Studio; **24** (top) © Steve Hiett; courtesy of Pamla Motown and Steve Hiett; (bottom) design and illustration: George Hardie; **25** Stuart Penney; produced by Tom Wommack; design: Albert Elia; **26** Peter Knapp; **27** (top) Hans Feurer; (bottom, left) Armet Francis; (bottom, right) Roger Charity; courtesy of Keith Wainwright *smilesalon.co.uk*; **28, 31** © Ian Murphy; Thea Cadabra *theacadabra.com*; **29–30** John Bishop; **32** © Tim Street-Porter; Table, Chair and Hat Stand © Allen Jones 1969; **33** (left) Tim Street-Porter; © Elizabeth Whiting & Associates *ewastock.com*; (right) Alberto Fioravanti; **34** (top) design and illustration: George Hardie; **34–35** (bottom), **35**, (top, right) Tim Street-Porter; design: Whitmore-Thomas, 1973; © Steven Thomas; (top, left) courtesy of John Stefanidis; (bottom, right) courtesy of Kartell; **36**, (top, left) © Hilary Hayton; (bottom, left) design: Milton Glaser, 1967; (right) courtesy of Winsor & Newton *winsornewton.com*; **37** © Alan Aldridge; **38** (left) © Patrick Hughes; (top, right) Oberto Gili; (middle, right) courtesy of Keith Gibbons; (bottom) courtesy of Habitat; **39** Grow Chemical Corporation UK, 1971; **40** Ian Murphy; © Thea Cadabra and James Rooke; **41** (left) John Dove and Molly White at Countdown *wonderworkshop.co.uk*; (right) © Paladin/Granada Publishing Ltd; **42** (top) Ian Murphy; © James Rooke; (bottom) Serge Bailhache; courtesy of Claude and François-Xavier Lalanne; **43** courtesy of Bd Barcelona Design. Image Rights of Salvador Dalí reserved. Fundació Gala-Salvador Dalí, Figueres, 2009; **44** courtesy of Art & Language and Lisson Gallery; **45** (top, left) © Serge Lutens 1978; (top, right) Pink Floyd *Wish You Were Here* album cover supplied courtesy of Pink Floyd (1987) Ltd/Pink Floyd Music Ltd. Artwork by Hipgnosis; (bottom) Roger Stowell; **46** Peter Knapp; **47** (left) © Robyn Beeche; (top, right) Oliviero Toscani/© Hachette Filipacchi Associés; (bottom, right) © Robyn Beeche; **48** (top) A Dejean/Sigma; Carrere Records, 1978; (bottom) Harri Peccinotti; **49** (top) © Oliviero Toscani for *L'Uomo Vogue*; (bottom) © Oliviero Toscani for Italian *Vogue*; **50** (left) courtesy of De Beers; **50–51**, **52** © Joe Gaffney for Georges Rech; **52** © SITE; **53** Steven Izenour; courtesy of Venturi, Scott Brown and Associates; (bottom) © Charles Moore Foundation; **54** © Tim Street-Porter; **55** (left) Shiro Kuramata for Cappellini; (top, right) Studio Alchimia; © Architetto Michele De Lucchi; (bottom, right) courtesy of Atelier Mendini; **56** (top, left and right) courtesy of Atelier Mendini; (bottom) Mario Carrieri; Collezione Cassina, 1975; **57** (top) Giorgio Molinari; © Architetto Michele De Lucchi; (bottom, left) courtesy of Venturi, Scott Brown and Associates; **58** © Jane England; © Susanna Heron, 1976. All rights reserved; **59** (top, left) Tim Street-Porter; (bottom, left) © Andy Sotiriou; **60** (top, left) © Val Furphy; (foreground) © Chloë Cheese; courtesy of Val Furphy; **61** Island Records, 1979; **62** (top, left) © Dagmar *dagmarfoto.com*; (top, right) courtesy of Peter Golding *petergolding.com*; (bottom, right) © Robyn Beeche; **63** (top) © Edwin Co Ltd; (bottom) courtesy of Peter Golding; **64** (top) Ian Murphy; © Thea Cadabra; (bottom, left) © Terry de Havilland; with thanks to Steven Philips at Rellik *relliklondon.co.uk*; (bottom) © Peter Knapp; **64–65** (background) courtesy of Stephen Rothholz; **65** (left) © Peter Knapp; (right) © Antony Price; **66** (left) design: George Hardie for Hipgnosis; (right) Baxter Dury/Ian Dury Estate; **67** (top, left) design: April Greiman; (top, right) Jill Furmanovsky; sleeve design: Malcolm Garrett/Assorted Images; © 1979 Malcolm Garrett; (bottom, left) courtesy of Mick Haggerty; (bottom, right) Rat Scabies/Dave Vanian/The Damned; **68–69** Antony Little for Osborne & Little; courtesy of Osborne & Little; **70** (left) courtesy of Barbara Hulanicki; (right) design: Milton Glaser; **71** (left) Harri Peccinotti; (right) courtesy of Anne Lancaster; (bottom) design: Milton Glaser; **72** (top, left) Everett Collection/Rex Features; (top, right) © Joe Gaffney; (bottom) courtesy of Jean-Charles Brosseau; **73** © Tim Street-Porter; **74** (left) Terence Donovan; (right) © James Reeve; Brighton Museum & Art Gallery; courtesy of Bevis Hillier; **75** MGM/BFI; **76** (left) © Stella Margetson, 1974; (right) Warner Bros, 1976; **77** (left) ITV/Rex Features; (right) ABC/Allied Artists/The Kobal Collection; **78** © Malcolm Bird; **79** (top, left) © Tim Street-Porter; (top, right) © Manfredi Bellati; (bottom) courtesy of Lyn Le Grice *lynlegrice@flowerloftstudios.com*; **80** (top, left) © Tim Street-Porter; (top, right) Oberto Gili; (bottom, left) courtesy of Lyn Le Grice; (bottom, right) courtesy of Rupert Williamson *rupertdesigns.co.uk*; **81** © Tim Street-Porter; **82–83** Tim Street-Porter; design: Whitmore-Thomas, 1973; © Steven Thomas; **84** Elizabeth Whiting & Associates; **85** (top, left) courtesy of Keith Gibbons; (top, right) Bill Toomey; © Julyan Wickham of Julyan Wickham Architects; (middle) Collier Campbell for Liberty, 1973; (bottom) Kinerk/Wilhelm Collection/Capitman Archives MDPL; **86** © Joe Gaffney for French *Vogue*; **87** (left) John Bishop; (right) © Serge Lutens, 1973; **88** (top) Mayotte Magnus; courtesy of Molly Parkin; (middle, left) Hans Feurer; (middle, right) Sarah Moon; model: Ingrid Boulting; design: Steve Thomas Associates, 1968; (bottom) courtesy of Ricci Burns; **89** (left) courtesy of Haro Hodson; (right) courtesy of Adeline André; (bottom, right) courtesy of Celia Birtwell; **90** (top) courtesy of Beatriz Lutyens; (bottom) John Bishop; **91** John Bishop; **92** John Bishop; **93** (top, left) © Johnny Dewe Mathews; (top, right) courtesy of Lloyd Johnson; (bottom, left) illustration: Michael Matou; courtesy of Robert Lusk; (bottom, right) illustrations: Kasia Charko; design: Whitmore-Thomas, 1973; **94–95** MAM Records, 1971; **95** (top) courtesy of Kenzo Archives; (top, right) Terence Donovan; (bottom) © Patricia Roberts; **96** (top, left) design: Bentley/Farrell/Burnett; courtesy of Bevis Hillier; (bottom, left) Rolph Gobits; illustrations: Kasia Charko; design: Whitmore-Thomas, 1973; (bottom, right) © Antony Little; **97** Canal+/BFI; **98** (top, right) Penguin Books, 1950, 1973; © 1926 by F. Scott Fitzgerald; (bottom) courtesy of Dormeuil; **99** (top) © Belle Epoque/Carrere Records, 1978; (bottom) © Hélène Majera, 1977; **100** (top, left) Ingeborg Gerdes; (bottom, left and right) © Johnny Dewe Mathews; **101** © Johnny Dewe Mathews/Rockarchive; **102** courtesy of Maureen Bampton; **103** (top and bottom) courtesy of Butler & Wilson; (middle) courtesy of Paul Reeves; **104** (top) GAB Archives/Redferns; (bottom) RB/Redferns; **105** (top) Ariola-Eurodisc, 1978; (bottom) Everett Collection/Rex Features; **106** Thut-Wainwright and Charles Iddings, Jr; Blue Thumb Records, 1971; **107** (top) courtesy of Paul Dunford *hingeandbracket-official.co.uk*; EMI, 1977; (top, right) Keith Morris/Redferns; (bottom, left) Clay Geerdes; © Carol Kossack; (bottom, right) © Jane England; **108** (top) MCA Records, 1974; (middle, left and bottom, left) © Joe Gaffney; (middle, right) Archive Photos/Getty Images; (bottom, right) courtesy of Tim Hauser; **109** BBC Picture Library/Redferns; **110** (left) Ian Dickson/Redferns; (right) © Jane England; **111** (left) Justin de Villeneuve; RCA, 1973; (bottom, right) © Johnny Dewe Mathews; **112–13** courtesy of Sanderson; © Abaris Holdings Limited; **114** © Bettmann/Corbis; **115** (top, left) Time & Life Pictures/Getty Images; (top, right) © Jon Naar, 1975, 2009; (bottom) © Charles Harker; **116** (left) © Architetto Michele De Lucchi; (right) design: Alessandro Becchi; produced by Giovannetti Collezioni; **117** © Jon Naar, 1975, 2009; **118** (left) courtesy of Carol McNicoll; (right) courtesy of Habitat; **119** (top) by kind permission of Laura Ashley Ltd; (bottom) courtesy of Habitat; **120** (left and right) Hans Feurer; **121** Michael Nicholson; © Elizabeth Whiting & Associates; **122** (top) © Jon Naar, 1975, 2009; (bottom) © 1971 Portola Institute, Inc; **123** (top, left) courtesy of Rupert Williamson; (top, right and bottom, right) courtesy of Craig and Gregory Sams *craigsams.com*; (bottom, right) © Marvin Lipofsky; **124** (left) © Patrick Guis/Kipa/Corbis; (top, right) © Wolfgang Ebert; (bottom, right) © Henry Diltz/Corbis; (top, right) © Clay Geerdes; **126** by kind permission of *Private Eye*; **127** (top) Harri Peccinotti; (bottom, left) © Levi Strauss & Co; (bottom, middle) © Martha Hill Ltd; (bottom, right) courtesy of The Body Shop International plc; **128** (top, left and right) © Wolfgang Ebert; (bottom, left) © Shelter Publications, Inc; (bottom, right) © Charles Harker; **129** courtesy of Atelier Mendini; (bottom) © Architetto Michele De Lucchi; **130** © Jean Paul Goude; **131** (top, left) Harri Peccinotti; (top, right) © Peter Knapp; (bottom, left and right) Jerry Wainwright, with permission from Ann Funsten; **132** (left) courtesy of Alexandra Hart; (right) Collier Campbell 1971; **133** (top) courtesy of Zandra Rhodes; (bottom) courtesy of Robert Lusk; **134** (top and bottom) © Jon Naar, 1975, 2009; (bottom, right) © Wolfgang Ebert; **134–35** © Jon Naar, 1975, 2009; **136–37** Ivan Pintar; courtesy of the Cosanti Foundation; **138** courtesy of Roy Peach; **139** (top, left) courtesy of Kenzo Archives; (top, right) courtesy of Roger Saul; (bottom, left) © Hachette Filipacchi Associés; **140** (left) courtesy of Sue Rangeley; (right) Mustafa Sami; **141** (left) Jerry Wainwright, courtesy of Alexandra Hart; (top, right) © Marvin Lipofsky; (bottom, right) courtesy of Alexandra Hart; **142** (top) courtesy of *Crafts*; (top, right) courtesy of Chris Hicks; (middle) M Lee Fatherree; © Marvin Lipofsky; (bottom) courtesy of John Makepeace; **143** (top, left and bottom) © Bd Barcelona Design; (top, right) courtesy of John Makepeace; **144** (left) by kind permission of Laura Ashley Ltd; **145** (top) illustration © Gretchen Schields 1978; © Folkwear 1978; (bottom) Charisma Records, 1972; (background) courtesy of Osborne & Little; **146** (top) courtesy of Robert Lusk; (bottom) Manfred Seelow; courtesy of Chantal Thomass; (background) courtesy of Sanderson; © Abaris Holdings Ltd; **147** (top) © Liberty; (bottom) © Oliviero Toscani for Italian *Vogue*; **148** (top) David Inshaw; (bottom) © Webb & Bower Ltd, 1977; **149** (top) Deluxe Publications Ltd, 1977; (top, right) © Peter Blake; (bottom) courtesy of Sue Rangeley; (background) courtesy of Lyn Le Grice; **150** (foreground) courtesy of Lyn Le Grice; (background) courtesy of Habitat; **151** (top, left) Phil Sayer; courtesy of David Mellor Design; (top, right) Roger Stowell; courtesy of Habitat; (bottom, right) Tim White; design: Whitmore-Thomas, 1973; © Steven Thomas; **152** design: Joe D'Urso; courtesy of Esprit; **152–53** © Michael Leonard; **154** (top) courtesy of Michael Jantzen; (bottom, left) courtesy of Kit Grover; (bottom, right) Larry Williams; courtesy of Ben Kelly; **155** © Tim Street-Porter; **156–57** © Robert Harding World Imagery/Corbis; **158** design: Ben Kelly and Peter Saville, DinDisc, 1980; **159** (top) © Sheila Rock; (bottom) courtesy of Habitat; **160** (top) © Robyn Beeche; (bottom) © Bettmann/Corbis; **161** (top) courtesy of Ricci Burns; (bottom, left) courtesy of Yvonne Swindon; (bottom, right) © Oliviero Toscani for *L'Uomo Vogue*; **162** courtesy of Yvonne Swindon; **163** (top) courtesy of Baron Wolman; (bottom, left) © Oliviero Toscani for *L'Uomo Vogue*; (bottom, right) text © Mary Ann Crenshaw; drawings: Richard Giglio *richardgiglio@earthlink.net*; **164–65** Ian Simpson; **166** (left) Tim White; design: Whitmore-Thomas, 1973; © Steven Thomas; **167** Oberto Gili; **168** John Bishop; **169** © David Parkinson, 1971, with thanks to Jon Savage and the England's Dreaming Punk Archive at Liverpool John Moores University; **170** (top, left) courtesy Ronald Feldman Gallery *feldmangallery.com* and Beverley Knowles Gallery *beverleyknowles.com*; (top, right) Daniel Nicoletta; (bottom) Karl Stoecker; cover concept: Bryan Ferry; art direction: Nicholas de Ville; Island Records, 1972; courtesy of Bryan Ferry; **171** Kasia Charko; design: Whitmore-Thomas, 1973; **172** (left) Sire Records, 1977; (right) courtesy of Andrew Wade *only-anarchists.co.uk*; **173** (left) © Leif Skoogfors/Corbis; (right) © Oliviero Toscani for *L'Uomo Vogue*; **174** (top) © Tim Street-Porter; (bottom) Elizabeth Whiting & Associates; **175** © Tim Street-Porter; **176** (top) courtesy of Trevor Myles; (bottom, left) courtesy of Carol McNicoll; (bottom, right) Tim Street-Porter; **177** (top) courtesy of Duggie Fields; (bottom) The Kobal Collection/Dreamland Productions; **178** (top, left) © Robyn Beeche; (top, right) © Rabanne & Rabanne; (bottom, left) courtesy of Keith Wainwright; (bottom, right) John Bishop; **179** © Robyn Beeche; **180** (top, left) David Wise; The Rumi Missabu Collection; (bottom, left) © Johnny Dewe Mathews; (right) courtesy of Juliet Mann; (background) © America Sanchez; **181** (left) Hans Feurer; (right) Atlantic Records, 1972; **182–83** courtesy of Jean-Bernard Cardon; **183** (top) © Jane England; (bottom, left) courtesy of Philippe Morillon; (bottom, right) © Edo Bertoglio; **184** (top) © Duggie Fields; (bottom, left) © Manolo Blahnik; (bottom, right) © Peter Knapp; **185** (top) © Joe Gaffney; (bottom) courtesy of Cindy Sherman and Metro Pictures; **186** © Joe Gaffney; **187** (top, left) Karl Stoecker; RCA Records, 1972; (top, right) Mercury, 1973; (bottom, right) Clay Geerdes; © Carol Kossack; (bottom, left) Warner Bros/Good Times/The Kobal Collection; **188** © Edo Bertoglio; (bottom) © Jane England; **189** (top) illustration by Richard Bernstein; Island Records, 1978; (bottom) Karl Stoecker © EG Records Ltd; cover concept by Bryan Ferry; Island Records, 1973; courtesy of Bryan Ferry; **190** (top) Elektra Records, 1973; (bottom) © Sheila Rock; **191** (top) Leslie/Lohman Gay Art Foundation, New York; © Delmas Howe; (top, right) Clay Geerdes; © Carol Kossack; (bottom, left) © Sheila Rock; (bottom, right) Clay Geerdes; © Carol Kossack; **192** © Ulla Larson-Styles; **193** (top) © Robyn Beeche; (middle) courtesy of the National Magazine Company and Peter York; (bottom, left and right) © Johnny Dewe Mathews; **194** (left) © Clive Arrowsmith; courtesy of Zandra Rhodes; (right) © Robyn Beeche; courtesy of Andrew Logan; (background) courtesy of Peter Golding; © *Ritz*; **195** (top) © Tate, London, 2009; David Hockney, *Mr and Mrs Clark with Percy*, 1970–71, acrylic on canvas, 84 x 120"; © David Hockney; (middle) © Tim Street-Porter; courtesy of Andrew Logan; (bottom) © Niall McInerney; **196** © Estate of Antonio Lopez and Juan Ramos; **197** (top) © Alain DeJean/Sygma/Corbis; (bottom, left) © *Façade*, founded by Alain Benoist and Hervé Pinard; (bottom, right) © Robyn Beeche; **198** (top) courtesy of Jean-Charles de Castelbajac; (bottom, left) courtesy of Chantal Thomass; (bottom, right) John Minihan/Evening Standard/Getty Images; **199** © Joe Gaffney; **200** (top) © James Wedge; courtesy of Nanni Strada; (middle) design: Joy Division and Peter Saville; Factory Records, 1979; (bottom) © Joe Gaffney; **200–1** © Peter Knapp; **202** (top, left) courtesy of Andrew Logan; (right) © Dennis Morris *dennismorris.com*; **202–3** (background) © Jane England; **203** (top, left) © Kate Simon; © 1977 CBS Records; (top, right) hair by Keith Wainwright at Smile (bottom, right) © The Estate of Derek Jarman, courtesy K Collins; **204** (top) © Dennis Morris; (bottom) © Jane England; **205** David Dagley/Rex Features; **206** (left) © Jane England; **207** (top) Sheila Rock; (middle) Grant Mudford; courtesy of Zandra Rhodes; (bottom) © Jane England; **208** (top) © Edo Bertoglio; (bottom) © Sheila Rock; **209** (top) courtesy of Lloyd Johnson; (bottom) 2Tone Records, 1979; **210** (top, left) Anthony Scibelli; © Edwin Co Ltd; (bottom, left) Patrick Hunt/Trevor Sorbie; (right) RCA Records, 1977; **211** (top and bottom, right) © Robyn Beeche; (bottom) © Sheila Rock; **212** (top, left) © Robyn Beeche; (top, right) © Johnny Dewe Mathews; (bottom) © Jane England; **213** (top) courtesy of Melissa Caplan; (bottom) © Timney Fowler; design: Sue Timney; **214** © Edo Bertoglio; **215** (top row, left) © Edo Bertoglio; (top row, right) © Jean-Paul Goude/Pierre Houles; (middle row, centre) © Dagmar; (middle row, left) © Edwin Co Ltd; (bottom, centre) courtesy of Franco Marabelli; (bottom row, right) © Dagmar; **216** © Tim Street-Porter; **217** (top) Fred Spurr as featured in Miss Selfridge; (bottom) © Jon Naar, 2010; **218** (top) RSO, Reprise, 1977; (bottom) © Guy Bourdin/Art + Commerce; **219** Oberto Gili.